M000290969

HISTORIC PHOTOS OF
THE MAIN LINE

TEXT AND CAPTIONS BY LAURA E. BEARDSLEY

TURNER
PUBLISHING COMPANY

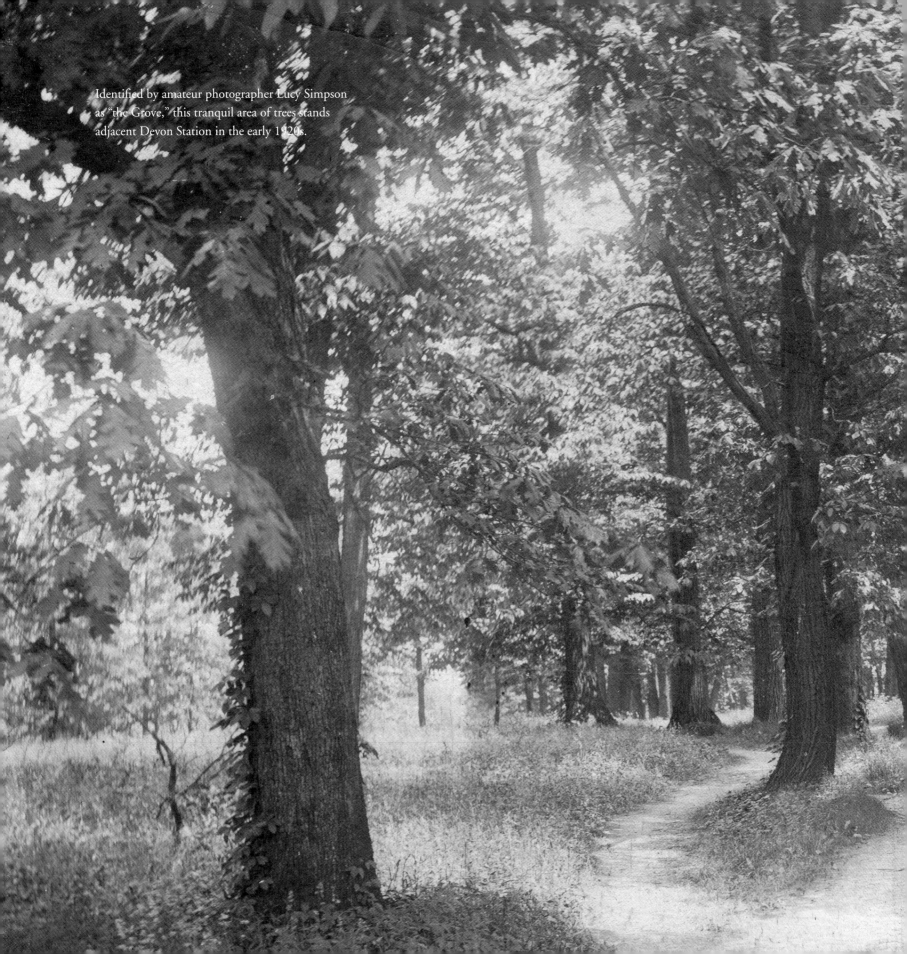

Identified by amateur photographer Lucy Simpson as "the Grove," this tranquil area of trees stands adjacent Devon Station in the early 1920s.

HISTORIC PHOTOS OF
THE MAIN LINE

Turner Publishing Company
200 4th Avenue North • Suite 950
Nashville, Tennessee 37219
(615) 255-2665

www.turnerpublishing.com

Historic Photos of the Main Line

Copyright © 2008 Turner Publishing Company

All rights reserved.
This book or any part thereof may not be reproduced or transmitted
in any form or by any means, electronic or mechanical, including
photocopying, recording, or by any information storage and retrieval
system, without permission in writing from the publisher.

Library of Congress Control Number: 2007937033

ISBN-13: 978-1-59652-420-0

Printed in China

08 09 10 11 12 13 14 15—0 9 8 7 6 5 4 3 2 1

CONTENTS

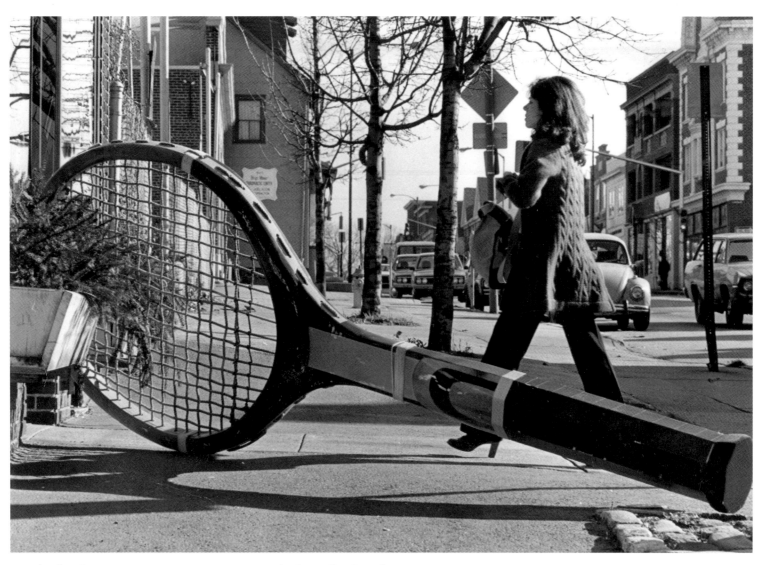

A twelve-foot-long tennis racquet greets customers at the James Cox Sportshop on Lancaster Avenue in Bryn Mawr in 1979.

Acknowledgments

This volume, *Historic Photos of the Main Line,* is the result of the cooperation and efforts of many individuals, organizations, and corporations. It is with great thanks that we acknowledge the valuable contribution of the following for their generous support:

Chester County Historical Society
Historical Society of Montgomery County
Historical Society of Pennsylvania
The Library Company of Philadelphia
Library of Congress
Lower Merion Historical Society
Radnor Historical Society
Temple University—Urban Archives

The author extends a special note of thanks to Erica Piola of the Library Company of Philadelphia for her invaluable contribution and assistance in making this work possible.

PREFACE

Few places in the world enjoy the unique history claimed by the region known as the Main Line. Located to the west of Philadelphia, its past is intimately connected to the storied history of that city. The importance of the railroad in America is also played out in a distinctive way, for it is the railroad that grants a name to the area and literally leads the way to progress and expansion. The story of the Main Line is ultimately a reflection of the American story of pilgrimage, settlement, and community success. From its earliest role as a destination for thousands of Dutch, Swedish, and Welsh colonists, the Main Line has offered refuge to those seeking both home and hearth.

Towns and communities along the Main Line form a part of four separate counties (Philadelphia, Montgomery, Delaware, and Chester) and six townships or boroughs. Relating its complete history is decidedly challenging as no single repository for its history exists. The intent of this book is to provide access to much of the nineteenth-century and twentieth-century history of the Main Line by way of the extraordinary array of photographs available in the library and historical society archives throughout the area. This goal would be unattainable without the generous assistance of the archivists and archives listed in the acknowledgments of this work. We are greatly appreciative.

Ultimately, the power of these photographs lies in their ability to objectively reflect a moment in time and place. It is in these images that we may catch a glimpse of the way life used to be and gain an understanding of how we arrived at the world we know today. With the exception of cropping images where needed and touching up imperfections that have accrued over time, no other changes have been made. The caliber and clarity of many photographs are limited by the technology of the day and the ability of the photographer at the time they were made.

The work is divided into eras. Beginning with the decade following the final construction and marketing of the Pennsylvania Railroad's line to Paoli, the first section records photographs from the years after the Civil War through the end of the nineteenth century, a time in which entire towns were developed. The second section details the remarkable

period of expansion from the turn of the century to the end of the First World War. The third section documents the period between the wars and into the post–World War II era, and the final section touches on the postwar boom to the recent past.

Every effort has been made to locate photographs that relate to the many aspects of life along the Main Line. Trains and automobiles, schools, churches, social and athletic clubs, and local businesses can all be found among the images in this book.

We encourage readers to explore this remarkable region and to seek out the many remnants of the past depicted in these pages. It is the sincere hope of the author and publisher that both longtime residents and those new to the area will be inspired to see their community in a new light and will gain a deeper understanding of their own place in its future.

—*Laura Beardsley*

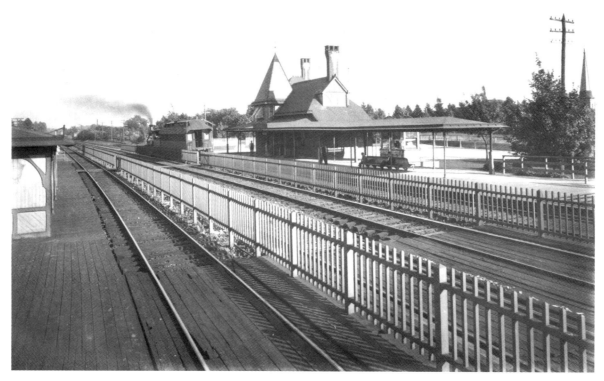

William Rau, commissioned by the Pennsylvania Railroad to photograph the entire length
of the Main Line from Philadelphia to Pittsburgh, took this view of the Wayne train station
around 1890–1895. The train waiting at the station was used by Rau during his travels.

From the Old Comes the New

(1832–1899)

The modern history of the Main Line begins in 1832 when the establishment of the Philadelphia and Columbia Railway allowed for improved movement of both people and freight from the product-rich farming and milling communities that lay to the west of Philadelphia. The new service was authorized as part of the "Main Line of the Public Works of the State of Pennsylvania," soon shortened to "the Main Line." The original path is followed today by the R5 train of the Southeastern Pennsylvania Transportation Agency (SEPTA).

The first government-built railway in the country, the P&C functioned much like a toll road. Populated by privately run horse-drawn wagons and freight cars, the line served the communities along its path as the parallel turnpike from Philadelphia to Lancaster had done since created in the 1790s. However, it was not until the advent of the steam engine and purchase of the line in 1857 by the Pennsylvania Railroad that its true value to the towns along the railroad was realized.

One of the chief complaints about the old railway was the difficulty experienced while maneuvering the steep grades and sharp curves. The Pennsylvania Railroad quickly addressed these concerns by physically redirecting and straightening the route, ensuring a fast and comfortable means of moving both freight and an increasing number of passengers. The railroad went further by actively promoting the line as perfect for those seeking the peace and comfort of a country lifestyle with the added benefit of easy access to the urban center in Philadelphia. Older towns such as Ardmore (originally Athensville) and Bryn Mawr (previously Humphreysville) soon found themselves at the heart of a booming summer resort industry driven by the construction of extravagant summer estates and the railroad's building of luxurious hotels and clubs, such as the Devon Inn and the Bryn Mawr Hotel.

As the last decades of the nineteenth century approached, a new form of real estate development initiated a middle-class boom in St. Davids and Wayne, towns specifically designed with the needs of the commuter in mind. Complete with new schools, churches, social clubs, and service industries, the Main Line had reached a new refinement as the twentieth century drew near.

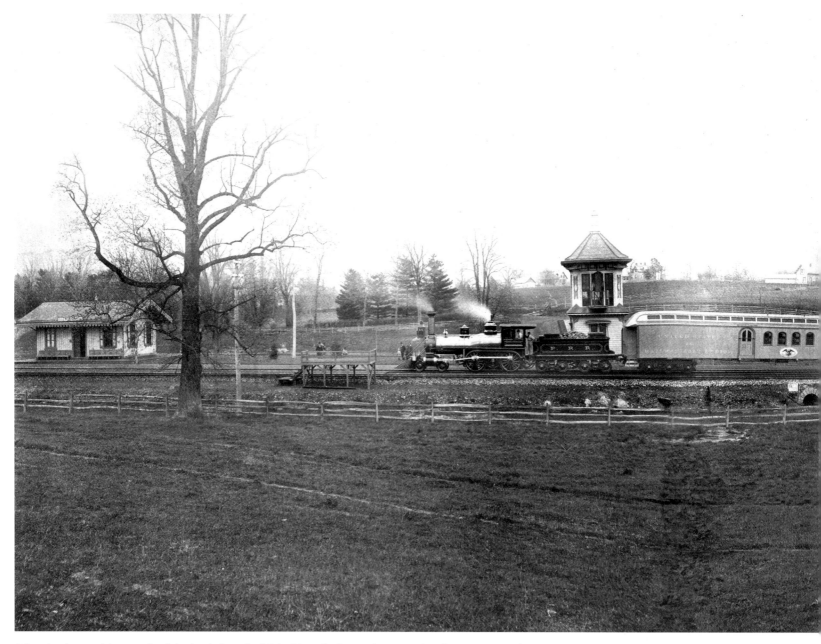

After slowly acquiring much of the land along its Main Line, the Pennsylvania Railroad commissioned Philadelphia-based photographer Frederick Gutekunst to record the company's activities along the rail line that ran from Philadelphia to Paoli. This photograph, taken about 1875, shows a P.R.R. steam-driven train at Merion Station. Pulling several postal cars as well as freight and passenger cars, this was the true workhorse of the railroad.

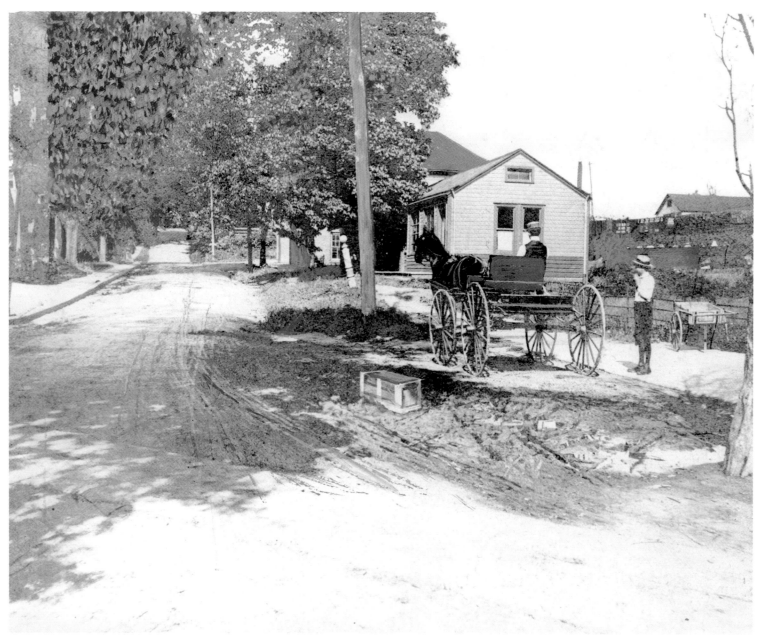

The view of Haverford Avenue looking east from Forrest Avenue around 1875. What was once a country lane now lies near the heart of Narberth, a thriving residential and commercial community with a population of almost 4,300.

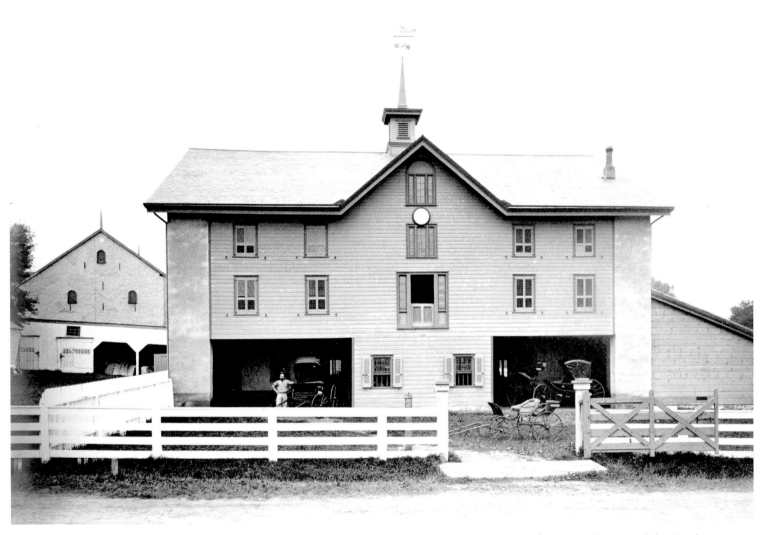

A south view of the main barn and granary, the stable for pleasure horses and the Coach House on the "Louella" estate in Wayne. Photographed by Frederick Gutekunst around 1875, these buildings formed part of J. Henry Askin's property. This area, named in honor of his two children, Louisa and Ella, was purchased and developed by George W. Childs and Anthony Drexel.

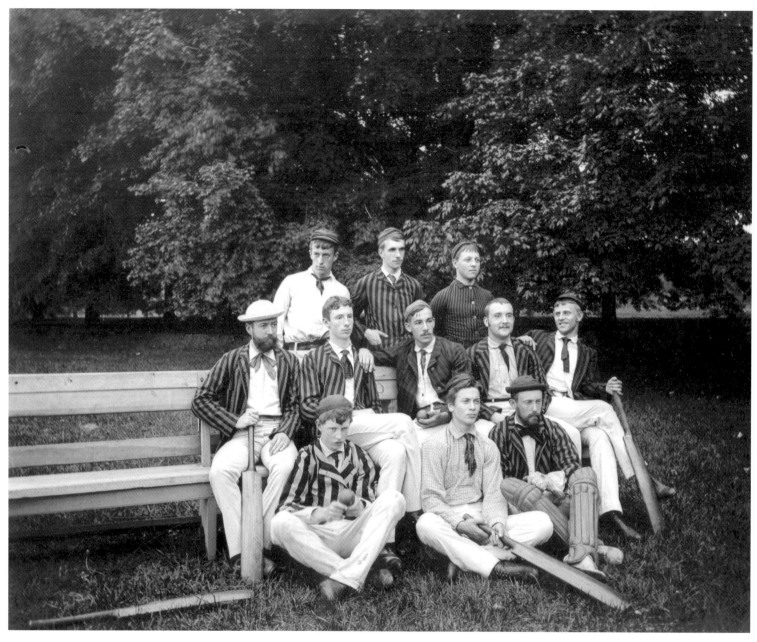

Haverford College was established in 1833 on Quaker principles and remains an important member of the Main Line's strong educational community. On June 4, 1885, the First Eleven of the Haverford College Cricket Club posed for a group photo, taken by fellow student Marriott C. Morris.

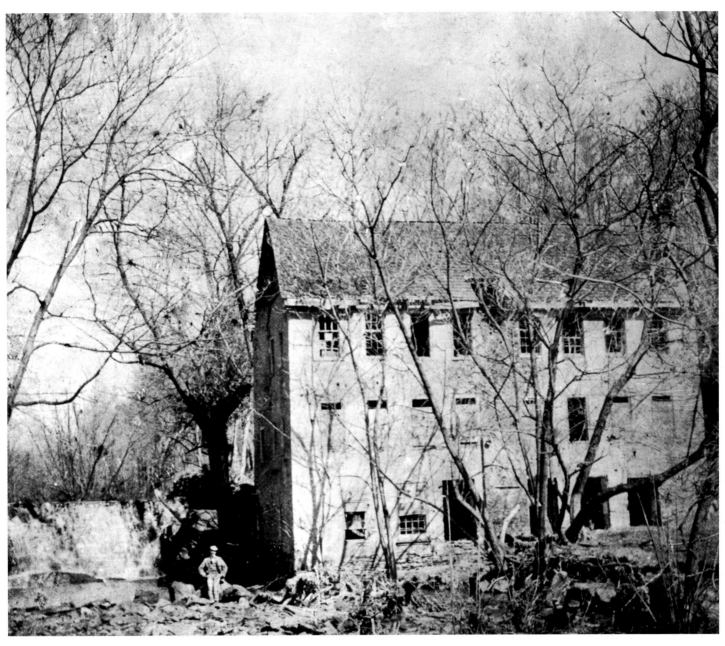

The John Roberts Grist Mill on Mill Creek in Ardmore as photographed about 1890. Constructed in 1746 to replace an older mill destroyed by fire, it continued to produce flour through the eighteenth century and into the nineteenth. Firmly grounded in his pacifist Quaker roots, John Roberts was nevertheless found guilty of treason in 1778 and hanged. A fragment of the mill wall can be seen along Old Gulph Road.

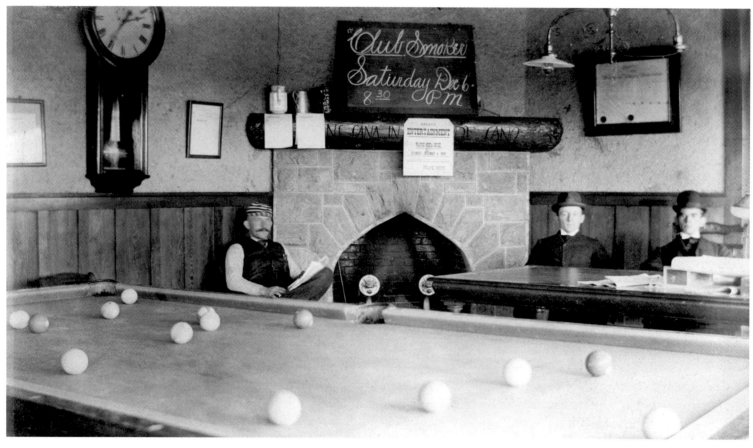

An interior view around 1890 of the Merryvale Athletic Association, in Wayne. Used over the years by the Wayne Country Club and the Radnor Cricket Club, half of the building was destroyed by fire after 1910. The remaining section of the original building is now a private residence.

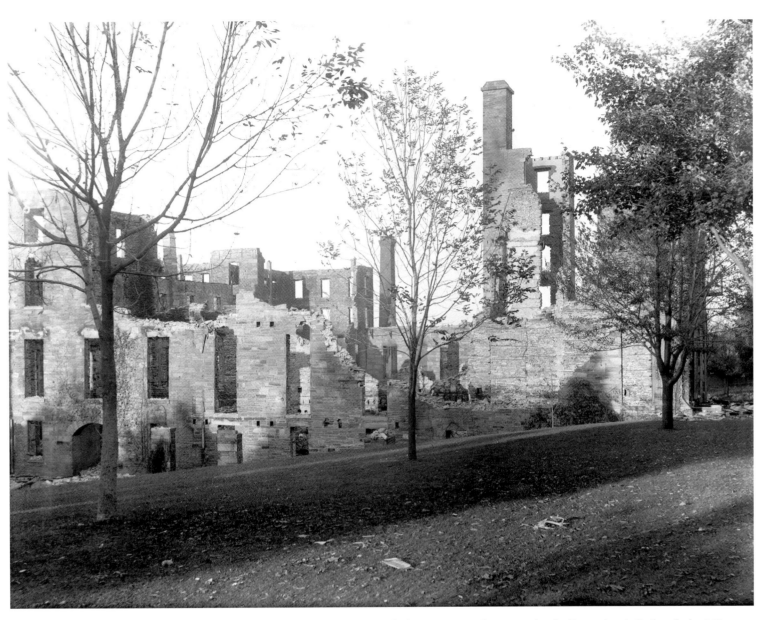

Ruins of the Bryn Mawr Hotel, about 1890. Built in 1871 by the Pennsylvania Railroad, the 250-room hotel became a prestigious summer resort just minutes away from the Bryn Mawr train station. The hotel burned in October 1887 but was subsequently replaced by a larger one designed by architect Frank Furness and his partner Allen Evans. When the popularity of Bryn Mawr as a resort destination declined because of newer attractions along the New Jersey Shore, the building was sold to the Baldwin School, a private preparatory school for girls that continues to use the building.

The Pennsylvania Railroad's Engine #1011 at Bryn Mawr,
August 29, 1890.

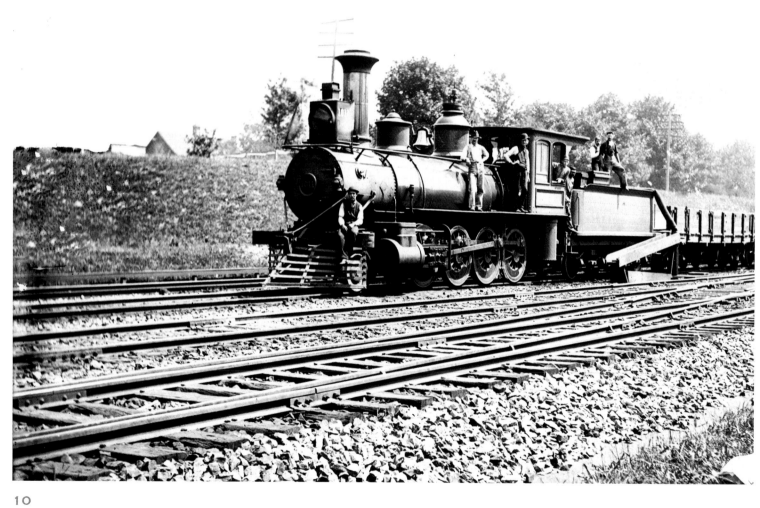

The Robert S. Redfield residence, shown in this photograph from September 1894, was typical of the homes built in the mid-1890s as part of the development in North and South Wayne by landowners George W. Childs and Anthony Drexel. Believed to be designed by the development firm of Wendell & Smith, the homes often featured elaborate window and roof designs known as the Eastlake or "stick" style of architecture. Wendell and Smith went on to aid in the development of Overbrook Park, farther along the Main Line railroad toward Philadelphia.

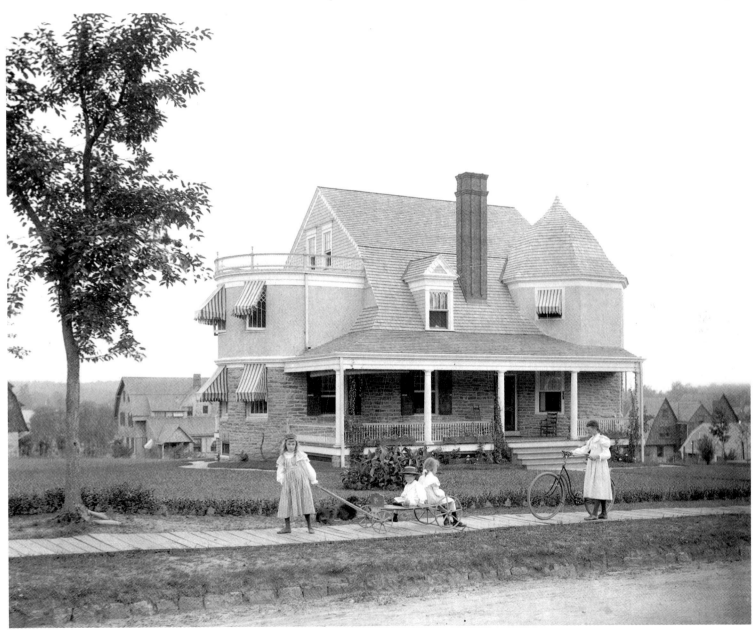

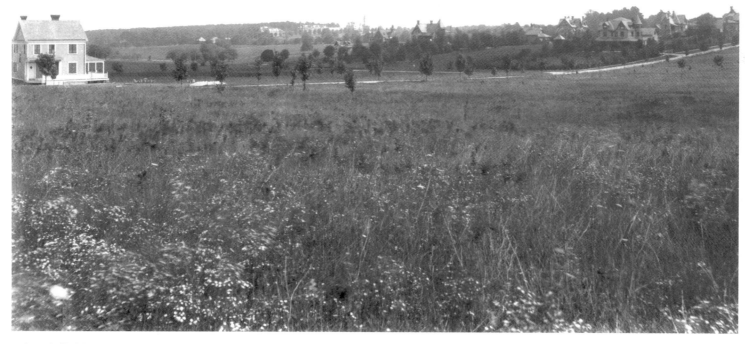

When skilled landscape photographer William Rau was commissioned by the Pennsylvania Railroad in 1891, the intent was to highlight both the beauty and benefits of passenger rail transportation along the Main Line railroad. Displayed at the 1893 World's Columbian Exposition in Chicago, photographs such as this one of the area around Rosemont served an important role as both advertisement and verification of the power of rail transportation in the eastern region of the country.

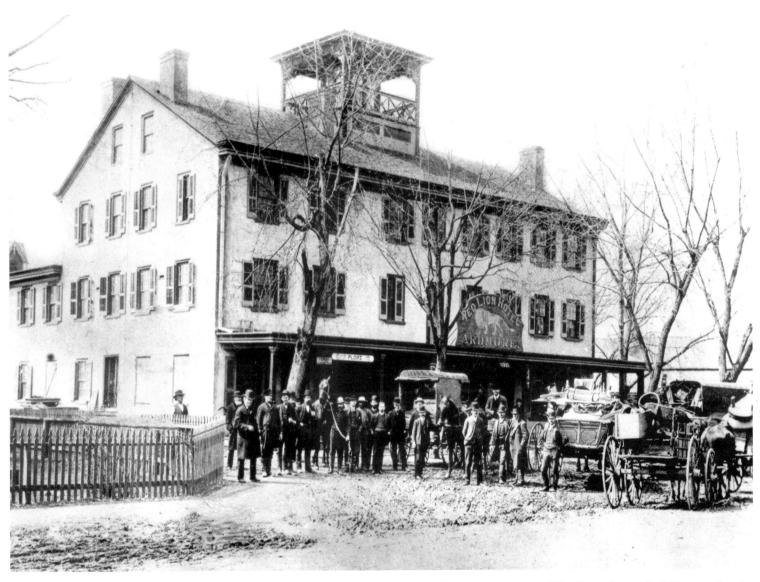

The Red Lion Hotel as it appeared around 1890. Demolished in 1941, the Red Lion stood at the center of the town, Ardmore, on Lancaster Avenue between Ardmore and Greenfield avenues.

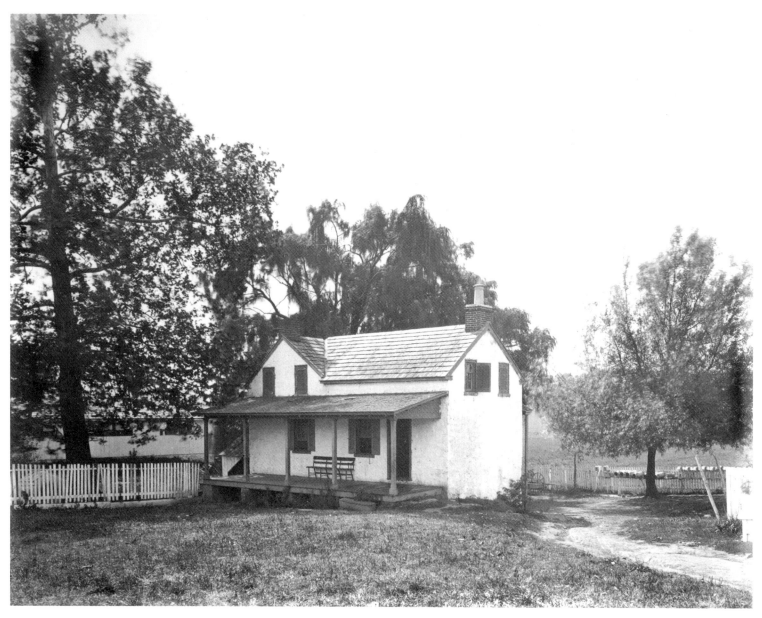

The springhouse at "Louella," the home of J. Henry Askin around 1875. A springhouse was a small building on top of a year-round spring. Open channels permitted water to flow through the lower part of the building. Along the top of the picket fence to the right of this large springhouse are jugs used to store milk in the spring's cold waters.

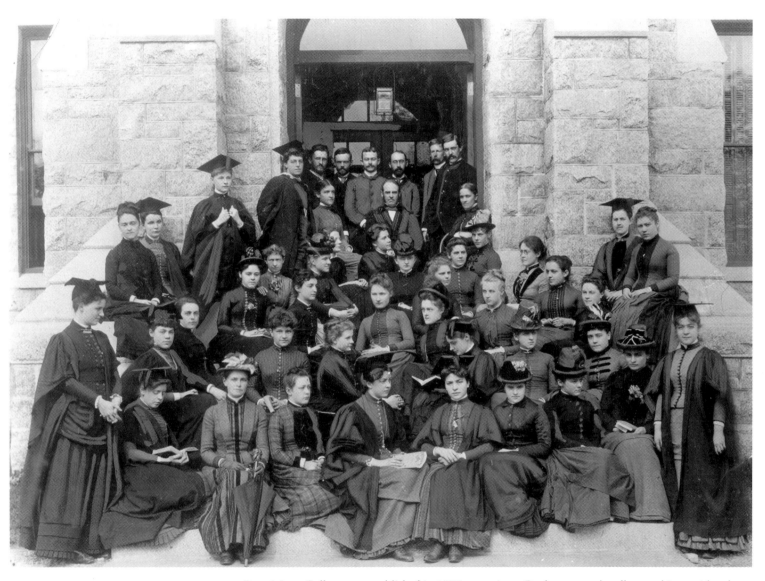

Bryn Mawr College was established in 1885 as a private Quaker women's college and is considered one of the premier liberal arts colleges in the nation. It was the first women's college in the country to offer advanced education to women in the form of Ph.D. programs. Men were first admitted in 1931 but only on the graduate level, a policy that continues today. In this portrait of students and faculty in 1886, professor and future president T. Woodrow Wilson can be seen at top-right.

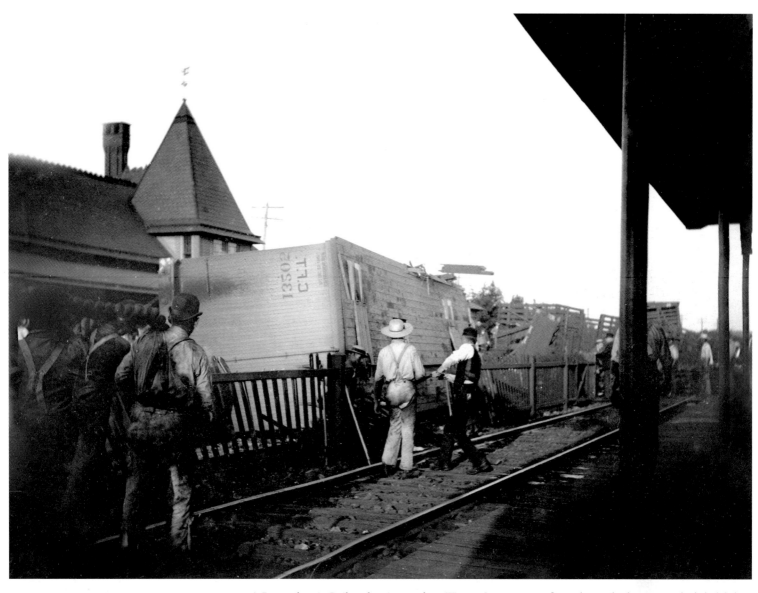

A Pennsylvania Railroad train wreck at Wayne Station, seen from down the line toward Philadelphia, was photographed by Haverford College student Marriott C. Morris on June 11, 1891.

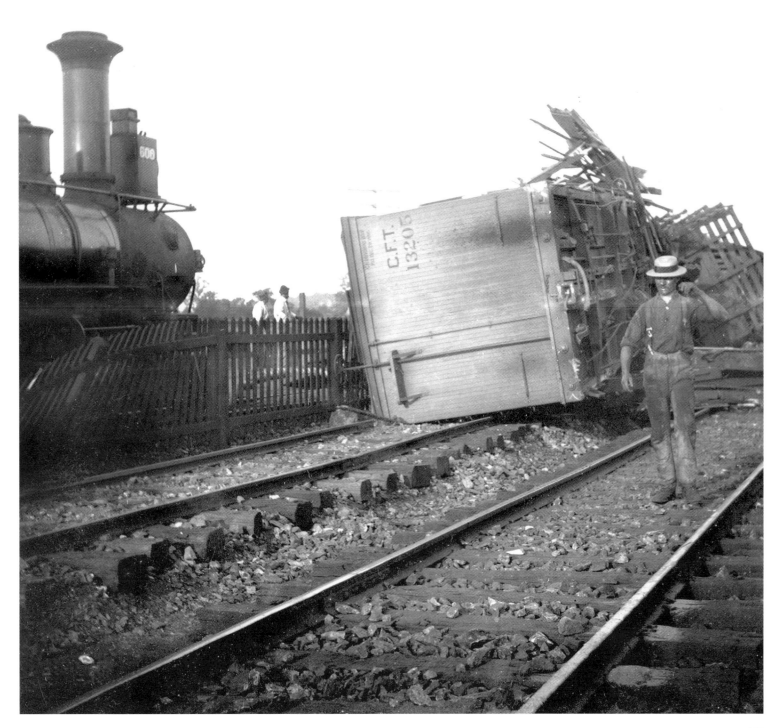

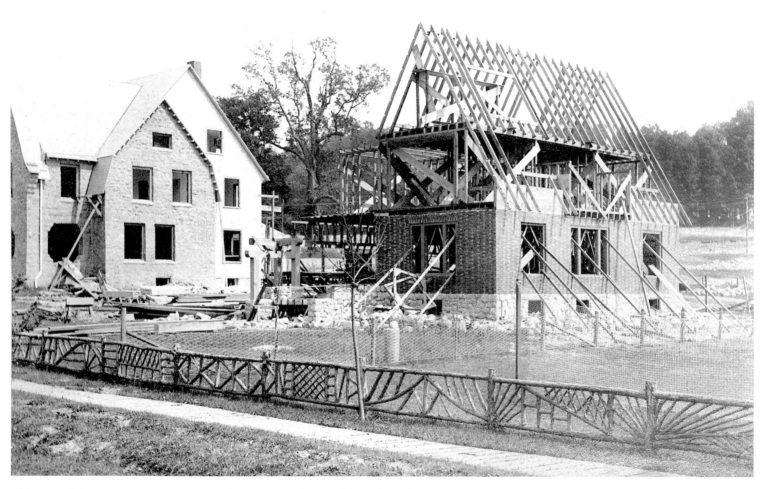

This view of the construction of a house in South Wayne does not hint at its unfortunate
future: the home was destroyed by fire shortly after its completion around 1895.

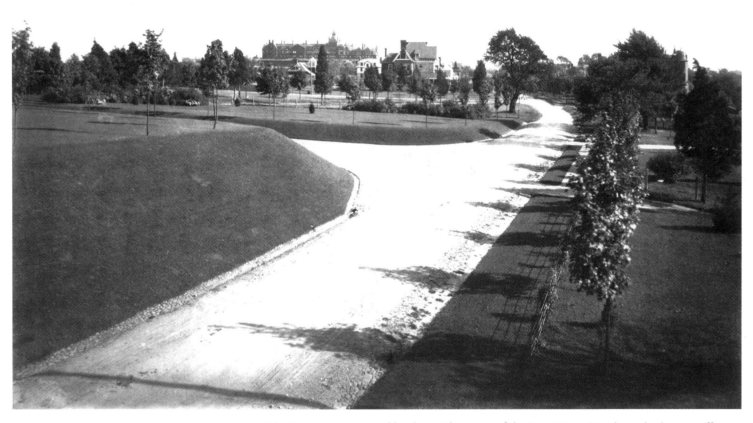

The Devon Inn, inspired by the quick success of the Bryn Mawr Hotel, was built in an effort to appeal to Philadelphia's wealthiest citizens as a summer resort. After the first building was destroyed less than a year after its completion, the inn seen here was built, in 1884. The Devon Horse Show was conceived and initially held on the grounds of the inn in 1896. The building was later acquired by the Valley Forge Military Academy in 1928. As before, less than one year after it changed hands, the inn was destroyed by fire.

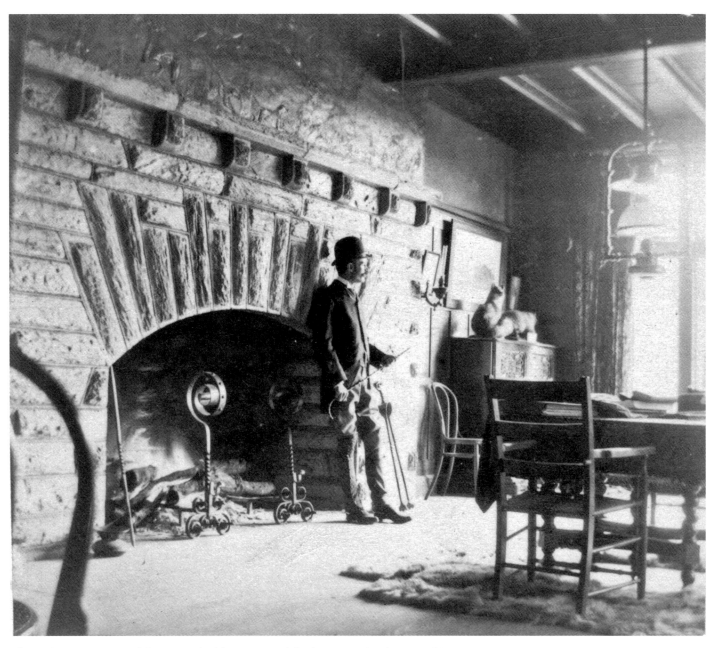

The Radnor Hunt, one of the country's oldest organized fox hunts, was headquartered in this clubhouse as early as 1886. This interior view was recorded in 1891.

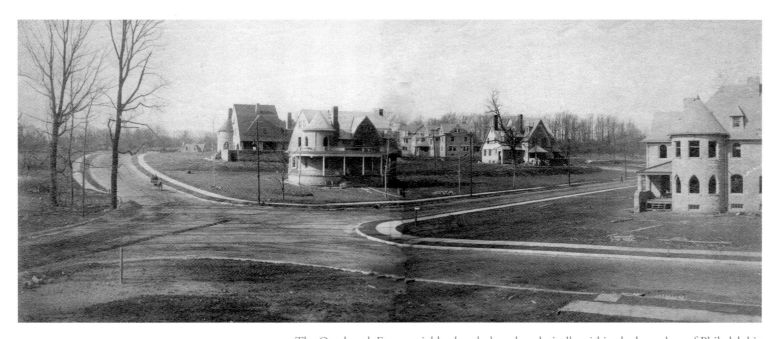

The Overbrook Farms neighborhood, though technically within the boundary of Philadelphia County, was initially envisioned as a continuation of the suburban development of land along the Main Line railroad. Seen here is the view from the second-story nursery of a home under construction in February 1894 located near Upland Way and Drexel Road. The road to the left leads to the Overbrook train station less than a quarter-mile away.

Located on North Wayne Avenue, the Wayne Estate Hall was destroyed when the adjacent Wayne Opera House burned in 1914. This photo, from around 1895, shows the original building before an addition was built on the right.

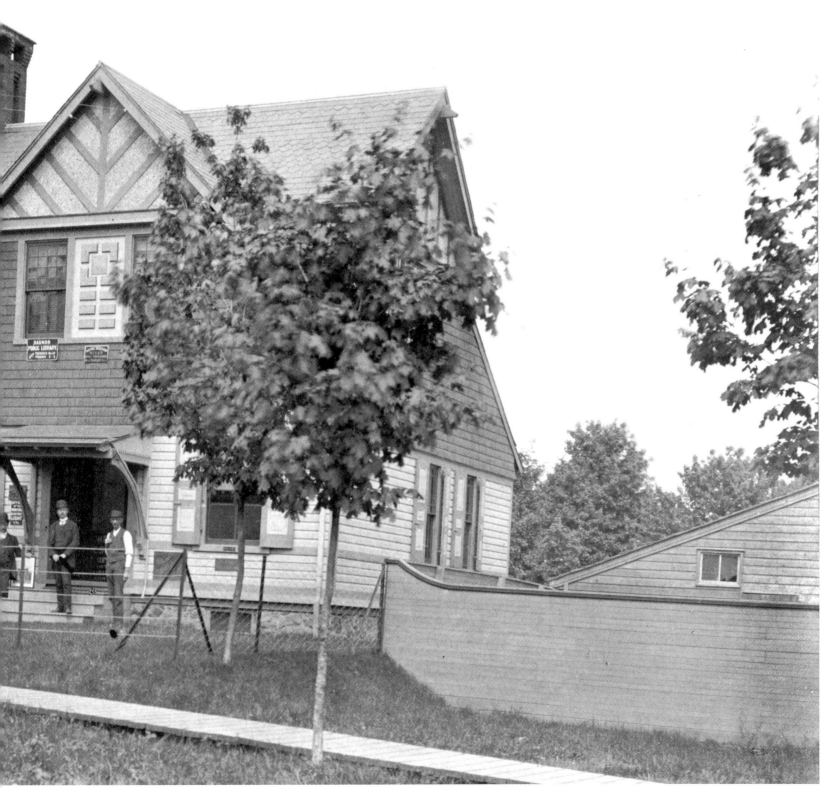

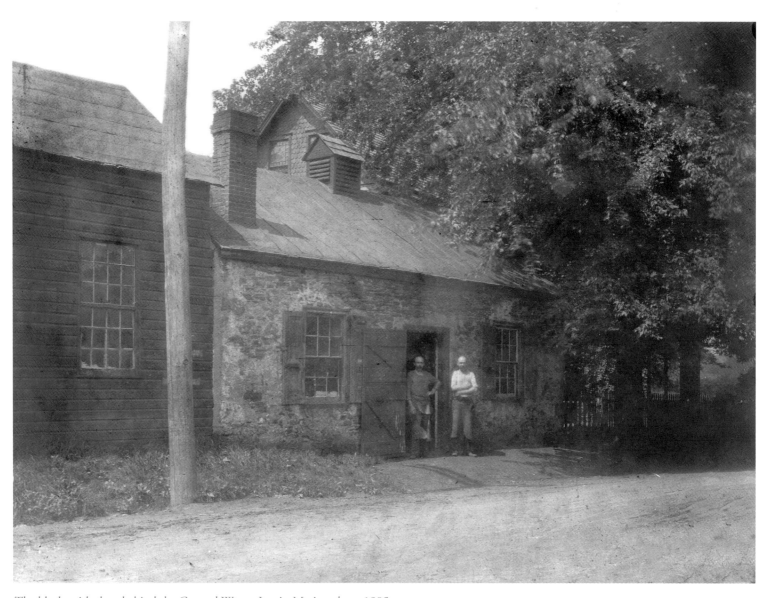

The blacksmith shop behind the General Wayne Inn in Merion about 1895.

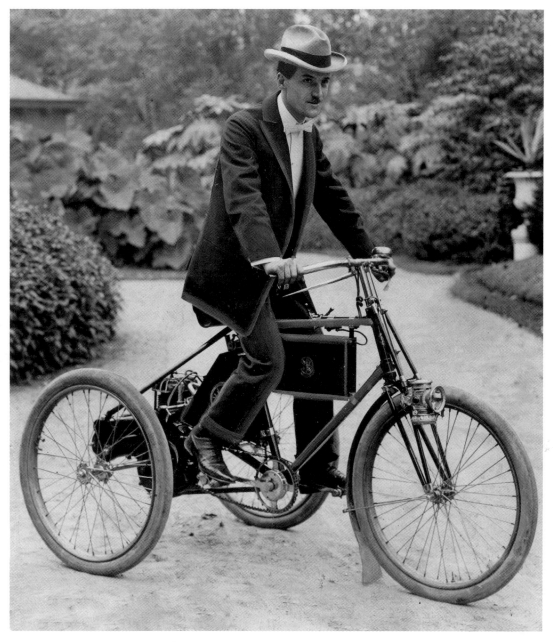

William Morgan, cofounder of Ardmore's Autocar Company, rides the Clark Gasoline Tricycle in 1897. The cycle, designed by fellow Autocar founder Louis S. Clarke, featured a number of design elements the company would use in the years to follow in its innovative car and truck designs.

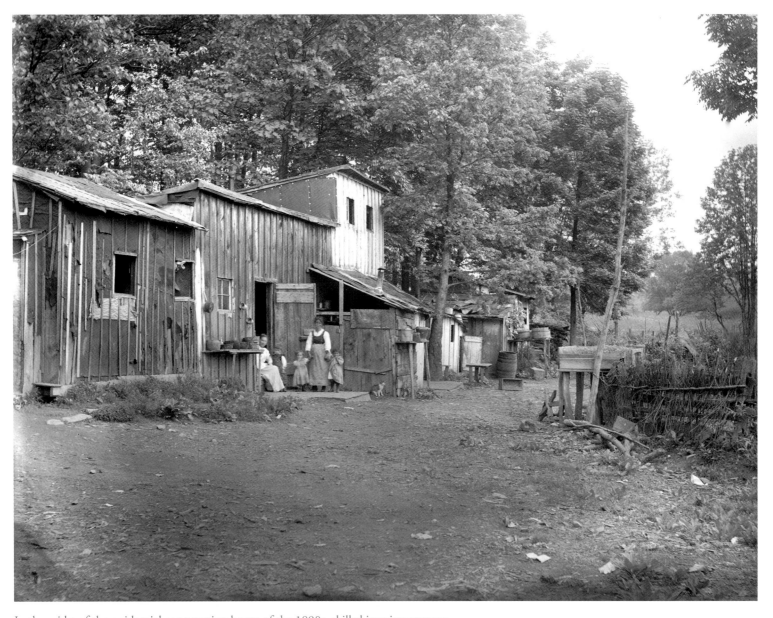

In the midst of the residential construction boom of the 1890s, skilled immigrant stone craftsmen and their families were drawn to the communities along the Main Line. Shown here on May 30, 1898, is the Italian settlement that grew up near Bryn Mawr.

A PLACE TO CALL HOME

(1900–1919)

As the new century began, the Main Line began to attract a more diverse year-round population of residents. Bankers and industrialists joined the farmers and blacksmiths. Thousands of workers were required to build and run the new towns and the many large estates that appeared in Villanova, Bryn Mawr, and elsewhere, and many took up residence. It was a moment of transition as communities moved away from the old agrarian lifestyle toward one more recognizable in the twentieth century: that of the suburban bedroom community.

By 1900 the railroad stations along the Main Line were in place, a string of pearls beckoning to all who wished to take advantage of the beautiful new neighborhoods that surrounded each station. As the number of both affluent and middle-class residents increased, so did the demand for services such as roads, schools, social or athletic clubs, and churches. With the decline in the number of locally producing farms, the freight cars along the line were often used to bring in supplies rather than to deliver the products of the Main Line to the rest of the world.

Thousands of residents looked to Philadelphia for their income and to their new homes for comfort and leisure. And those train riders learned a new mnemonic to help them remember the 17 stations that meant "home": Old Maids Never Wed And Have Babies; Really Vicious Retrievers Snap Willingly Snarl Dangerously Beagles Don't, Period. In order from the first stop after 30th Street Station, the original station names are Overbrook, Merion, Narberth, Wynnewood, Ardmore, Haverford, Bryn Mawr, Rosemont, Villanova, Radnor, St. Davids, Wayne, Strafford, Devon, Berwyn, Daylesford, and Paoli.

But even as the role of the railroad was never so clear, it was also never so vulnerable. In the preceding decades, all commerce was driven by the availability of the trains that moved from Philadelphia to Lancaster and points beyond. New developments in automobile technology threatened that sovereignty. The Lancaster Turnpike was purchased by the state in 1917, which eliminated the toll and allowed for improvements along the old road. By the end of the First World War, the transformation was complete. Nearly all trains that ran along the Main Line carried people rather than products, emphasizing the area's new role as a modern suburb.

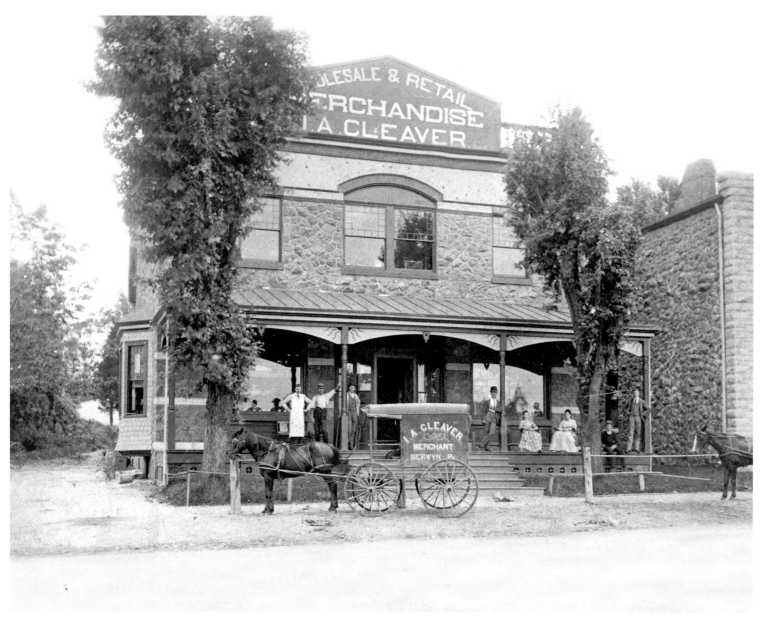

I. A. Cleaver's general store in Berwyn about 1900. Berwyn, like other towns along the Main Line, was initially established along the old Lancaster Turnpike and Conestoga Road used by thousands of travelers throughout the eighteenth century as the main route westward. By the late nineteenth century, businesses such as Cleaver's often continued to serve the new settlements spurred on by the growth and success of the railroads.

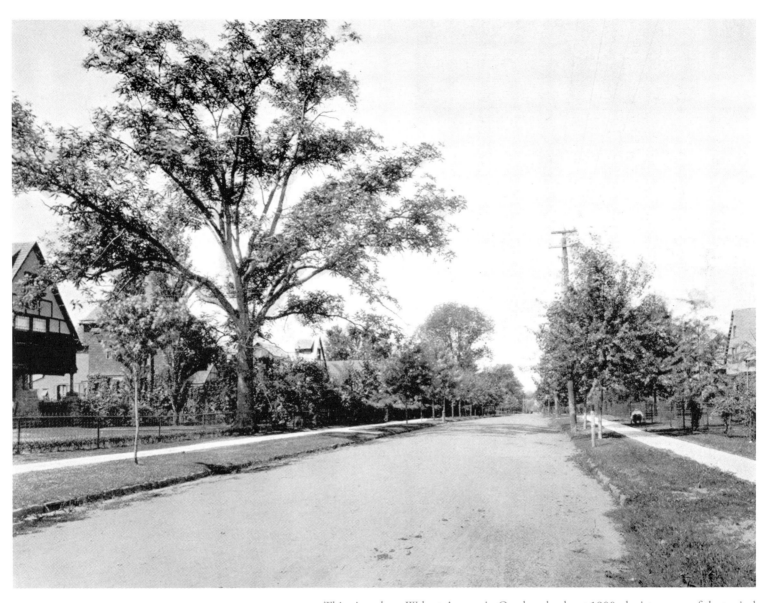

This view along Walnut Avenue in Overbrook, about 1900, depicts many of the typical attractions offered in the newly completed development. Wide streets, beautiful new homes that often measured 2,000 square feet, landscaped lawns, and easy access to the Overbrook station along the Main Line railroad were just a few of life's benefits in the new and elegant suburbs.

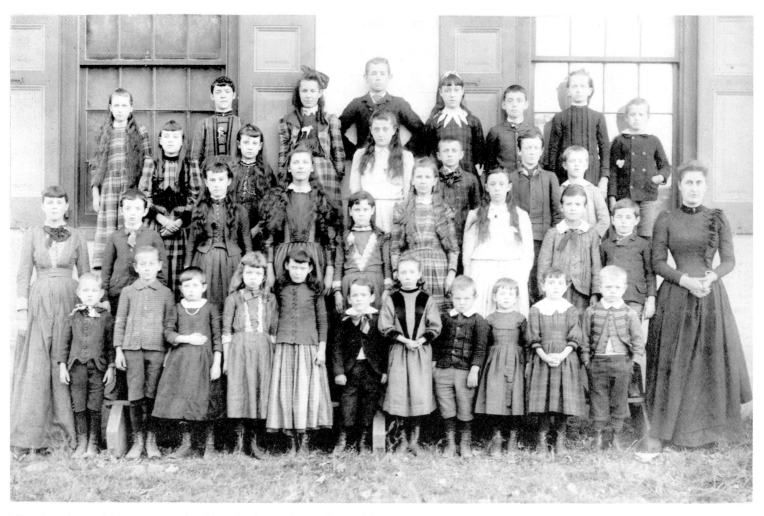

This class photo of the Wynnewood public school was taken in front of the town's second school around 1900. The first, built in 1836, was destroyed by fire in the 1860s. The second school was built on the same location, at Lancaster Avenue and Wynnewood Road, in the 1870s.

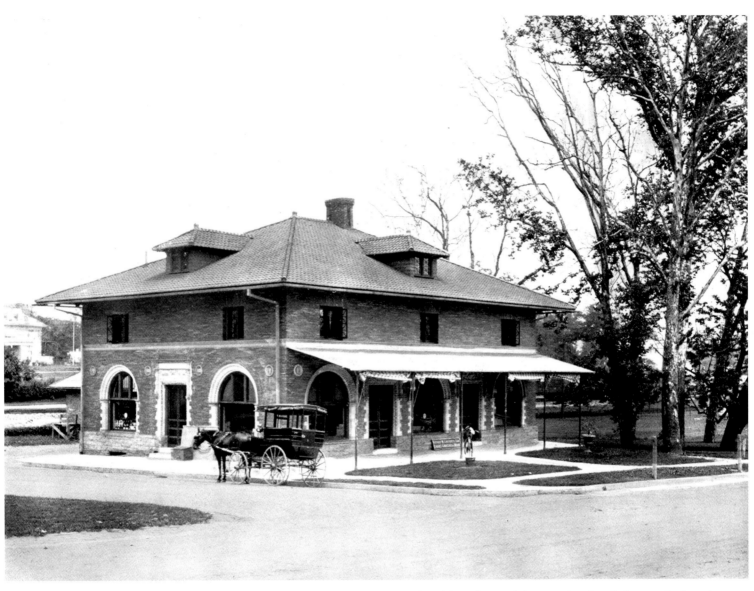

One of several commercial buildings for retail shops in Overbrook that was built at the same time and of similar design as the single family homes that populate the 1890s development. This photograph was used in an advertising book published by developers Wendell and Smith.

A wintry scene in Wayne photographed by resident Robert S. Redfield in March 1902.

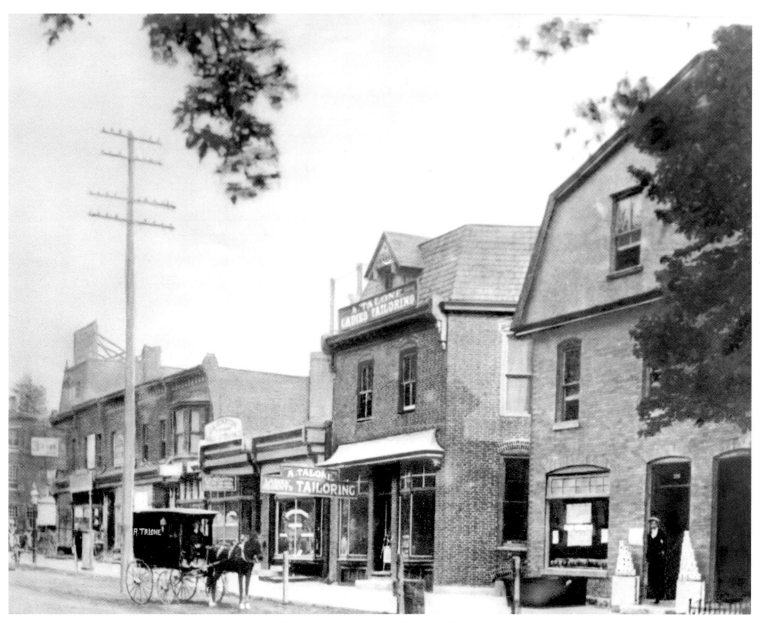

The tailoring firm of A. Talone is shown in a photograph from the early 1900s at 318 Lancaster Avenue. The Ardmore landmark still occupies the building today.

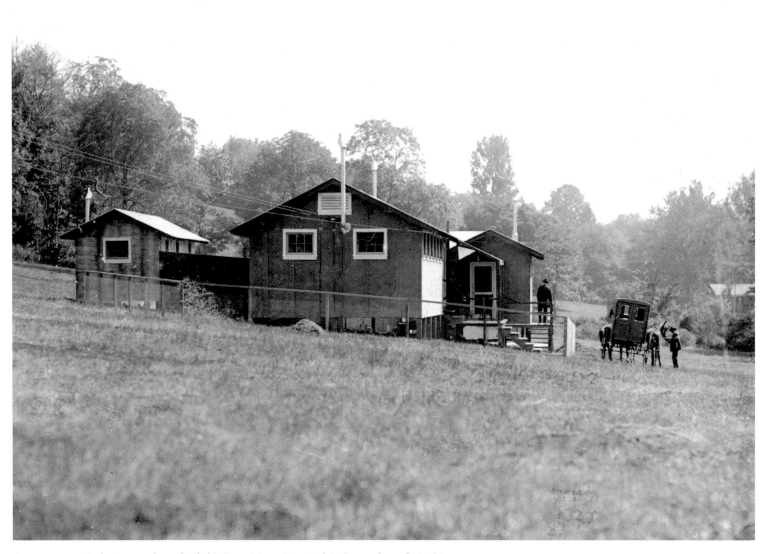

An emergency isolation ward was built by Bryn Mawr Hospital in September of 1916 in response to a polio epidemic. The 16-bed wooden building was closed after six weeks and was sold to the Social Services Department of the hospital.

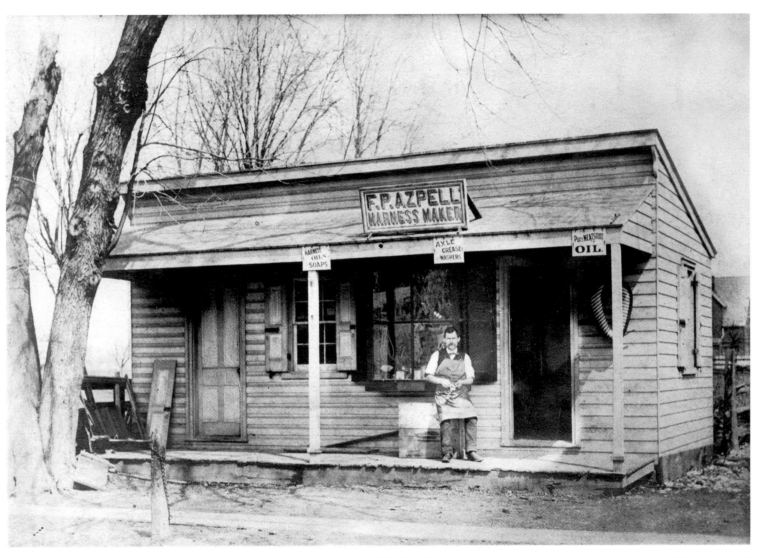

F. P. Azpell's harness shop was located near the intersection of Lancaster and Ardmore avenues in Ardmore.

Built in 1900, Lower Merion Township's first jail and police headquarters were located behind the firehouse on West Lancaster Avenue.

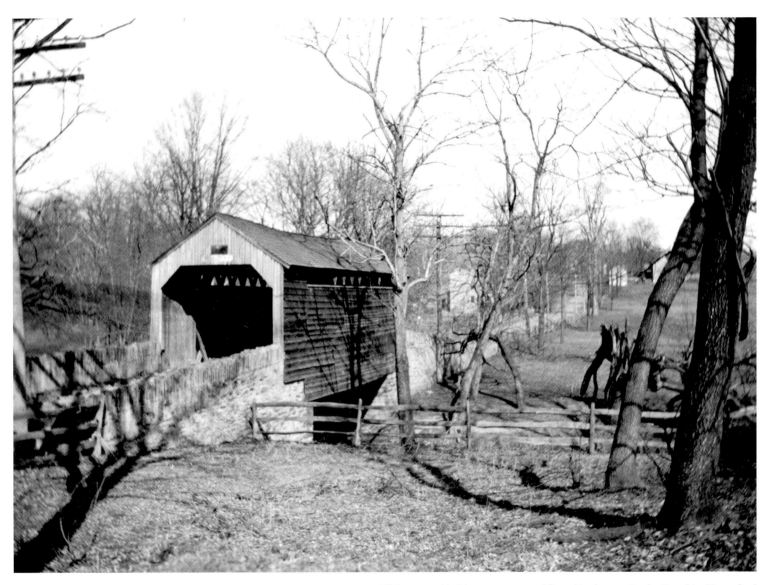

This covered bridge crosses over Ithan Creek near Darby Road in Haverford Township. It was remodeled in 1932, approximately 20 years after this photograph was taken.

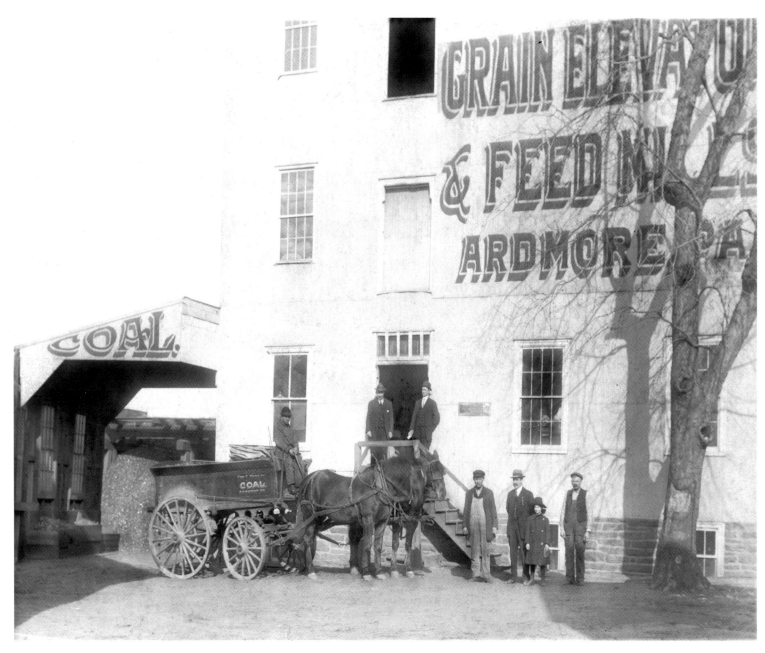

Edward Murray's grain elevator and feed mill, on Murray's Lane in Ardmore, served many of the agricultural needs of the community until the end of the nineteenth century. With the growth of residential developments and the decrease in farmland, farms along the Main Line began to disappear, leading to the failure of many related businesses.

The tennis courts located at 6023 to 6055 Drexel Road in Overbrook Farms were one of the many amenities highlighted by developers Wendell and Smith in their advertising publication released about 1910.

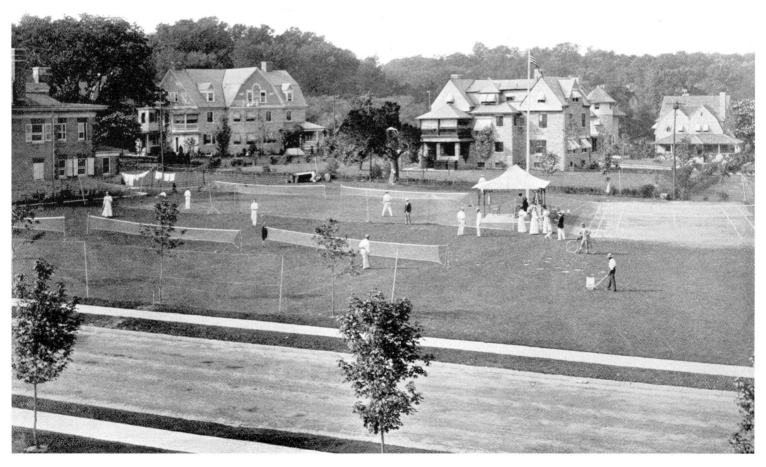

Facing south from Old Conestoga Road, around 1905.

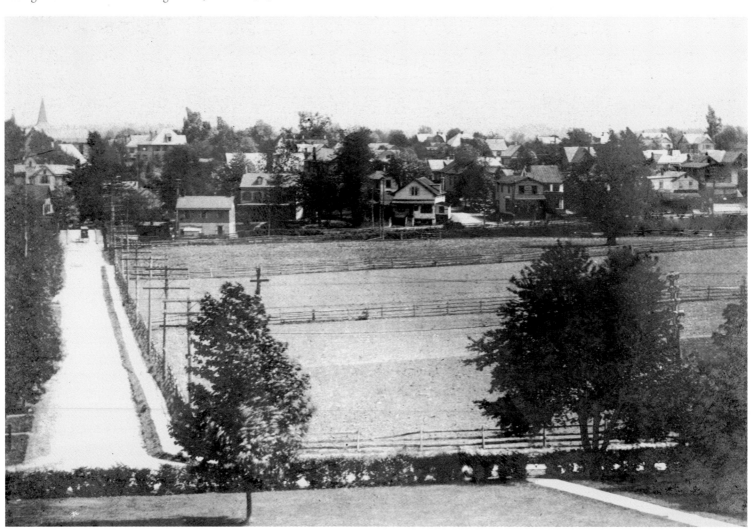

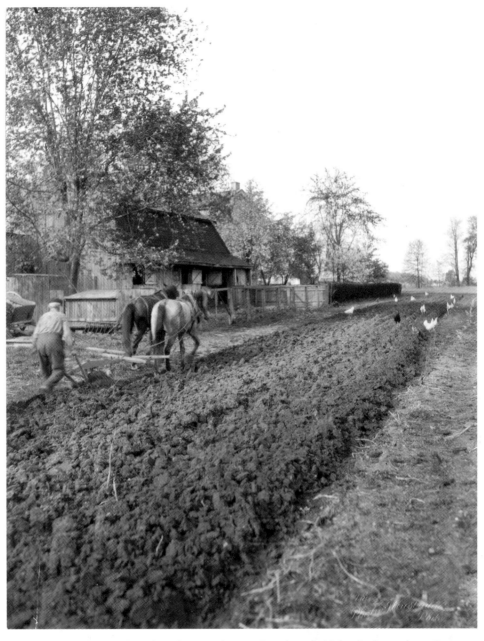

As late as 1910, when this photograph was taken, long-held family farms along the Main Line still survived. Within a few more years, many of these farms would be bought and developed as residential neighborhoods or for the creation of large estates.

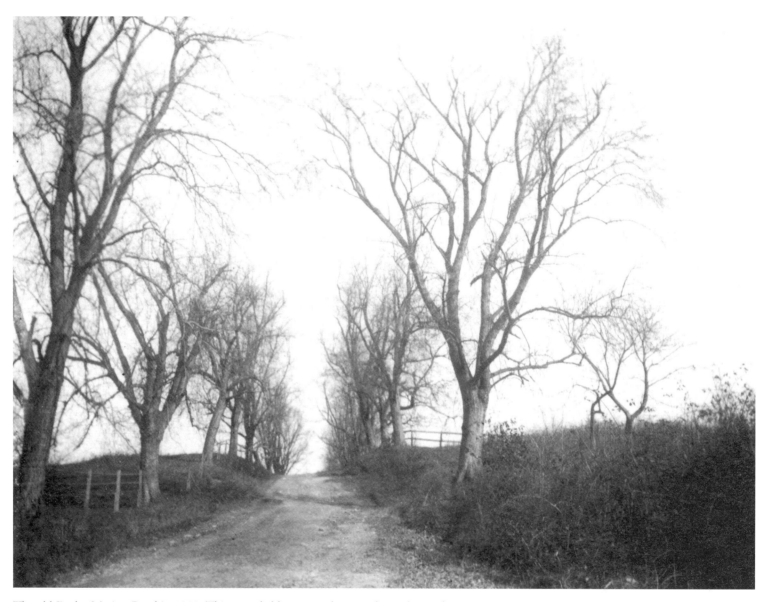

The old Darby-Merion Road in 1903. This remarkable country lane was located near the intersection of Haverford Road and 65th Street in Overbrook. A few years later it was surrounded and consumed by residential and commercial developments.

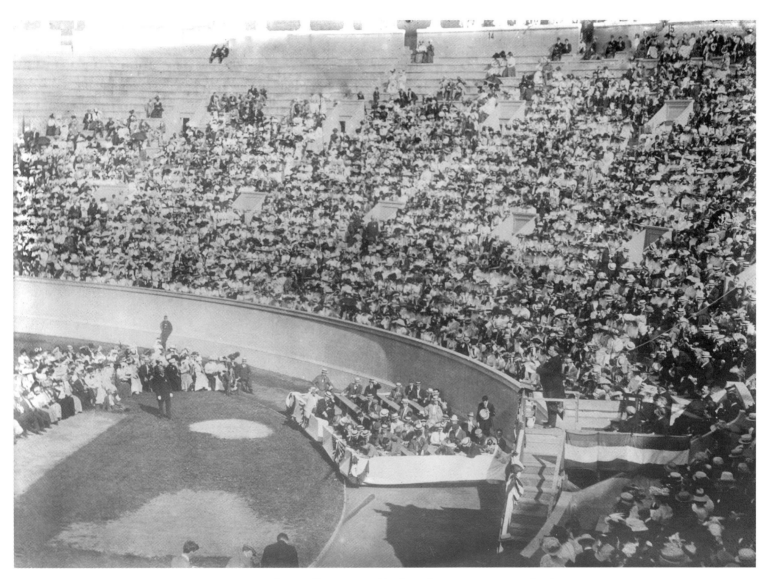

President William Howard Taft speaks at Bryn Mawr College's commencement exercises in June 1910. Taft's eldest daughter Helen was a student at the all-women college and would go on to graduate in 1915. Just four years later, while serving as Dean of the College, she would become the Acting President, making her the youngest college president in the history of the United States.

Shown here in 1911, Narberth's oldest existing house is believed to be of Swedish origin and was likely built in the late seventeenth or early eighteenth century. The earliest part of the structure, to the right in the photograph, is a plastered log cabin. Located on Shady Lane, it is still owned and used as a private residence.

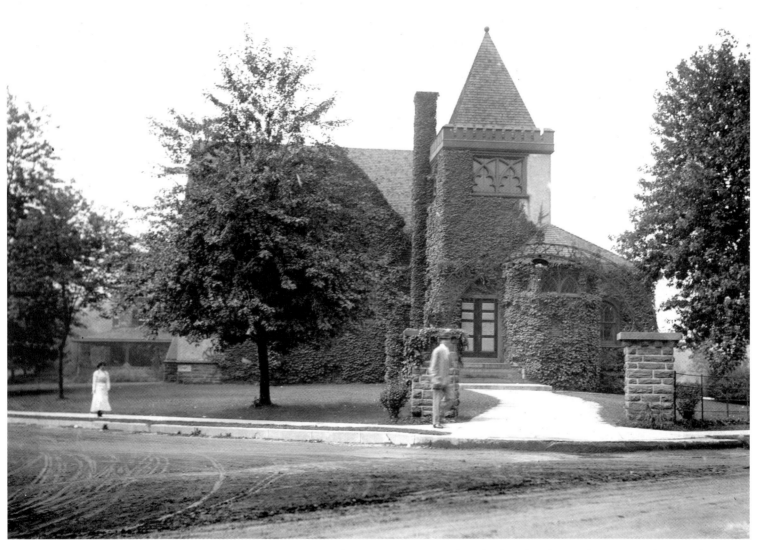

The Matthew Simpson Memorial Methodist Church in Ardmore, around 1910. The church building, located at Argyle Road and Lancaster Avenue, was dedicated on April 26, 1896. The congregation merged with the Ardmore Methodist church and moved to its current location at Argyle and Linwood roads in 1949.

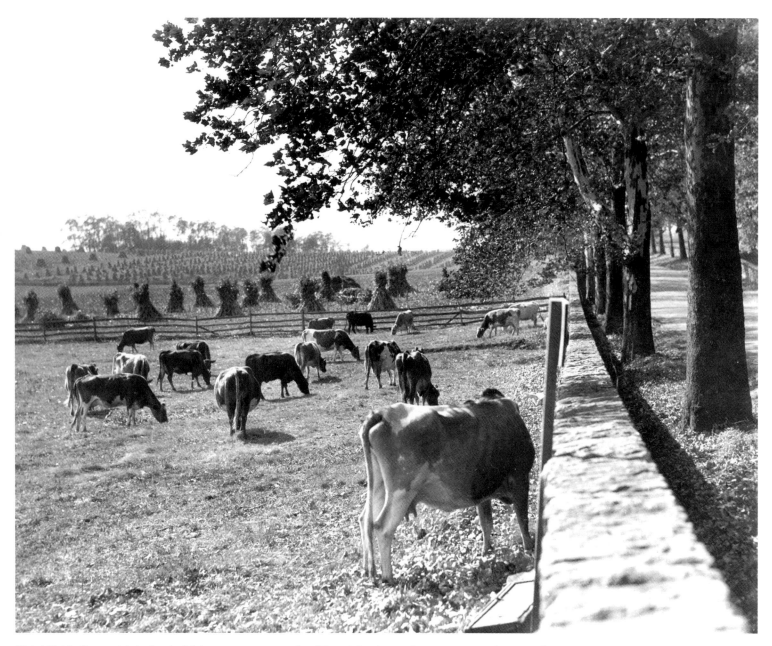

This hillside farm, with its herd of dairy cows, was a staple of Bryn Mawr's agrarian economy at the turn of the century. The pastoral views, initially an attractive feature for those visitors seeking rest and relaxation at the new Main Line resorts, were overtaken by the demand for homes and services as residential towns were built around the Main Line rail stations.

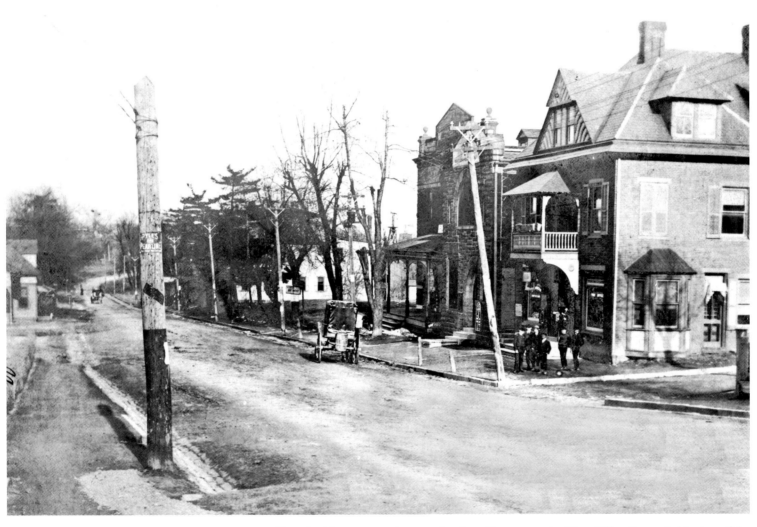

Described by amateur photographer Lucy Simpson as the "Post Office Corner," this view of the intersection of Lancaster and Main avenues in Berwyn clearly shows the small-town feel of the area. A notation on the original photograph, from around 1905, indicates that the building to the right housed Connor's Drug Store and was once the post office.

Mr. H. W. Lukens, of Montgomery County, proudly displays his new automobile about 1915.

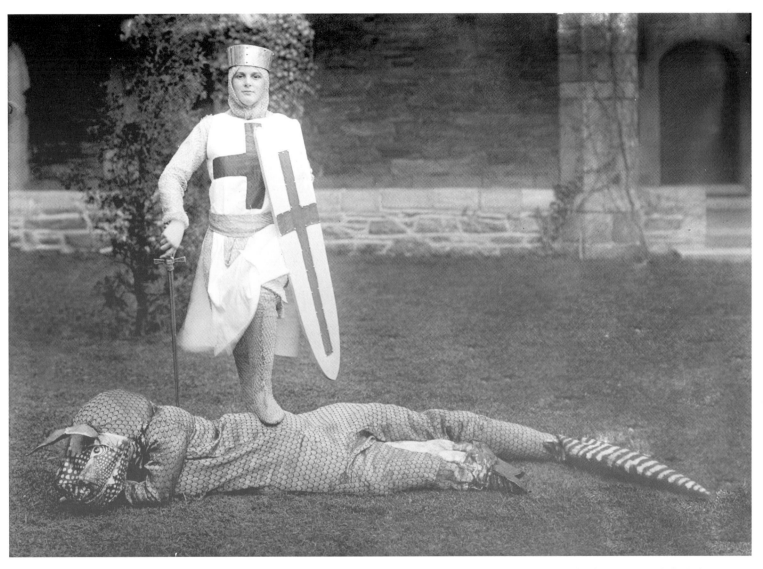

Bryn Mawr College student Constance Hall, in the role of St. George, defeats the Dragon during a May Day play around 1915. Miss Hall was a member of the Class of 1917.

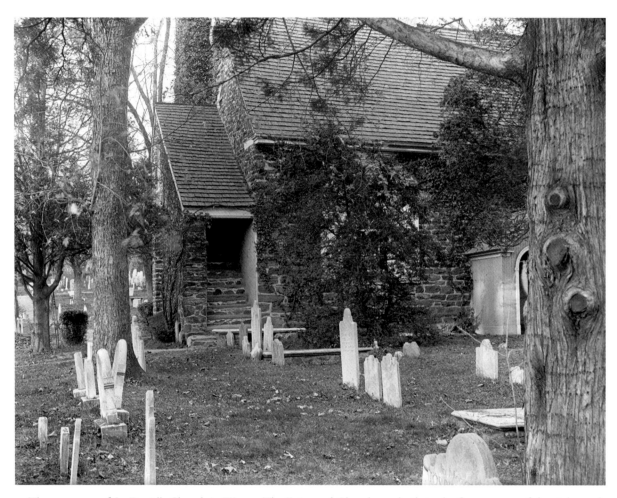

The cemetery of St. David's Church in Wayne. The Episcopal Church was built in the first quarter of the eighteenth century by Welsh-speaking congregants, many of whom were sons and daughters of original Welsh purchasers of land from Pennsylvania founder William Penn. Through the eighteenth century the church remained an important center of the local Welsh community. As Wayne and other Main Line communities expanded, so did the church. At the time of this view around 1920, St. David's was one of the preeminent Protestant churches along the Main Line.

HIGHS AND LOWS

(1920–1949)

In the years between the First and Second World Wars, life along the Main Line was generally one of stability, comfort, and prosperity. Within the communities along the Main Line, postwar prosperity was reflected in the continued development and construction of homes and businesses, many of them oriented to demands for domestic and leisure services. Institutions such as social or athletic clubs and churches welcomed new members to play and worship alongside longtime Main Liners while still maintaining an atmosphere of affluence and special privileges.

When the market crashed in 1929, the Main Line suffered fewer losses than most of the nation, due in part to the overall financial stability of its residents and of Philadelphia. Several banks and a handful of businesses closed, but for the average citizen little had changed. In fact much had been improved. Shopping districts along Lancaster Avenue attracted new shop owners and residents, who were drawn to the area by the continued construction of middle-class housing. Old and often inadequate roads and bridges benefited from the creation of the Works Progress Administration, which initiated dozens of expansion and improvement projects.

Some progress was slowed, however, as national trends and policy changes affected the Main Line. In a reversal of earlier times, fewer large estates were built, perhaps in response to the creation of the Federal Income Tax and the rapidly increasing costs of running an estate. The number of farms continued to decrease as demand for housing joined with improvements in road transportation, which allowed for the importation of goods from points more suitable for year-round farming.

As the Second World War approached, the Main Line was secure in its position as a prosperous and content suburb. Family history and associated social rankings, always a part of the Main Line, became even more pronounced as a result of a nationwide interest in colonial American history and genealogy. Ultimately, however, it fell to middle-class residents to grant most Main Line towns their unique flavor, often emphasizing neighborhood and community over larger financial or regional connections. The overall character of the Main Line as a desirable, beautiful, and socially significant place to live and play was at last firmly established.

The residence of George H. McFadden, known as Barclay Farm, as it appeared in 1921. Built in Rosemont in the late 1760s, the building was a tavern called the Sorrel Horse Inn during the American Revolution. Within a few years of this photograph, the building was completely renovated under the direction of architect Horace Trumbauer.

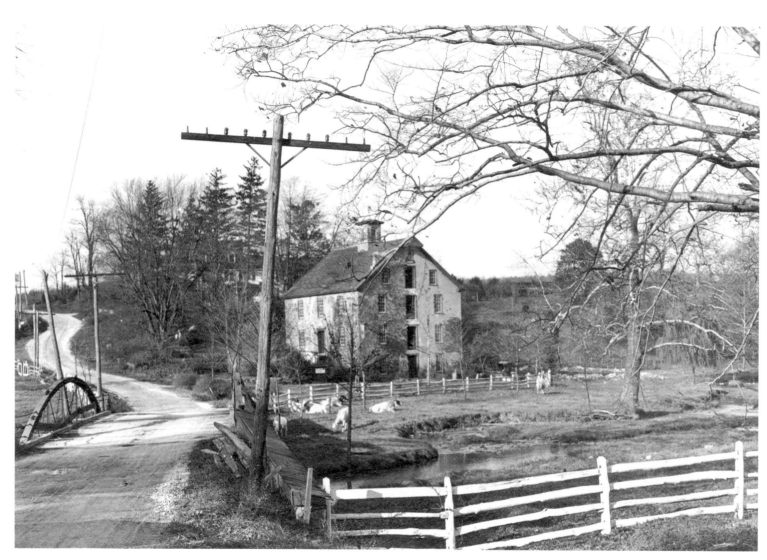

The Great Valley Mill on Valley Road near the Paoli Station about 1920. The mill originally on this site was built in 1710 and was likely active during the American Revolution when George Washington and his men wintered in Valley Forge. The mill pictured here was built in 1859 and can still be seen at 72 North Valley Road in Paoli.

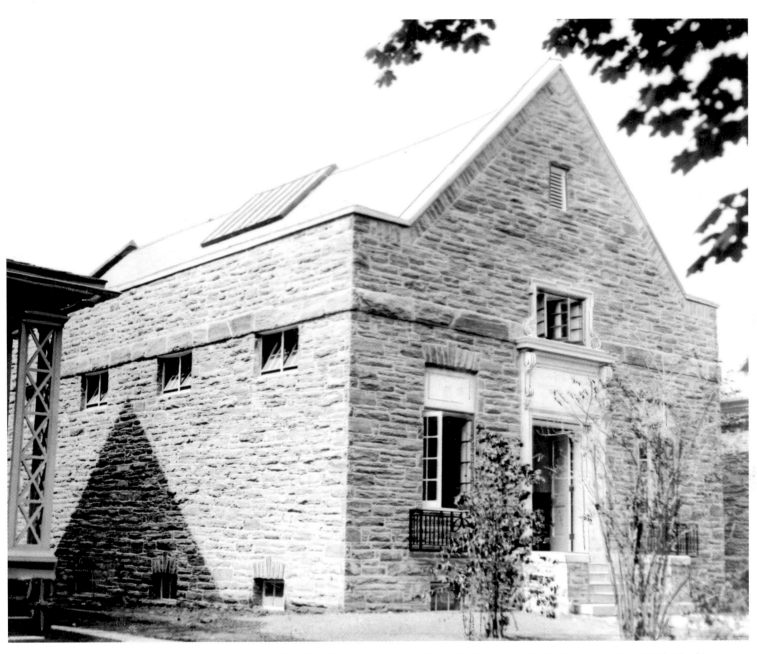

The Ethel Saltus Ludington Library in Ardmore at its dedication in May 1924. The library was gifted to the Women's Club of Ardmore by Charles H. Ludington in honor of his wife who died of tuberculosis in 1922. A second Ludington Library was built in Bryn Mawr in 1926. Both library buildings continue to serve their communities today.

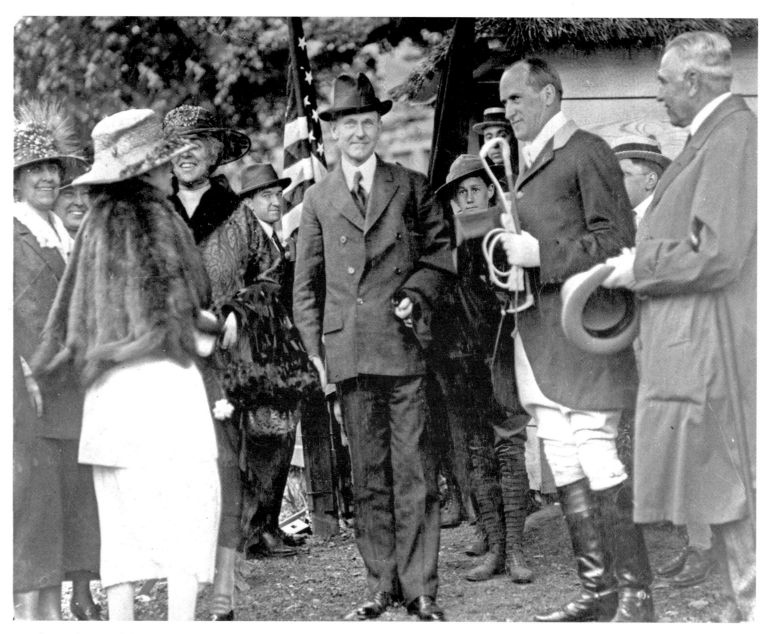

President Calvin Coolidge (at center) with his wife and several members of the Main Line community are shown attending the Devon Horse Show on May 30, 1922. First held in 1896, the Devon Horse Show is the oldest and largest outdoor multi-breed horse show in the nation. Original interest in establishing the show grew from the important role of horses in transportation as the number of large estates multiplied along the railroad line. The horse show continues to emphasize good horse breeding and training, as it did when founded.

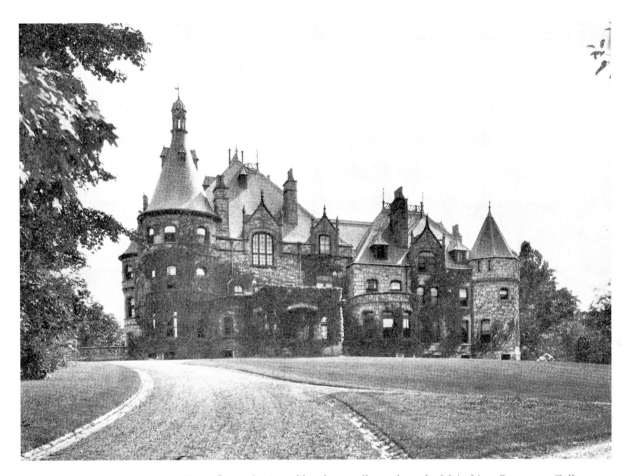

One of several private liberal arts colleges along the Main Line, Rosemont College was founded in 1921 by the Society of the Holy Child Jesus. The main building, seen here in October 1924, was built as a private home for Joseph Sinott in 1891 and was known as "Rathalla." It featured 32 rooms and stood at the center of an extensive 40-acre estate.

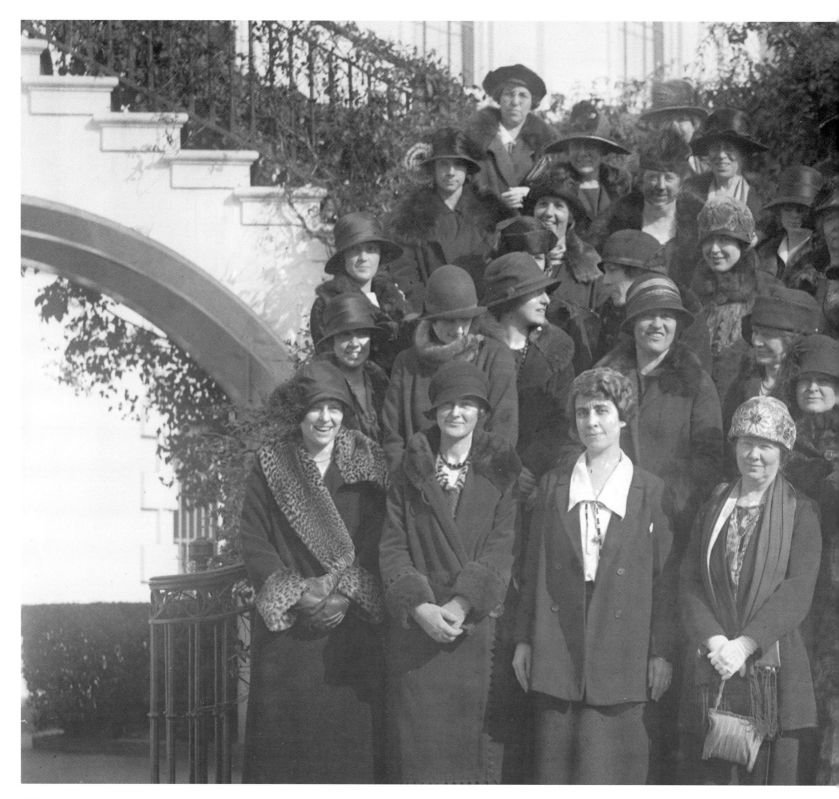

Though the purpose of the visit remains unclear, First Lady Grace Goodhue Coolidge welcomed alumnae of Bryn Mawr College to the White House on November 19, 1924. Mrs. Coolidge, a gracious and popular First Lady, was also known for her work in education as a teacher of the deaf.

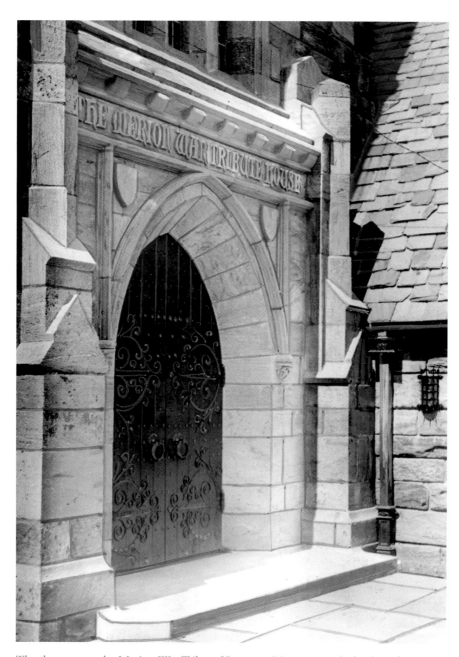

The doorway to the Merion War Tribute House on May 12, 1924, the day of its dedication. Built by the Merion Civic Association on land donated by businessman Eldridge R. Johnson, the house was intended as both a memorial to peace following the end of World War I and a community meeting space. It is still used today by the Merion Civic Association and is frequently rented for parties.

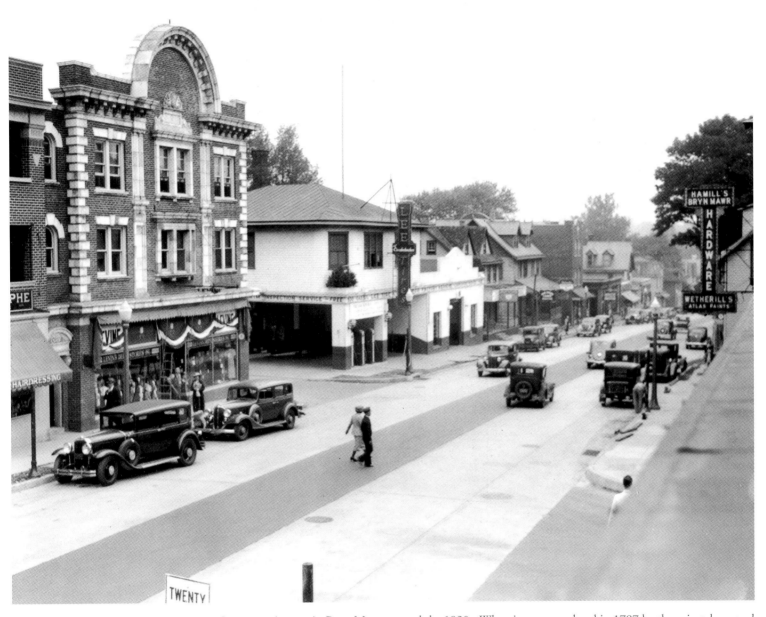

Lancaster Avenue in Bryn Mawr around the 1920s. When it was completed in 1797 by the privately owned Philadelphia and Lancaster Turnpike Company, the turnpike was the first paved long-distance road in the United States. Extending from Philadelphia to Lancaster (actually the Susquehanna in Columbia), the pike served as the primary trade and transportation route westward from Philadelphia until the railroad was built in the 1820s. Note the Bryn Mawr Hardware store, which is still in business today at 903 Lancaster Avenue.

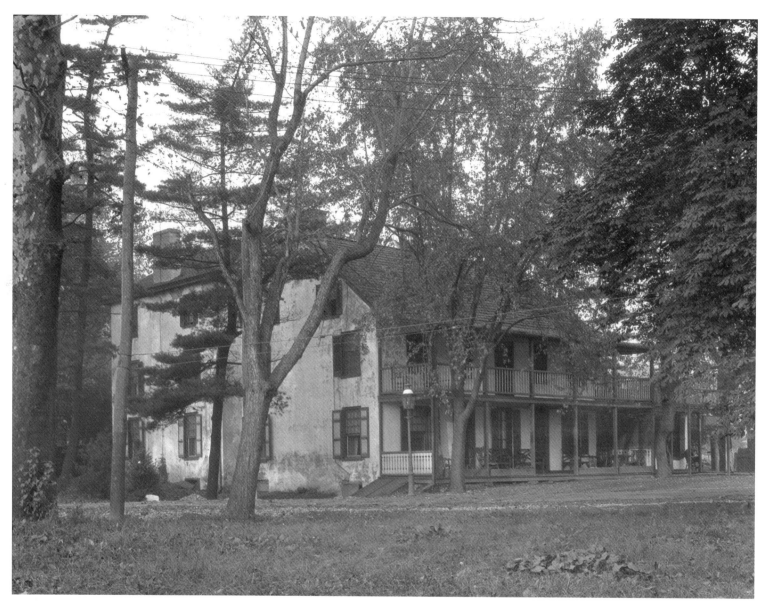

View of the front of the General Wayne Inn, Merion. Built in the early 1700s, by the time of the American Revolution it was a successful wayside inn and tavern. General Anthony Wayne stayed at the inn on September 13, 1777, following the Battle of Brandywine. The next evening, General George Washington was a guest at the inn. It is believed that the inn was named in honor of Wayne in the late 1770s.

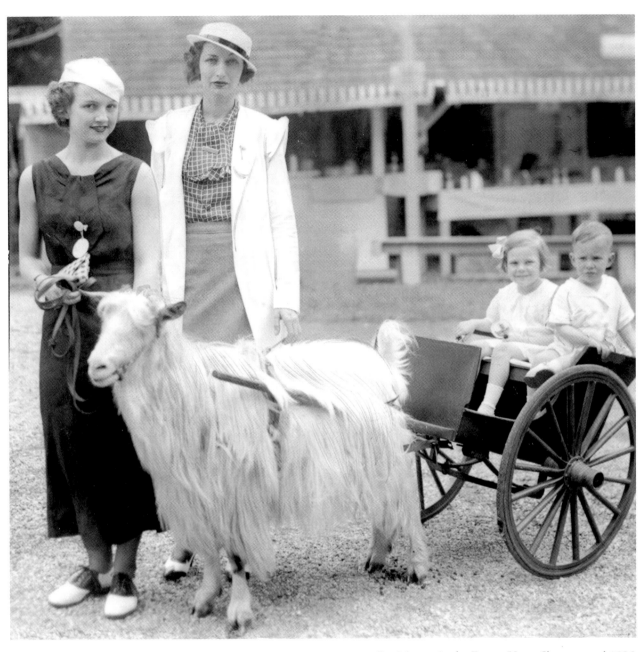

Participants in the Devon Horse Show around 1925.

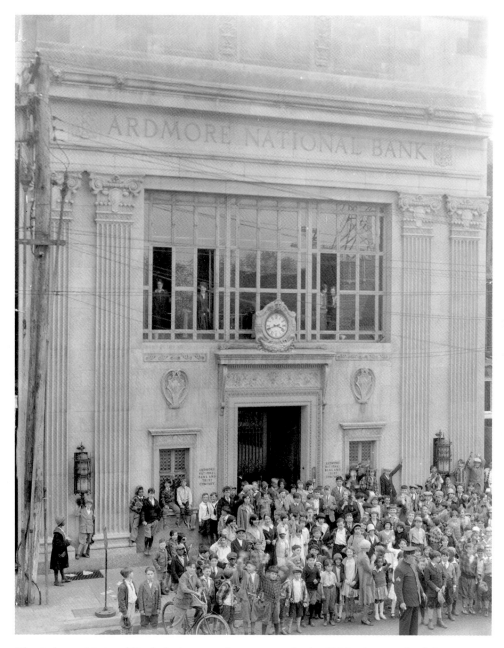

The Ardmore National Bank during an unknown event in the 1920s. As a result of the market crash of 1929 the bank was forced to close. The Ardmore National Bank was one of just three banks in Ardmore at that time.

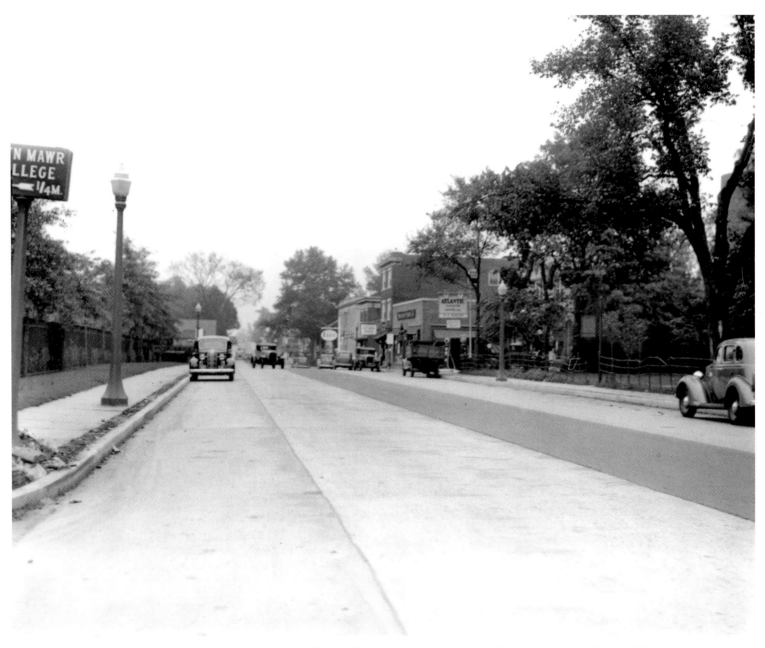

A street-level view of Lancaster Avenue in Bryn Mawr in the late 1920s. In 1876, the privately owned Lancaster Turnpike was purchased by the Pennsylvania Railroad with the intent of preventing streetcar competition along the rail route. The State of Pennsylvania eventually purchased the route in 1917, and it was incorporated into the national numbered route system, becoming U.S. Route 30. At different points along the highway it is known today as Lancaster Pike, Lancaster Avenue, and the Lincoln Highway.

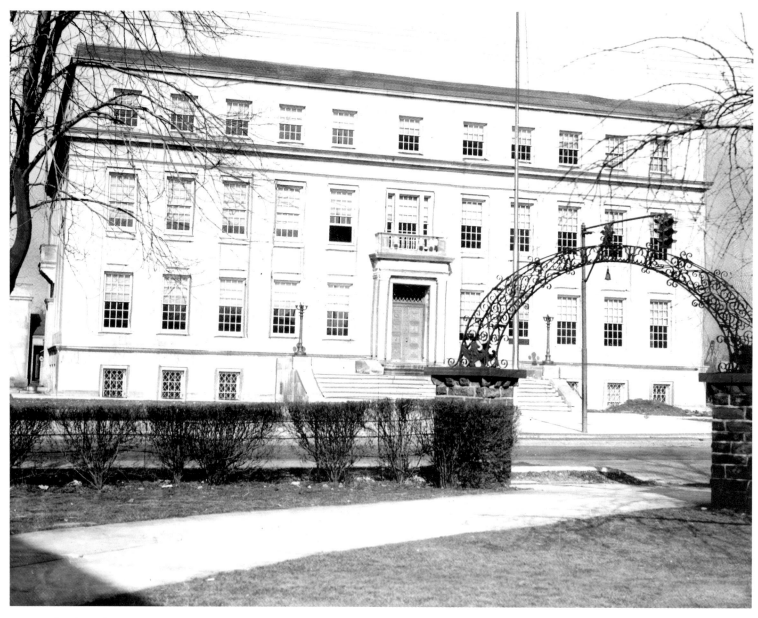

A view of Ardmore's new Community House and Township Hall at Argyle Road and Lancaster Avenue. The building, designed by the firm of Zantzinger, Borie, and Medary, was dedicated in March 1926 and is still used as the Township Administration Building.

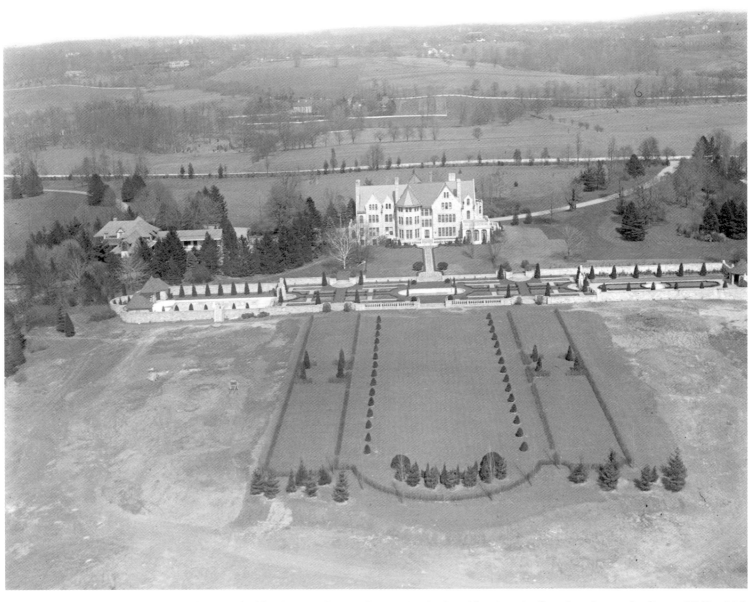

Photographed by the Aero Service Corporation in the mid-1920s, the formal gardens at the George W. Kendrick residence in Villanova were still under construction nearly ten years after work on the estate began.

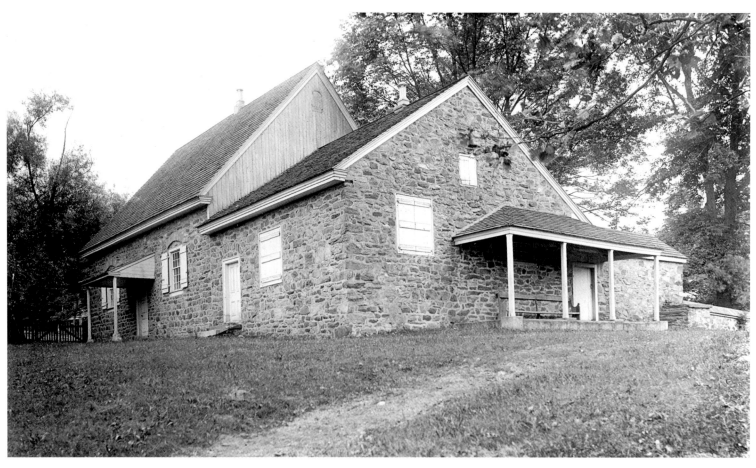

The Meeting House seen here is the second built by the Religious Society of Friends in Radnor in 1718. In the years following the 1827 division between the "Orthodox" and "Hicksite" movements within the Society of Friends, Radnor Meeting was discontinued. By the 1930s, efforts were made to reunite both branches of the Philadelphia Yearly Meeting, a feat accomplished with the reorganization of the Radnor Monthly Meeting in 1956.

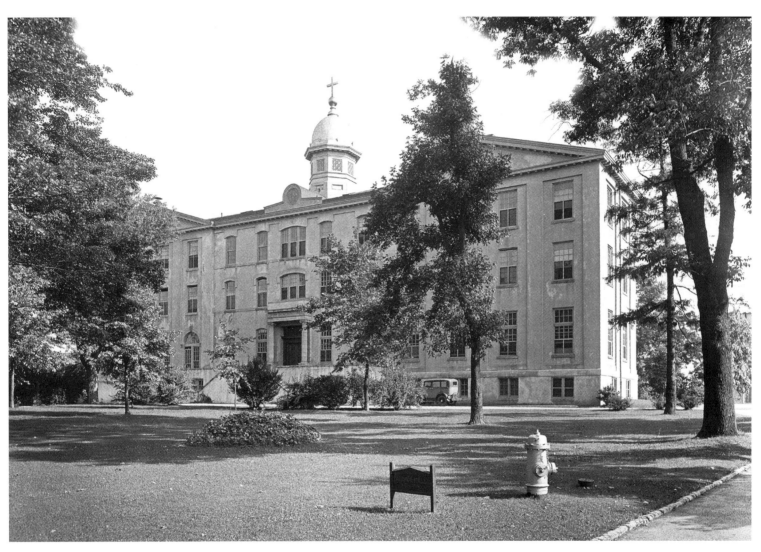

The Alumni Hall at Villanova University, about 1925. Built in 1848, it remains one of the oldest structures on campus. It is believed that the building was used as a hospital during the Civil War as well as during the influenza epidemic following World War I.

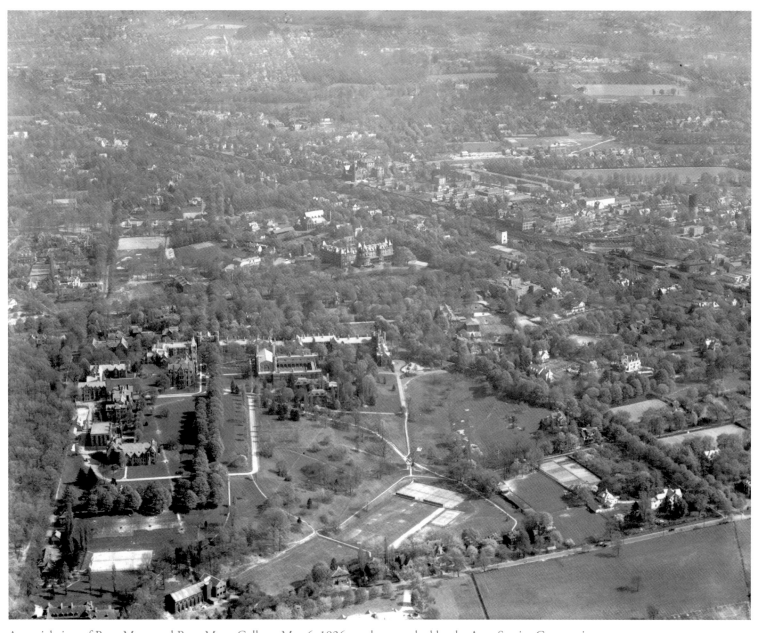

An aerial view of Bryn Mawr and Bryn Mawr College, May 6, 1926, as photographed by the Aero Service Corporation. The enormous Baldwin School building (formerly the Bryn Mawr Hotel) is visible at center.

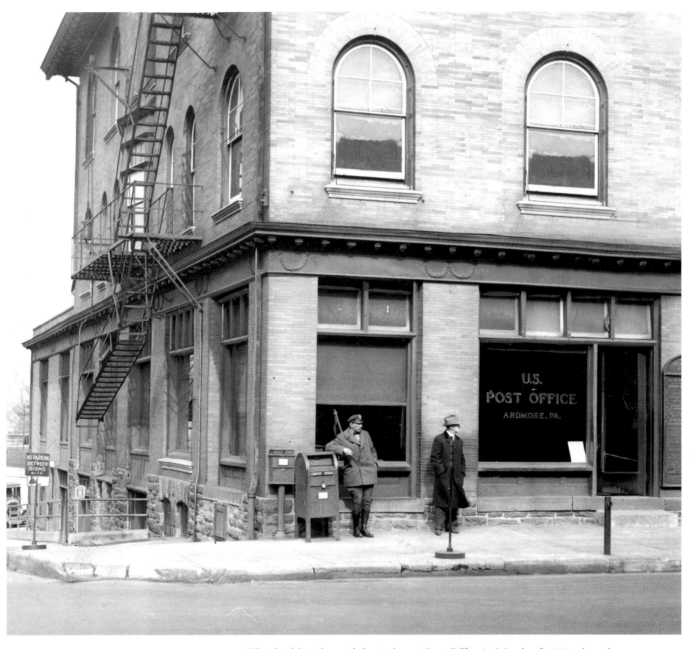

This building housed the Ardmore Post Office in March of 1927 when the government announced plans to abandon the outdated facility.

Strafford, one of the smallest communities along the Main Line, built the Strafford Consolidated or Graded School in 1927. The eight-room school was attended by children in first through sixth grades. The town is currently served by the Tredyffrin Township School District.

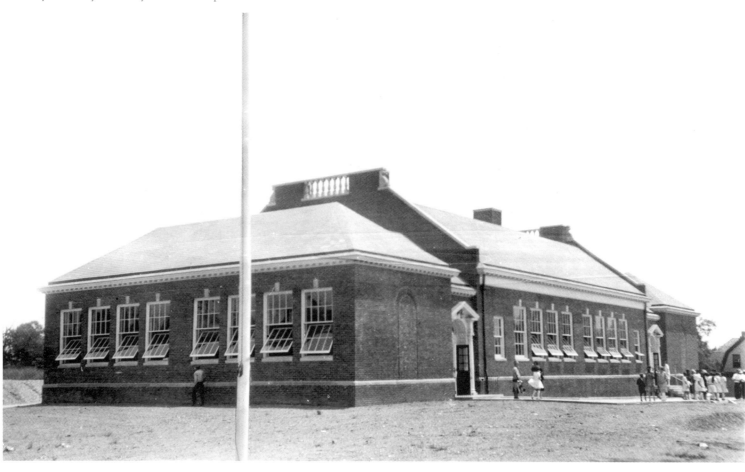

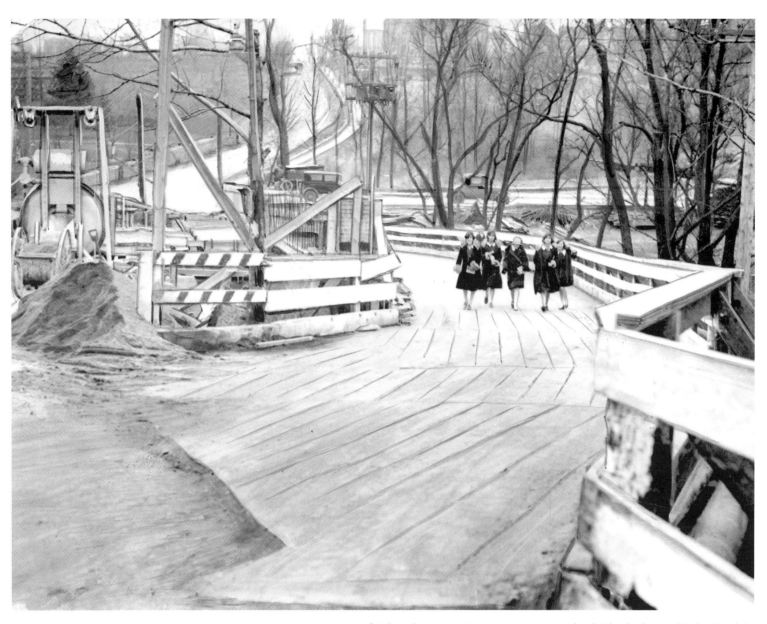

A group of girls is shown crossing a temporary wooden bridge built over Darby Creek in Haverford Township in 1927. As part of the township's highway improvement initiative, a new concrete bridge at Eagle Road was built in addition to generally regrading and improving both Eagle Road and Haverford Avenue.

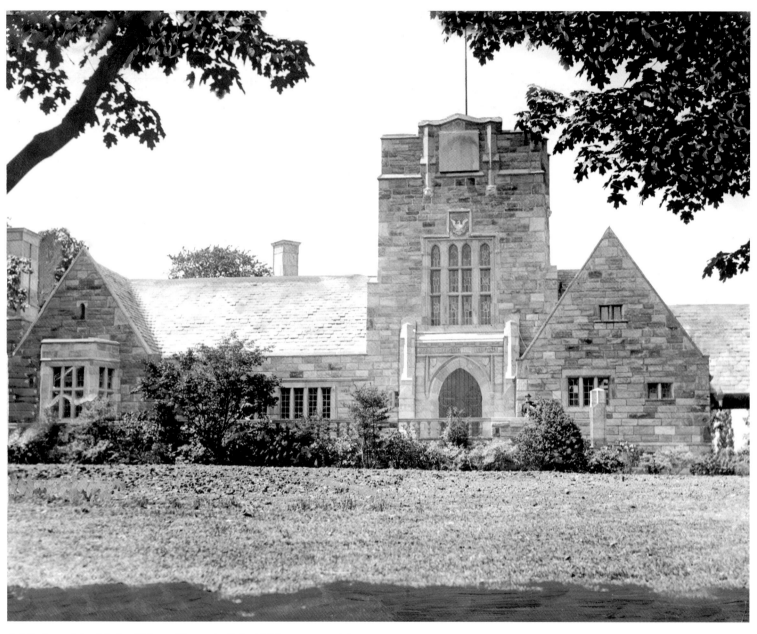

A full view of the Merion Tribute House, built in 1924 as a memorial to peace following the end of World War I and as a community meeting space.

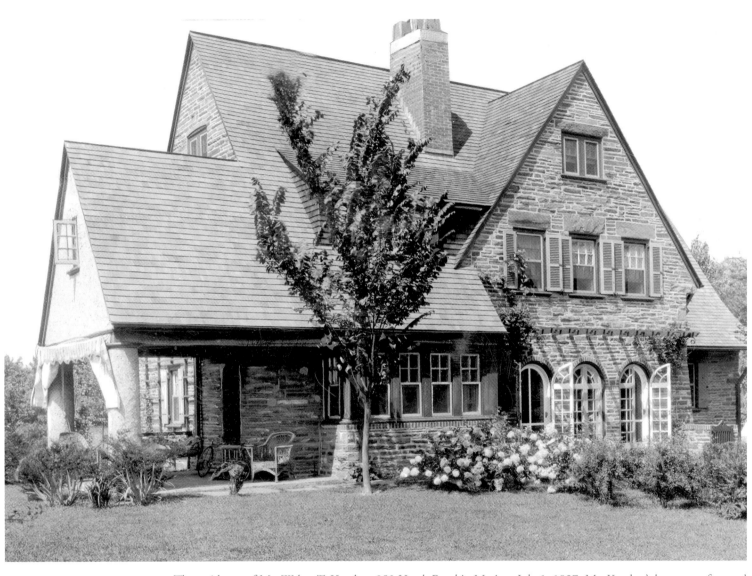

The residence of Mr. Walter T. Karcher, 353 Heath Road in Merion, July 1, 1927. Mr. Karcher's home was featured in the Philadelphia newspaper *Evening Bulletin* because it represented the new style of homes available in the attractive postwar suburban communities. The brief article accompanying this photograph notes that the house was placed 60 feet from the curb and featured built-in bookcases as well as a sewing room and a playroom.

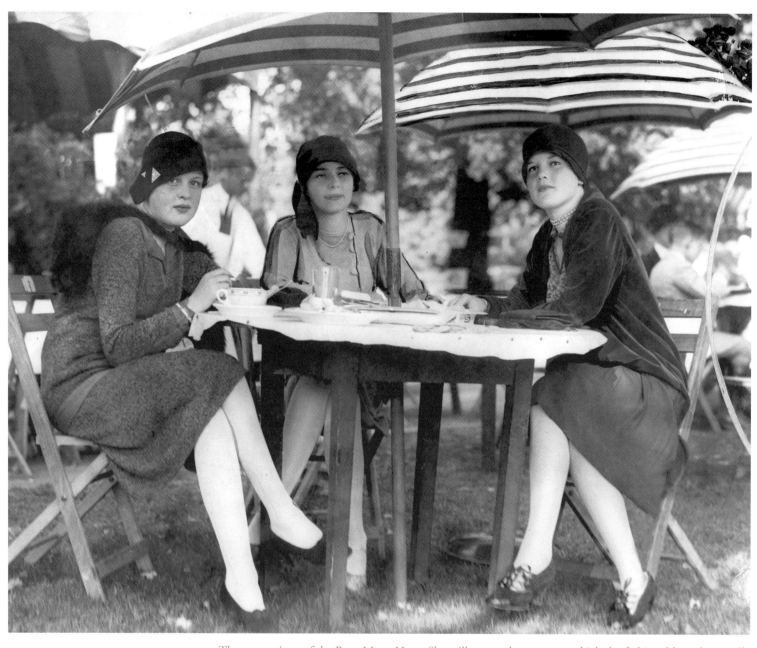

These two views of the Bryn Mawr Horse Show illustrate the extent to which the fashionable and generally affluent residents of the Main Line flocked to events that combined sport with society.

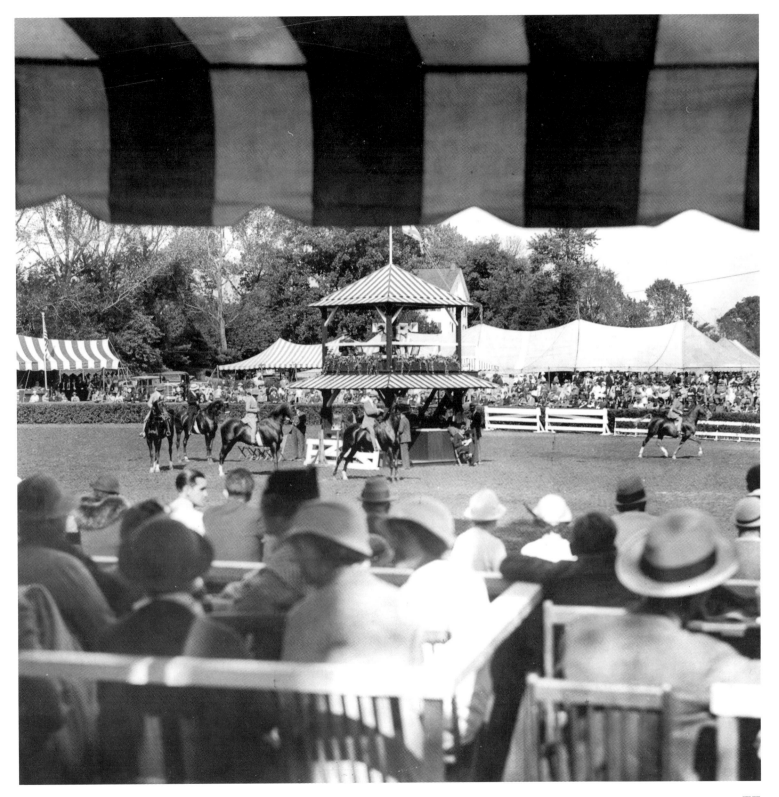

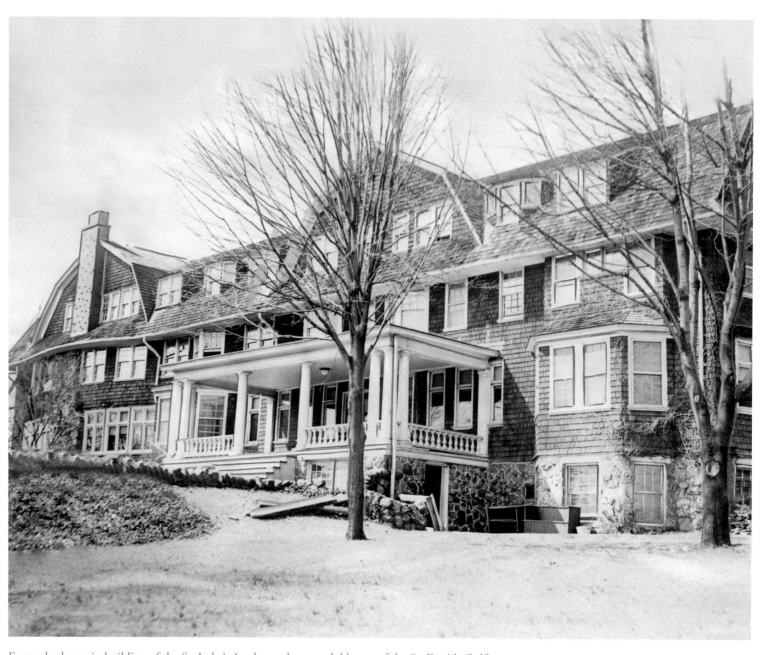

Formerly the main building of the St. Luke's Academy, the new clubhouse of the St. Davids Golf
Club was first opened to members in April 1928. One year later the clubhouse was leased to the
Valley Forge Military Academy following a fire that destroyed their new home in the old Devon Inn.
The St. Davids Golf Club moved into a nearby farmhouse where it is still located today.

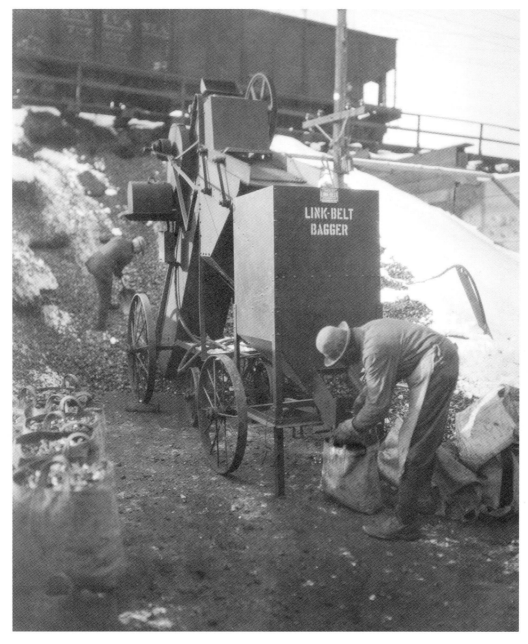

A worker in the Smedley-Mehl coal and lumber yard in Ardmore loads coal into a bag using the Link-Belt Loader and Bagger mechanisms. The photograph was taken in December 1928.

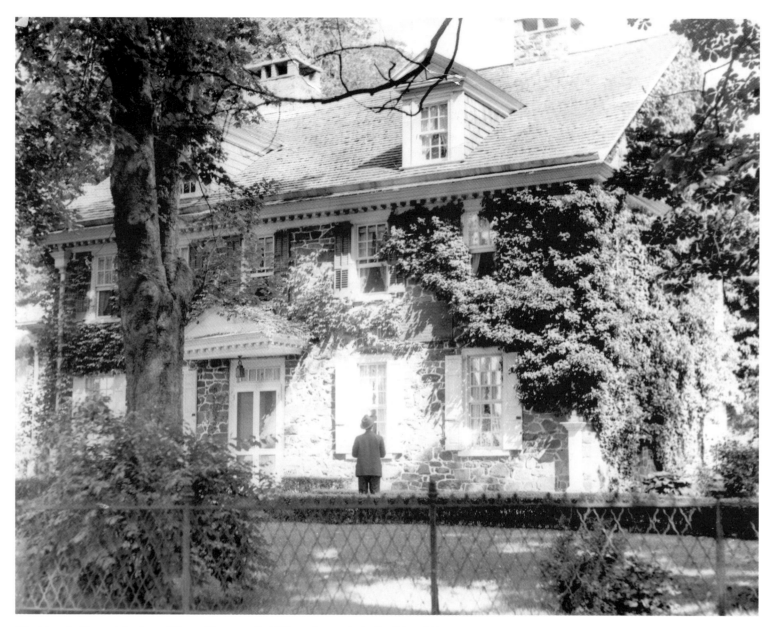

The historic General Anthony Wayne House, called Waynesborough, in Paoli in 1928. William Wayne, the general's great-great-grandson, looks at the house. The home was continuously owned by descendants of Wayne until 1965. It is currently managed as a historic site by the Philadelphia Society for the Preservation of Landmarks.

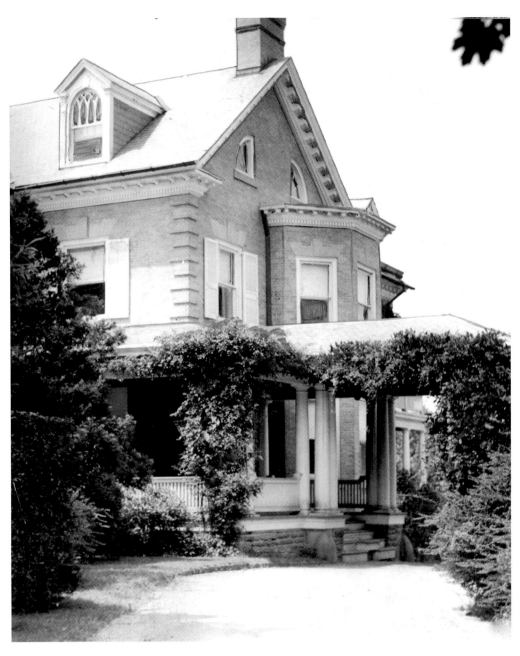

The home pictured here was for a brief time the center of an increasingly prevalent community debate as neighborhoods along the Main Line experienced a dramatic increase in population that resulted in a growing need for services. The former home of Humbert Powell on Windmere Avenue was purchased by Radnor Township in 1928. The township intended to convert the home into a town hall and police station, but neighbors in Wayne launched a protest in an effort to prevent commercial development in their district. The neighbors were successful and the block remains a residential street.

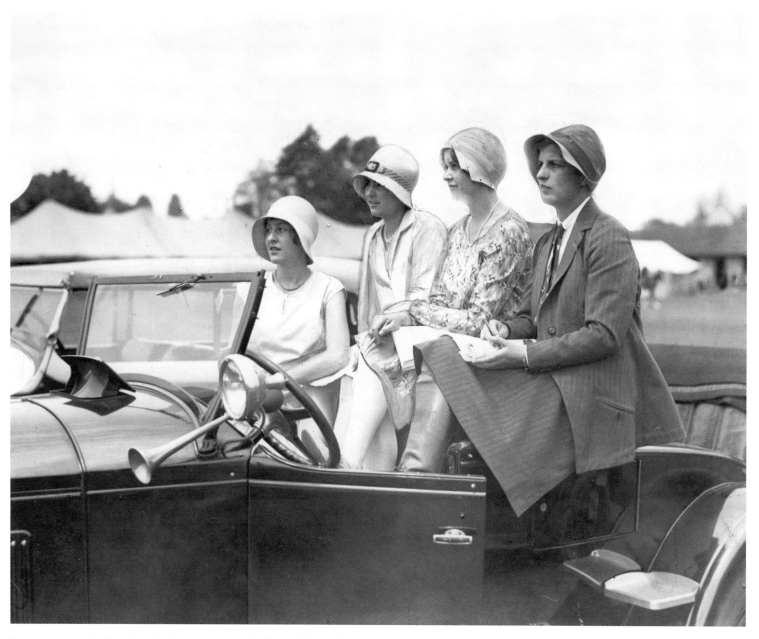

Four spectators in charming cloche hats attend the Devon Horse Show in 1929. From left to right they are Kitty Beale, Betty Bray, Elizabeth Greer, and Stella M. Elkins.

The newly completed First Church of Christ, Scientist, in Ardmore, on November 10, 1929. The building was sold by the church to a developer around 2005. After community petitions and a general outcry to save the church building proved successful, it was sold by the developer to the Household of Faith Deliverance in 2006. A threatened demolition of the church building was prevented.

T. Allen Hilles, Haverford College Class of 1870, waits on the morning of June 9, 1929, to formally dedicate the new laboratory of applied science he funded for the college.

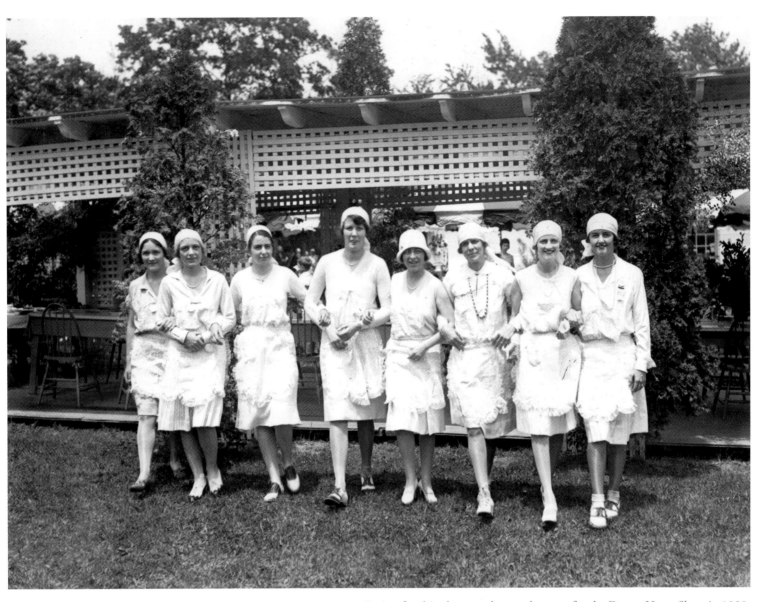

Posing for this photograph are volunteers for the Devon Horse Show in 1929.

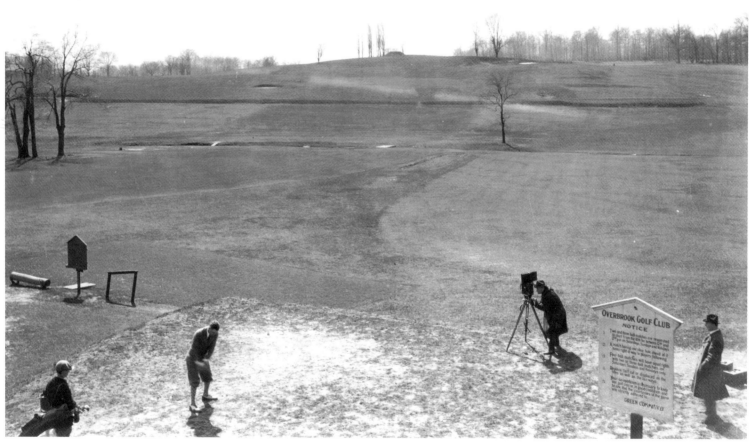

Prior to 1950, the Overbrook Golf Club was located on land now occupied by Lankenau Hospital. Founded in 1900, the club is in Bryn Mawr. A motion picture photographer stands to the right.

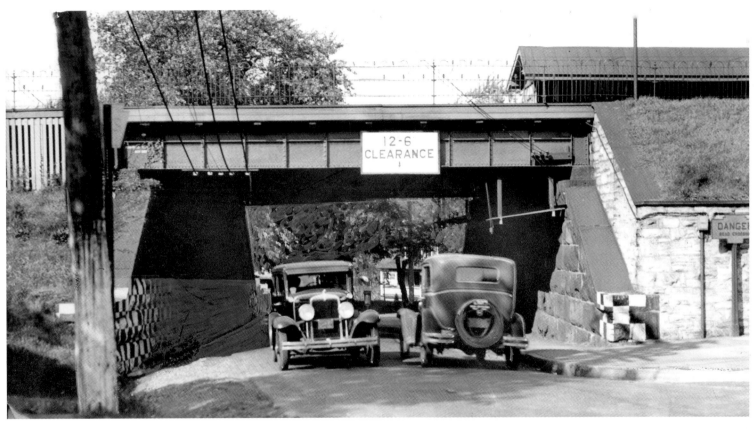

North Wayne Avenue where it crossed under the Main Line railroad at Wayne. Two motorists are shown at the tunnel on December 6, 1930. At the time, the state considered doubling the width of the underpass to 40 feet and adjusting the height to 14 feet. As the communities along the Main Line aged, so too did their infrastructure. Roads and bridges, such as this one, were often targeted for expansion by the Works Progress Administration during the 1930s.

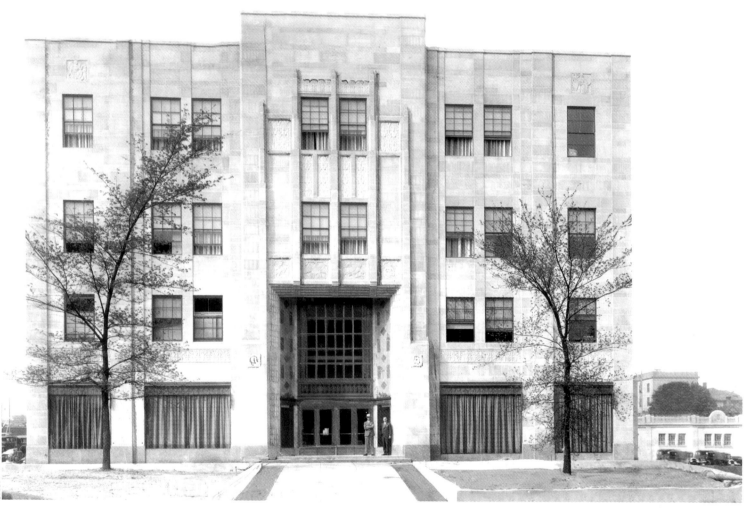

The first Strawbridge and Clothier department store in the suburbs opened in Ardmore on May 12, 1930. It was marketed as an opportunity for middle-class suburban shoppers in Delaware, Chester, and Montgomery counties to avoid entering the city for their general shopping needs.

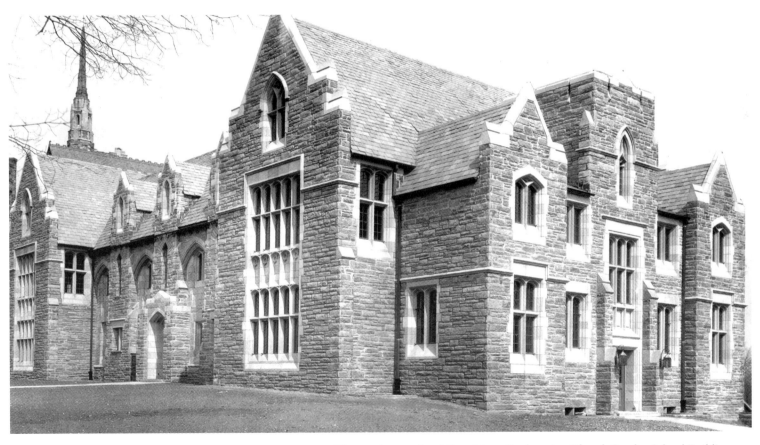

The newly completed Bryn Mawr Presbyterian Church Sunday School Building was dedicated April 25, 1931. Organized in 1873, the congregation built its first chapel the following year and a larger church building nearby in 1886. Currently more than 3,500 members worship in the historic church.

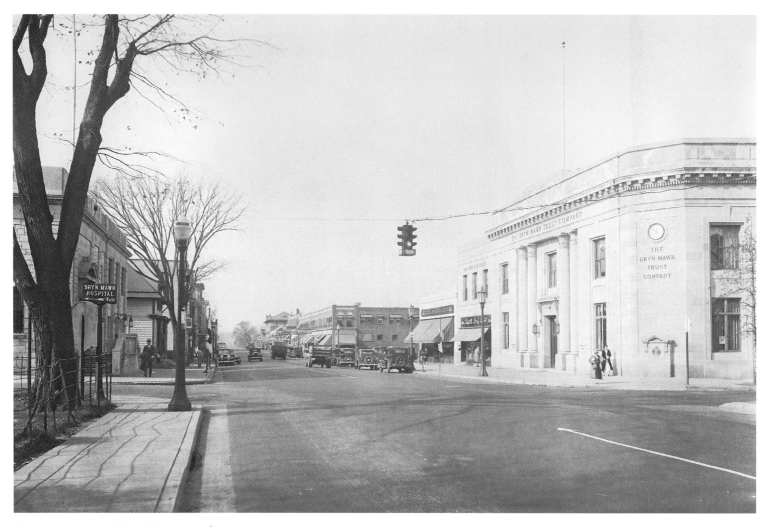

Lancaster Avenue in Bryn Mawr around 1935.

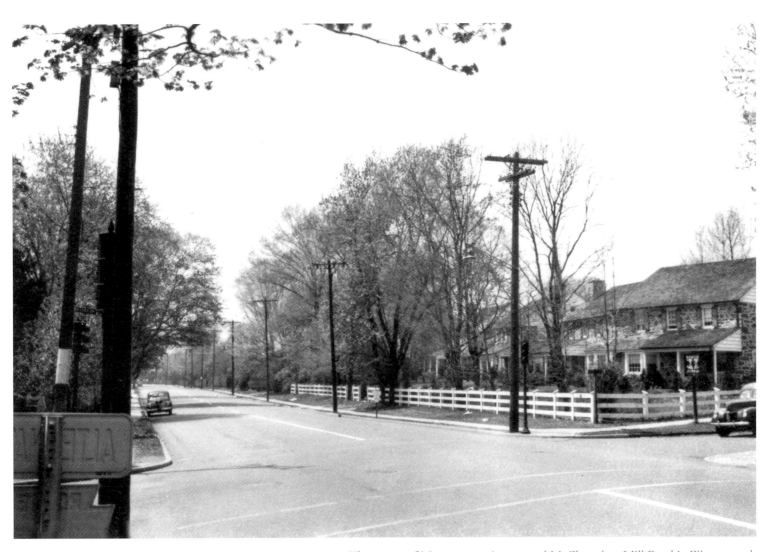

The corner of Montgomery Avenue and McClenaghan Mill Road in Wynnewood.

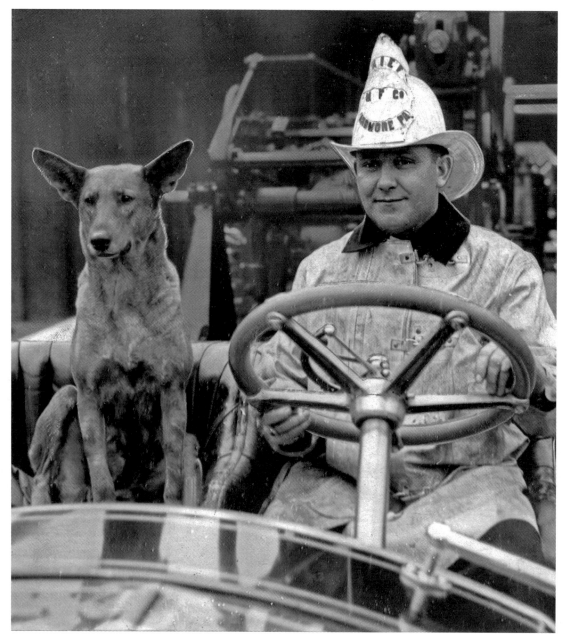

One member of the Merion Fire Company in Ardmore, with Mitzi the firedog, proudly displays one of the company's fire engines around 1932. An aerial ladder truck was purchased by the company in 1929 primarily in response to the construction of tall stores and office buildings in Suburban Square.

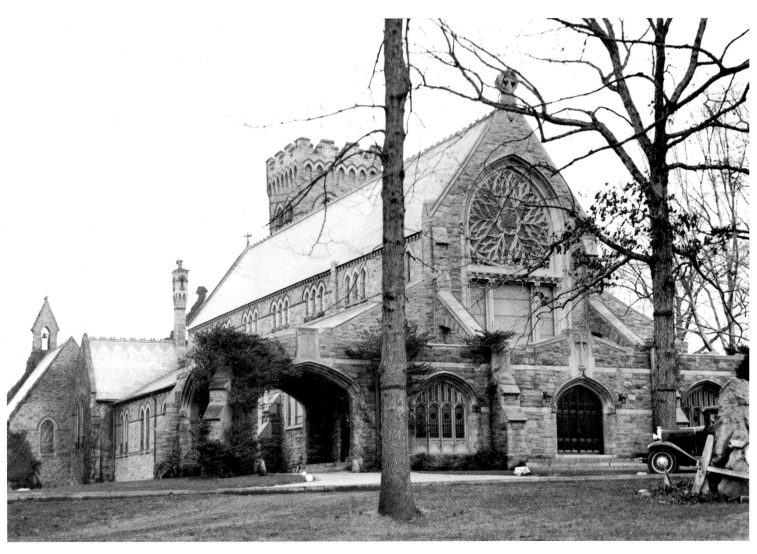

The Protestant Episcopal Church of the Redeemer, Bryn Mawr, as it appeared on January 16, 1932.

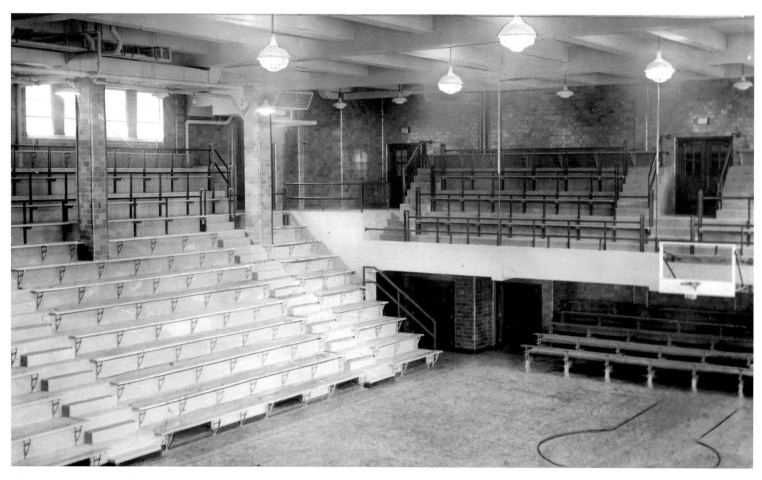

The new gymnasium of the Lower Merion Junior and Senior High School shortly before
its first basketball game December 10, 1932. The school building was built in 1910, but
demolished in 1963 to make way for the high school in use today.

The new Easttown Township School opened in Berwyn in October 1932 to accommodate four hundred students in grades kindergarten through seventh. The $235,000 building featured 16 classrooms and a combined gymnasium and auditorium.

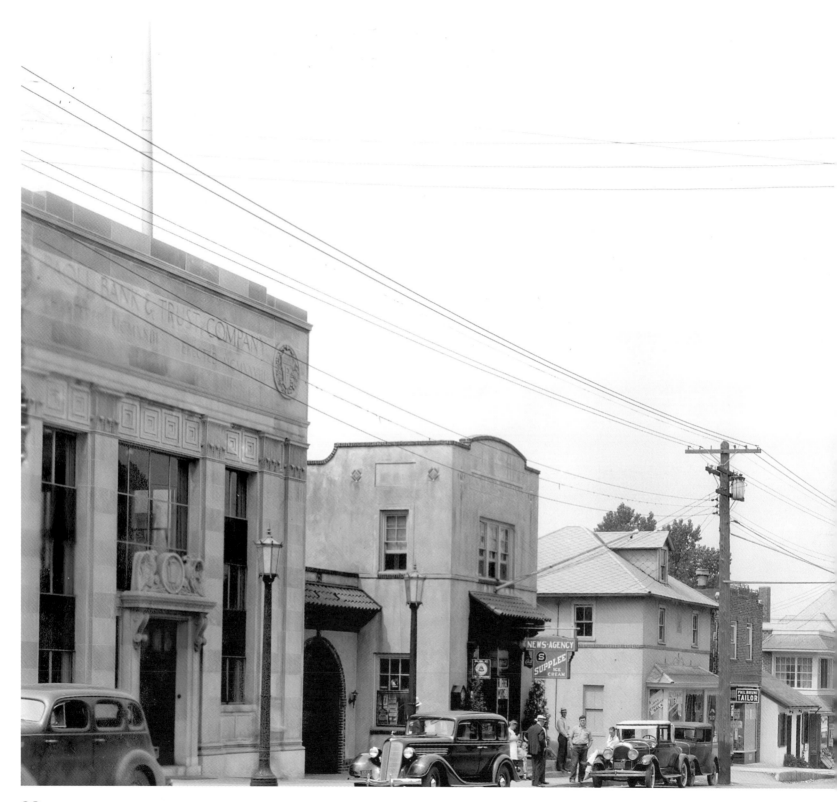

Lancaster Avenue in Paoli around 1935.

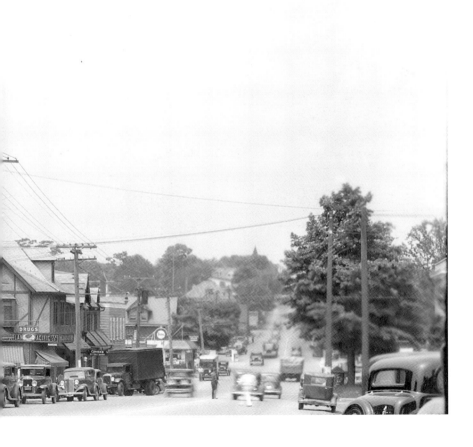

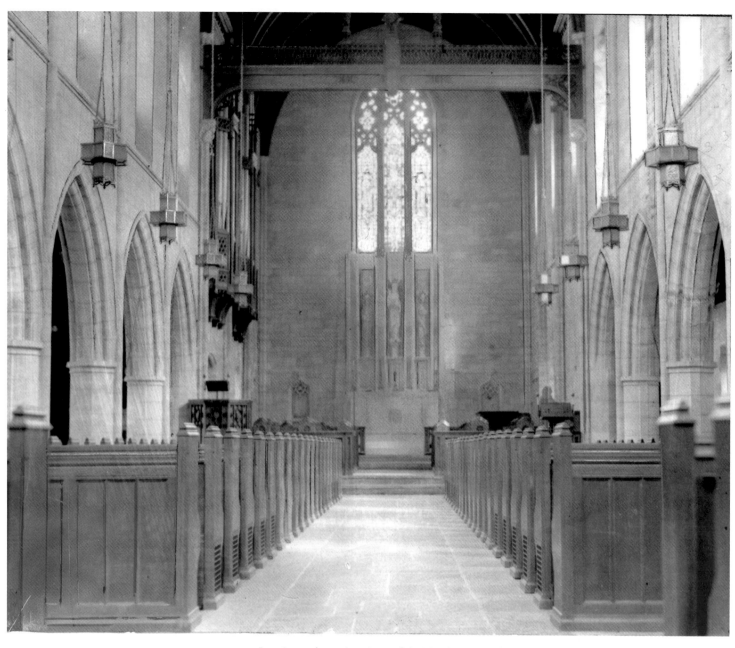

Interior and exterior views of the Nevil Memorial Protestant Episcopal Church of St. George in Ardmore, as it appeared on March 23, 1933.

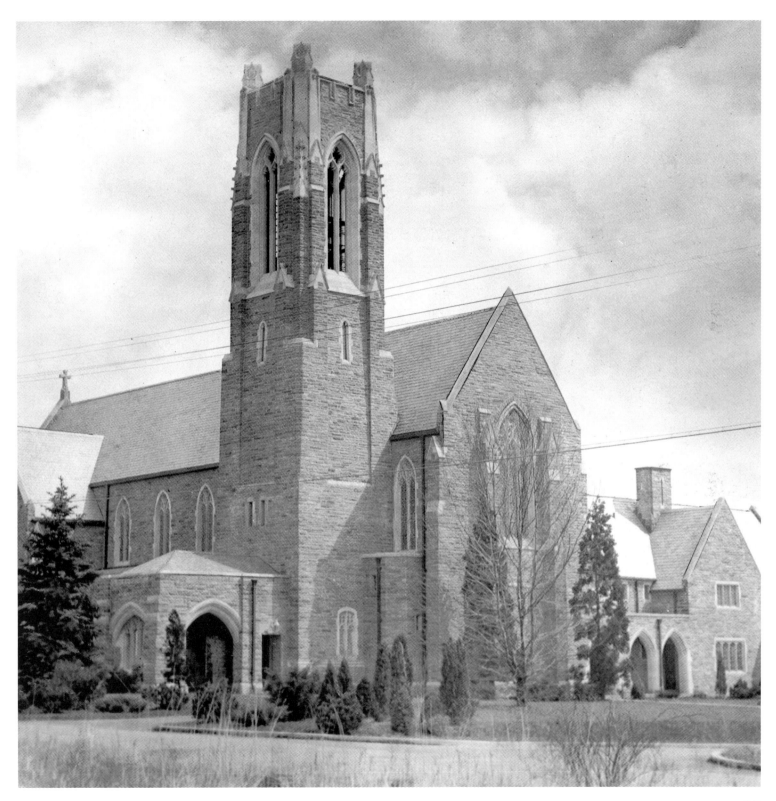

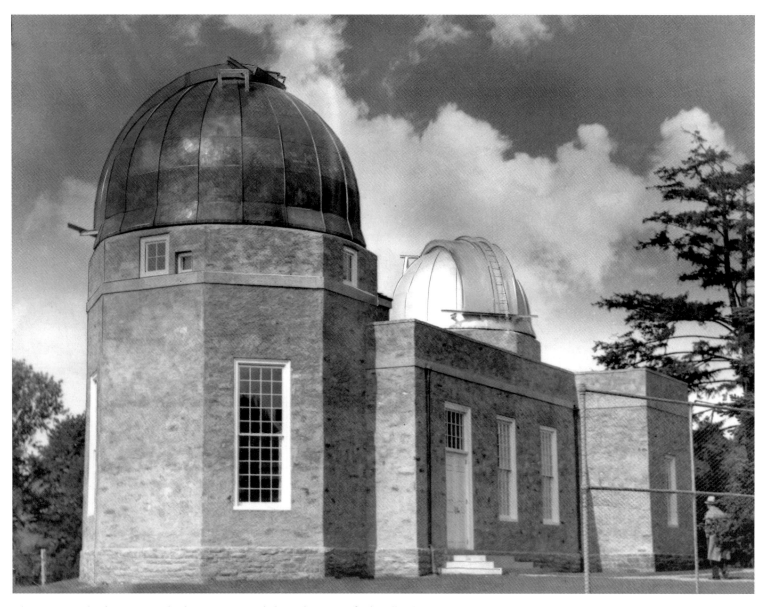

The new Strawbridge Memorial Observatory was dedicated at Haverford College's
Centennial in 1933. In addition to a library and classrooms, the observatory featured two
revolving domes and two telescopes. The observatory is still used by students in the college's
astronomy classes and occasionally by members of the public for special events.

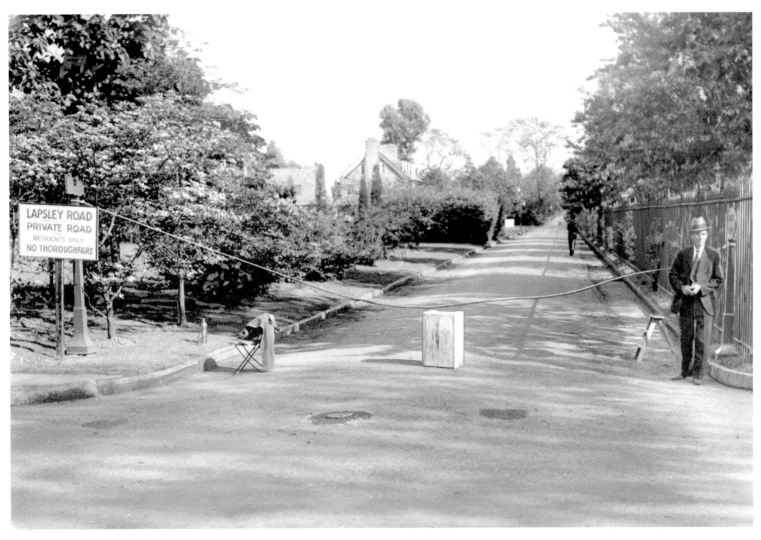

"The Bars Are Up on Lapsley Road in Merion," went a newspaper article that accompanied this photograph on May 19, 1933, describing efforts among residents on Lapsley Road (now Lane) to prevent "itinerant trucks, schoolboys and other unauthorized traffic" from trespassing. In addition to a sign, a rope, and a soap-box, the road was guarded by the man seen to the right. The Barnes Foundation, a private art school and museum that opened in 1929, is located near the intersection pictured here.

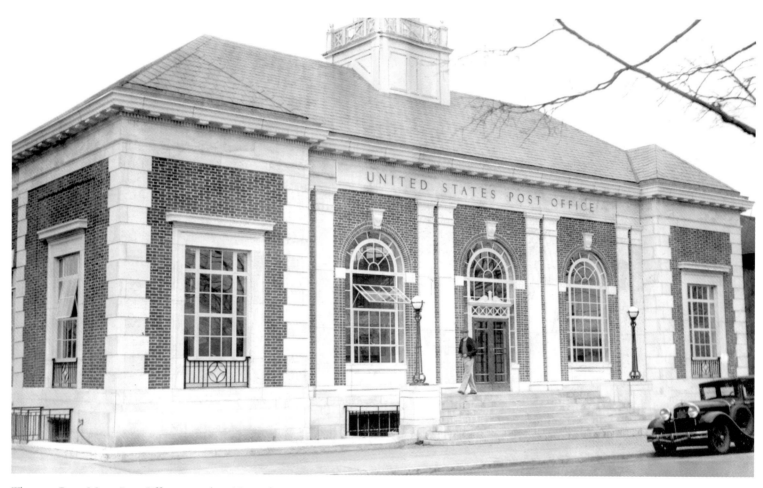

The new Bryn Mawr Post Office opened on November 25, 1933.

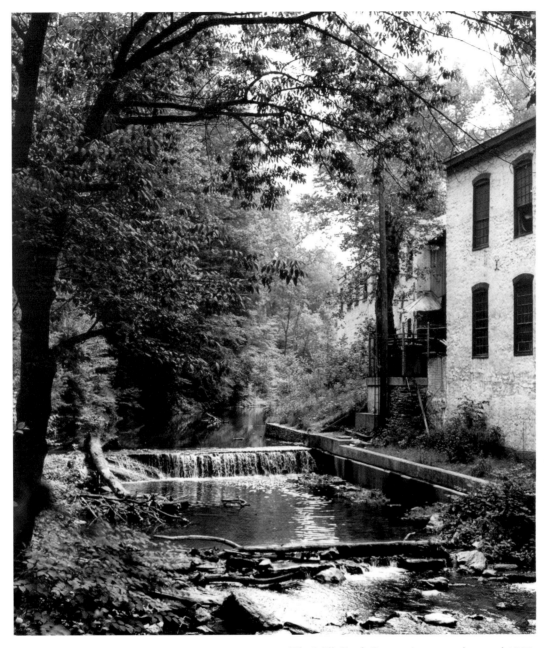

The Mill Creek Dam as it appeared around 1935.

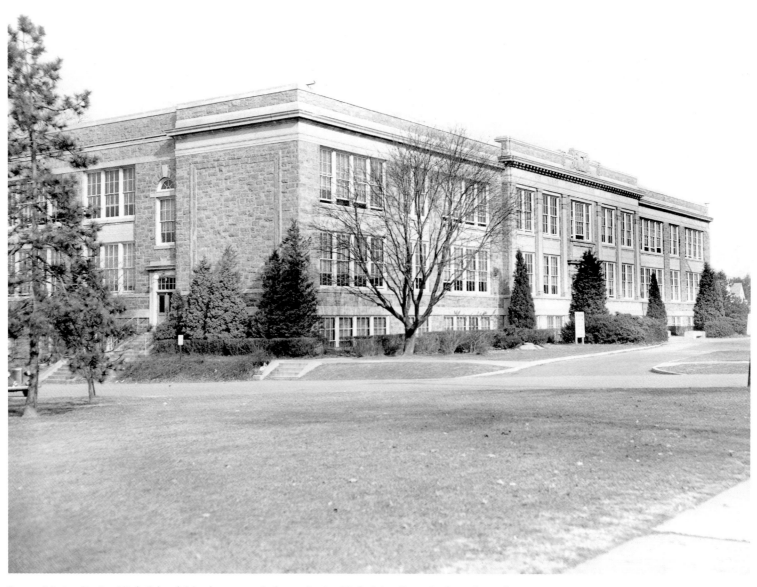

Lower Merion Junior High School (also known as Ardmore Junior High School) was built in the early 1920s and occupied until 1992. It was demolished in spite of extensive protests from the community.

Police sergeant Charles Gervin and others inspect damage to the Narberth Elementary School ceiling sometime in the 1930s.

Along a small back street, life goes on in Ardmore on June 17, 1938.

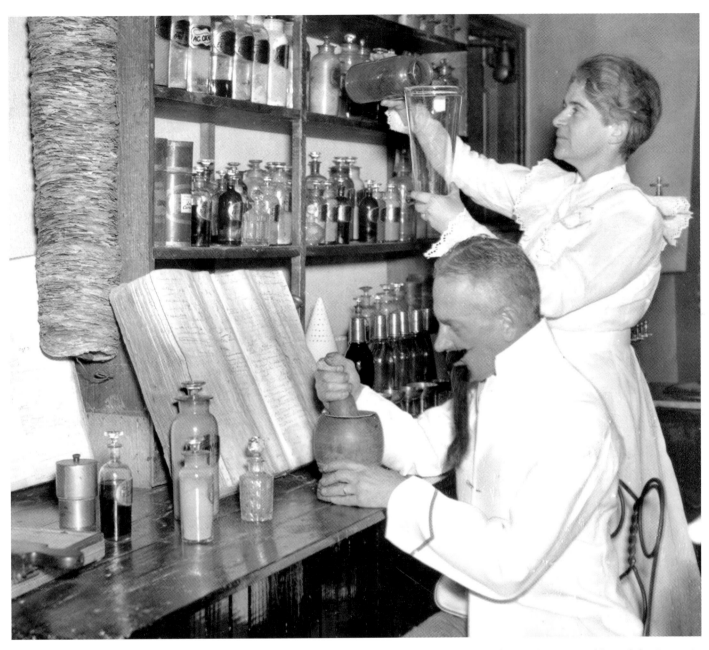

Local citizens of the Main Line proudly depict the Ardmore of 1887 during a Golden Jubilee Bazaar in December of 1937. Mr. and Mrs. H. H. Wallower, of Haverford, are portraying a doctor and nurse using medical equipment of the period.

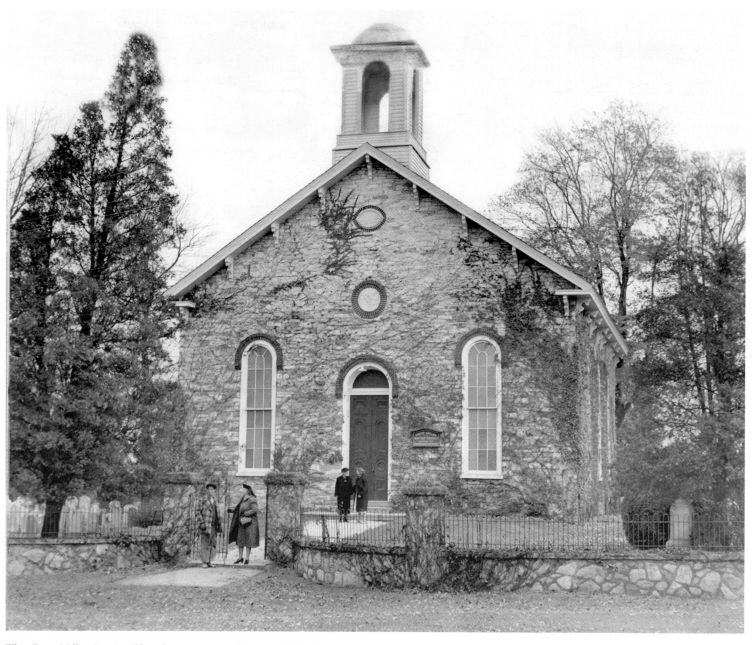

The Great Valley Baptist Church as it appeared in 1939. The church was
built in 1805 on what is now North Valley Forge Road in Devon.

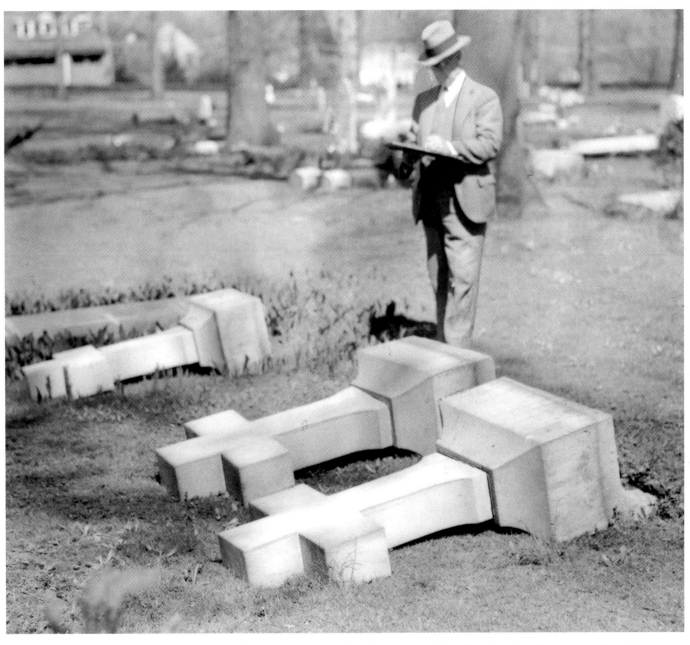

Grave markers in the historic cemetery of the Church of the Redeemer in Bryn Mawr were vandalized in 1938. Similar damage was reported in St. David's cemetery near Devon.

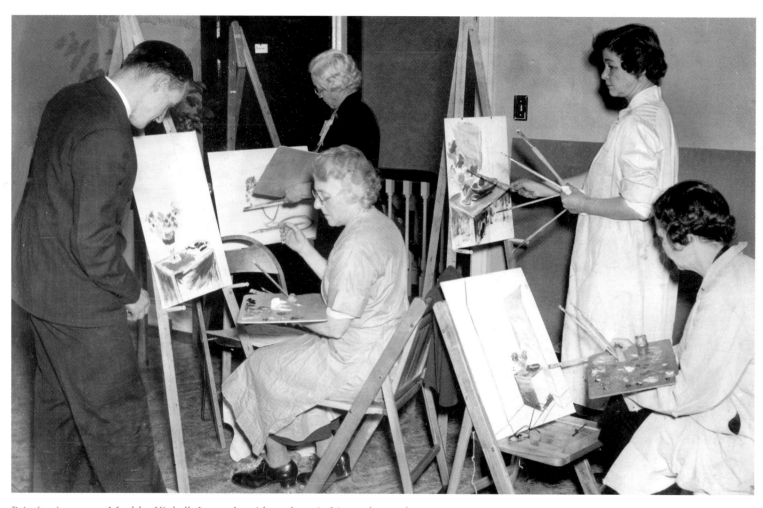

Painting instructor Maulsby Kinball, Jr., works with students in his art class at the
Bryn Mawr Art Center in October 1937.

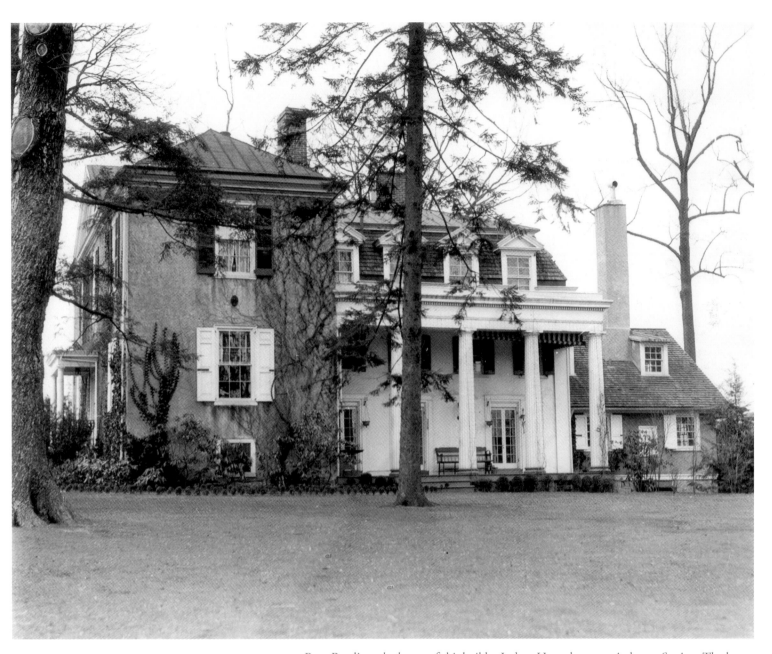

Pont Reading, the home of shipbuilder Joshua Humphreys, at Ardmore Station. The home was built in three sections—from right to left, in 1730, 1760, and 1813. Humphreys owned a shipyard along the Delaware River in Philadelphia where the frigate USS *Constitution* was designed, built, and launched in 1797. Bryn Mawr was for a time called Humphreysville in honor of the longtime residents.

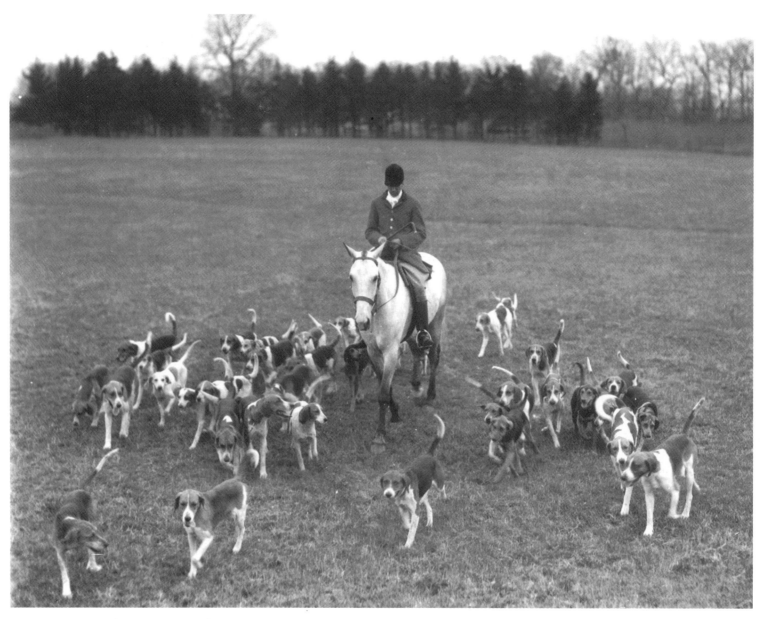

Participants in one of several historical foxhunting clubs along the Main Line around 1940. Foxhunting (mounted) and pack hunting (on foot) are long-established sporting and cultural events in several communities along the Main Line. Many large estates maintained their own kennels and packs, and private clubs such as the Radnor Hunt and the Bryn Mawr Hounds continue to run in season. In the recent past, increasing concerns among animal rights activists led to challenges to hunting activities, but hound breeding and fox hunting remain essential activities for many Main Liners.

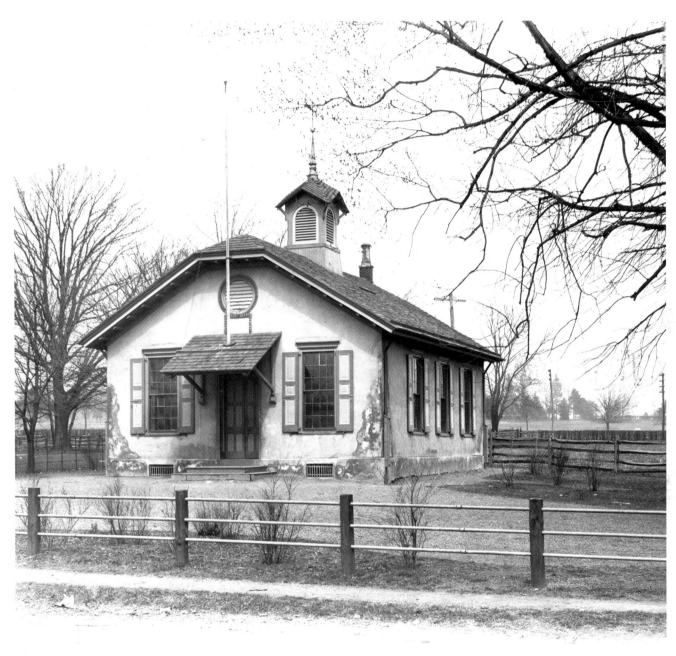

The second Wynnewood School built in 1879 near the corner of Lancaster Avenue and Wynnewood Road. It was used until 1916 and is believed to have been demolished in the early 1950s.

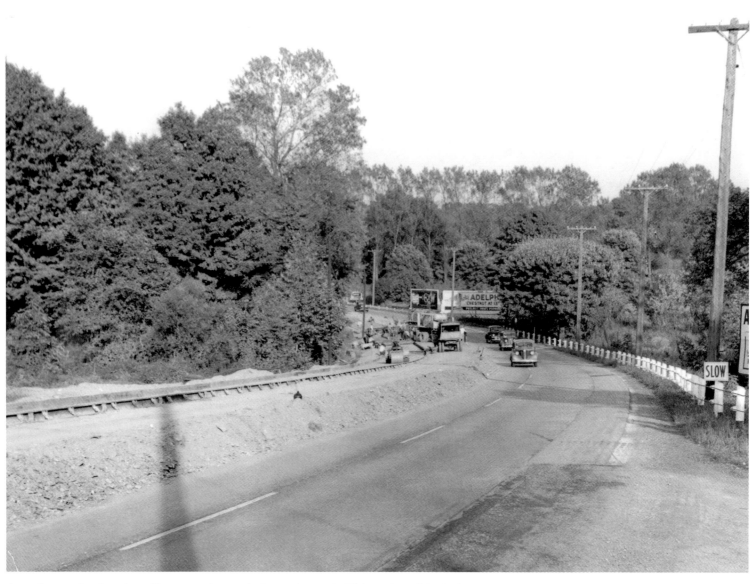

A nearly completed section of Lancaster Avenue in September 1940. This section of the highway, located near Devon, had been the scene of several deadly crashes the previous winter. The new road was eight feet wider and banked to prevent skidding.

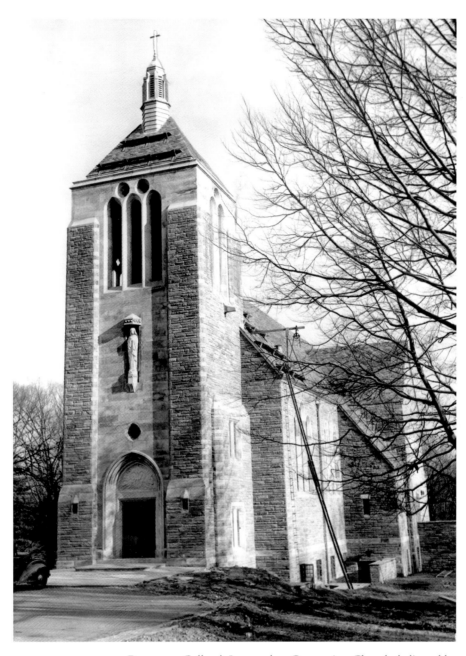

Rosemont College's Immaculate Conception Chapel, dedicated by
Cardinal Dougherty on January 9, 1941.

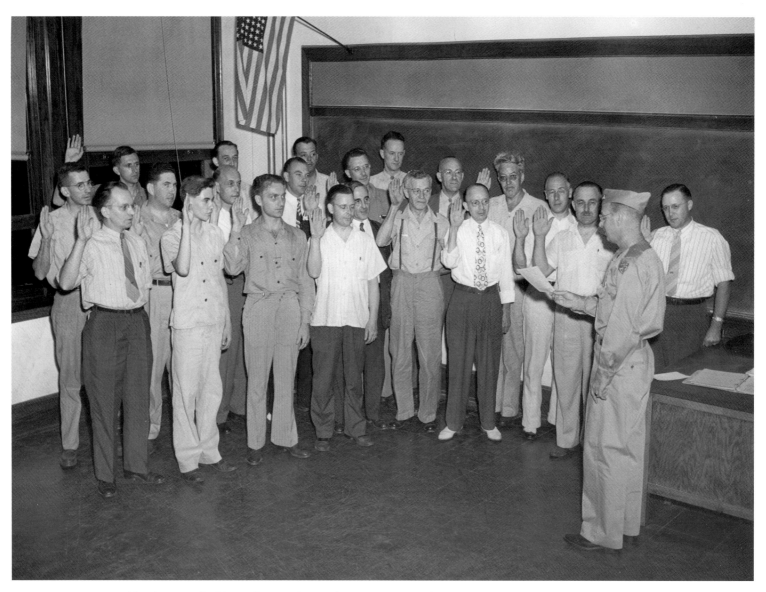

In response to an appeal by the Haverford Township Auxiliary Police, a new group of recruits is sworn in on August 5, 1943. The men were part of an effort to assist the police during alerts, air raids, and blackouts. The township required only that the men be above the age of 21, of average health, and of good character.

The northwest corner of Montgomery Avenue and McClenaghan Mill Road in Wynnewood, in 1943.

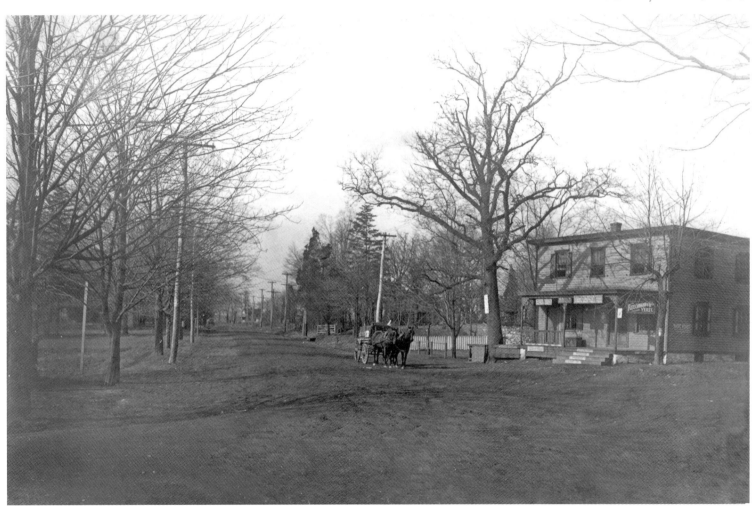

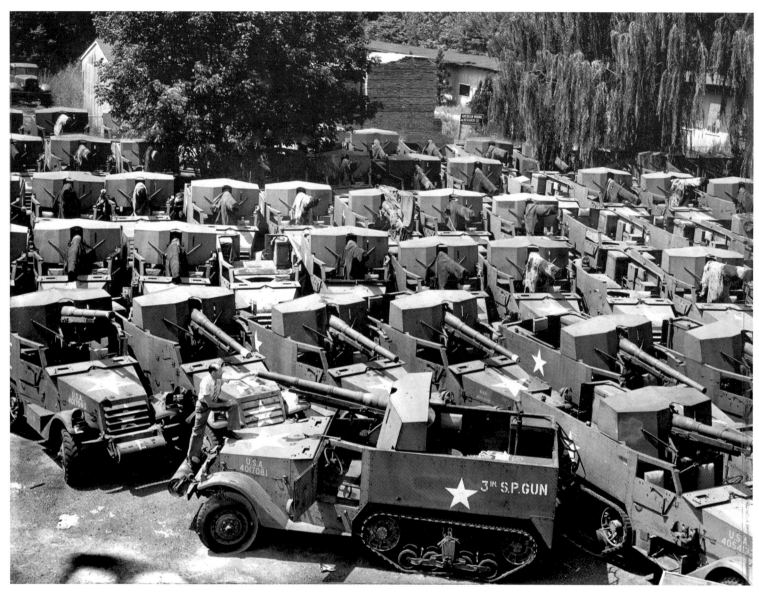

Founded in Pittsburgh in 1898, the Autocar Company of Ardmore manufactured cars and trucks until 1911 when it stopped building cars to focus on its popular line of trucks. The trucks continued to be successful. During the Second World War, more than 30,000 vehicles were produced in Ardmore. The trucks pictured here are damaged half-trucks (trucks with tracks as rear wheels), which have been returned to Ardmore for repair following service in the war.

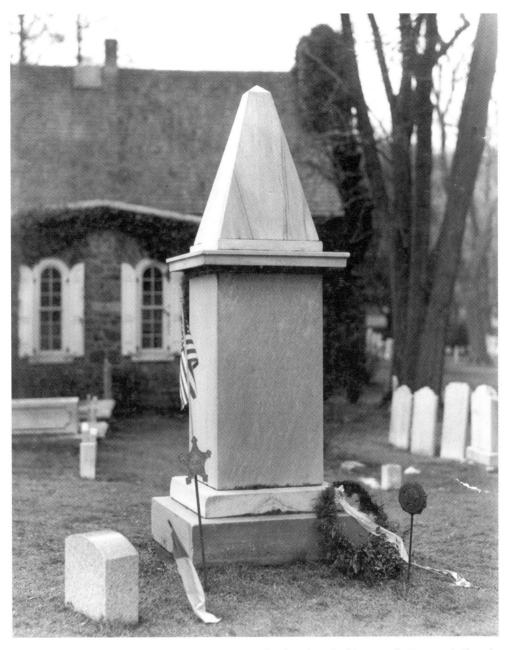

The grave of General Anthony Wayne in the churchyard of St. David's Episcopal Church.

Employees of the Autocar Company of Ardmore listen as veterans explain the workings of a naval anti-aircraft gun. Patricia Albany, an Autocar employee, is seen at the controls.

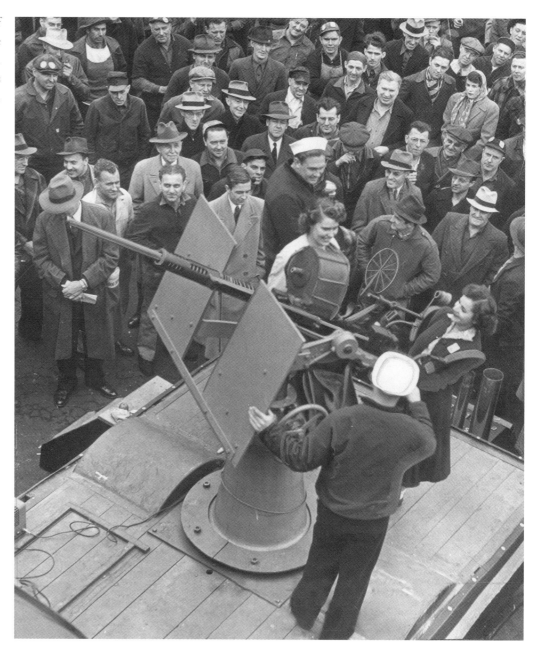

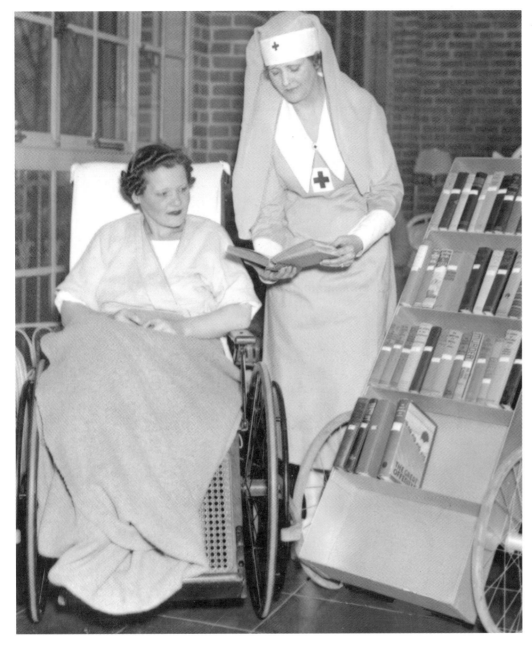

A nurse and a patient at Bryn Mawr Hospital review available reading material in the 1940s.

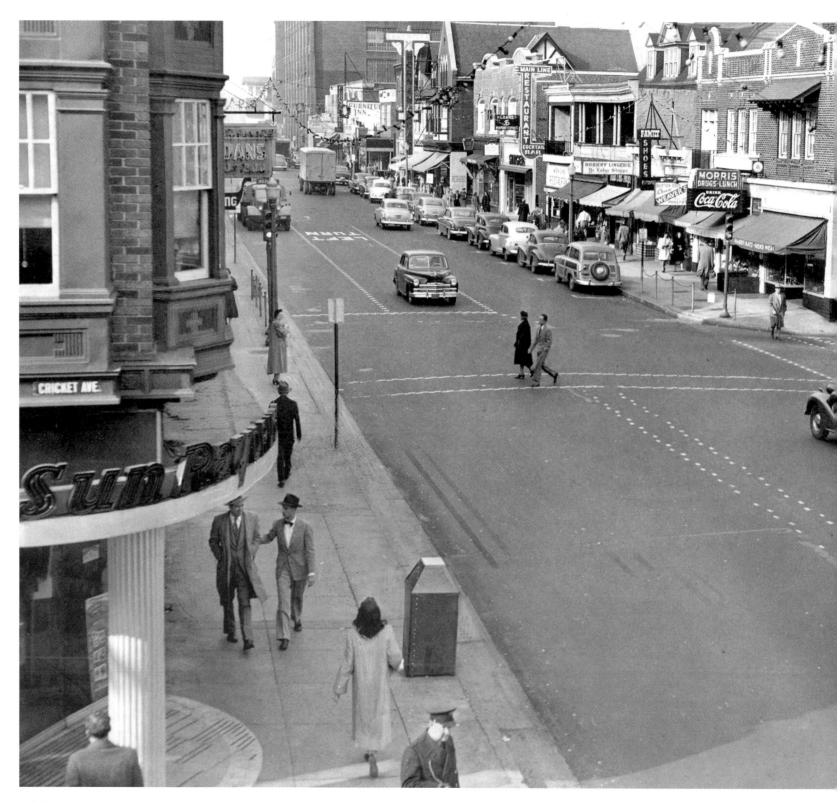

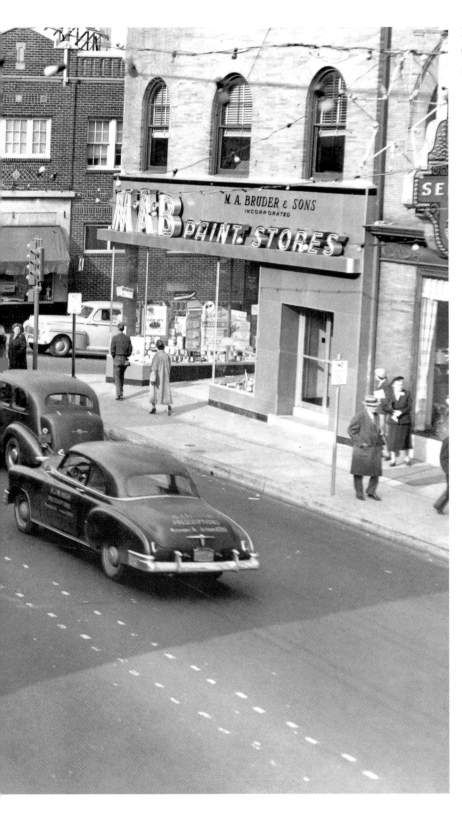

Lancaster Avenue in Ardmore around 1945. The five-story Autocar Company factory at the far end of the street was destroyed by a massive fire on July 31, 1956.

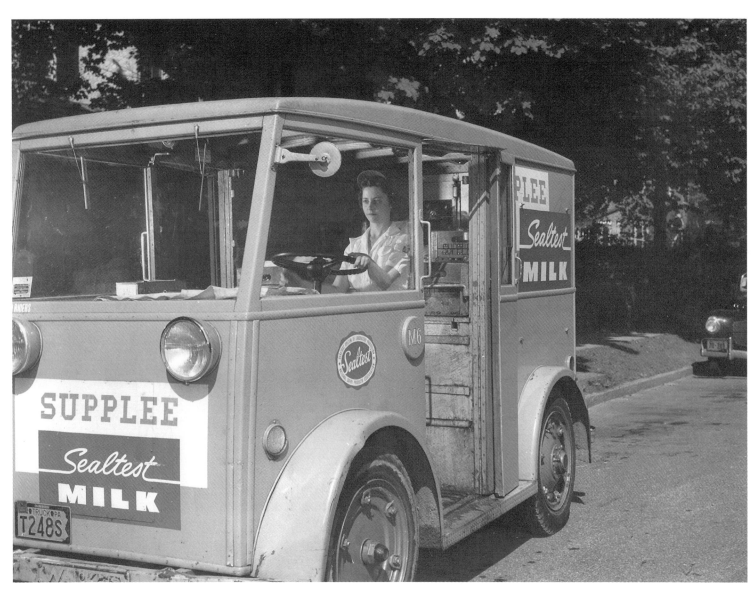

Miss Pearl Gold and Mrs. Helen Joyce, whose husband was serving overseas in the U.S. Navy, were among many women who began working for local companies during World War II. They are seen here delivering milk for the Supplee-Wills-Jones milk company in Bryn Mawr in 1943.

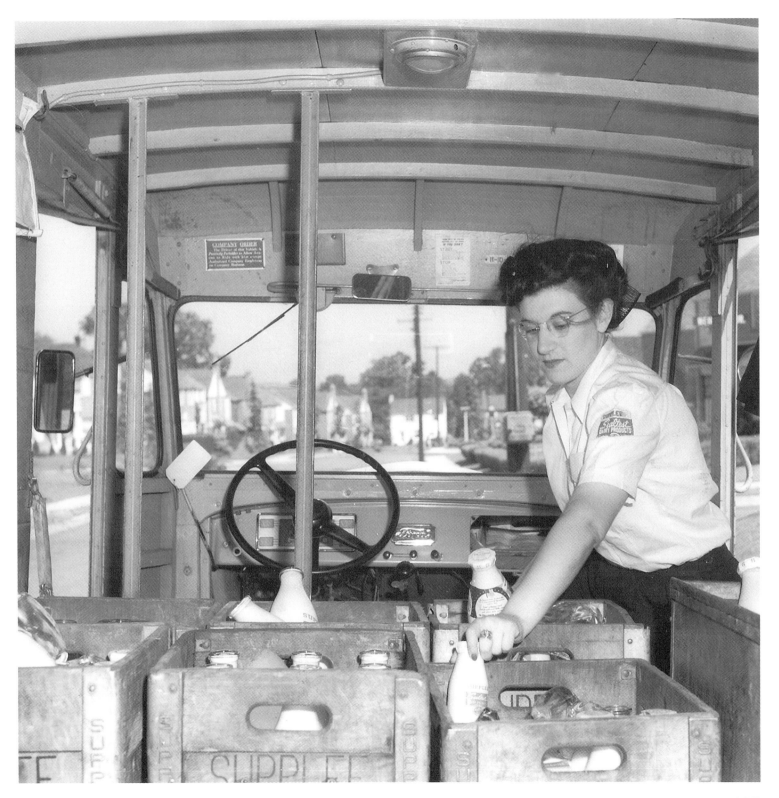

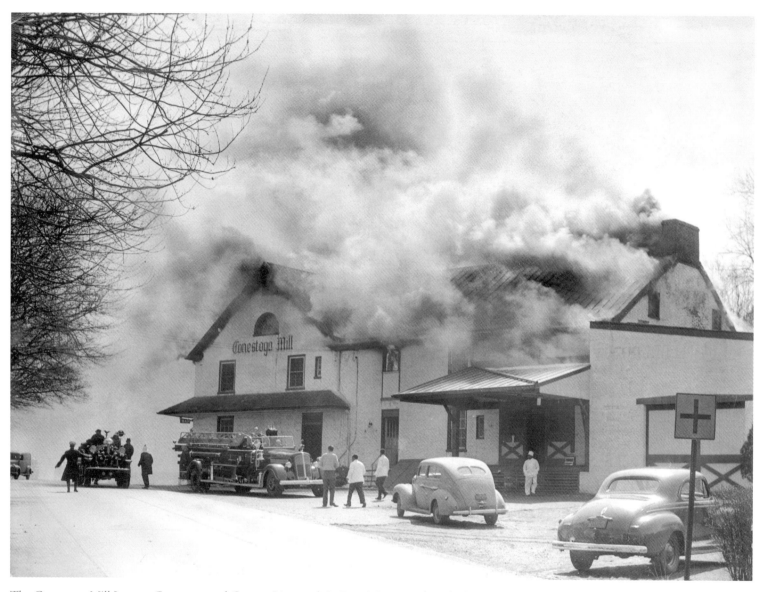

The Conestoga Mill Inn, on Conestoga and County Line roads in Bryn Mawr, was heavily damaged by fire in March 1944. The fire was noteworthy because the owner, Paul Ferraris, was serving in the Army at the time.

A parade was held along Lancaster Avenue in 1940 to commemorate the 50th Anniversary of the Merion Fire Company. Pictured here are the Allentown Fire Company Band and the Washington Fire Company of Conshohocken.

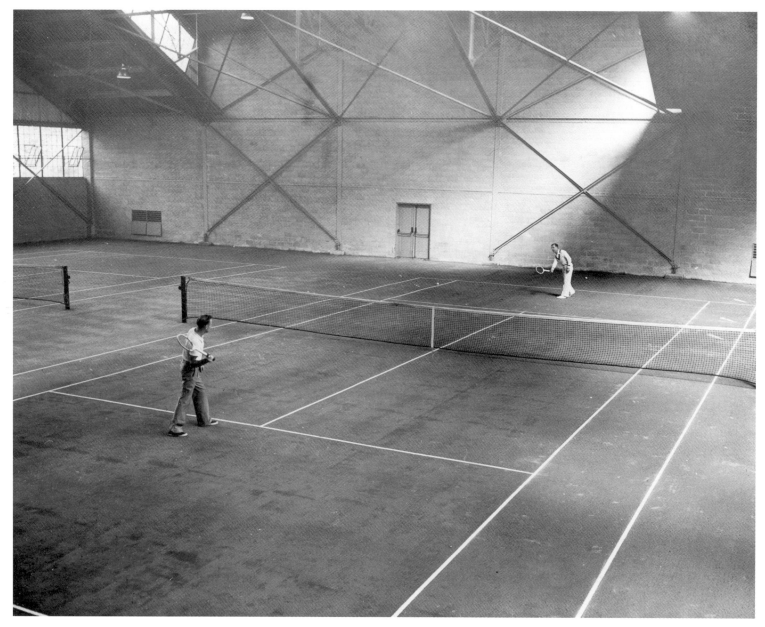

Indoor tennis courts in Ardmore.

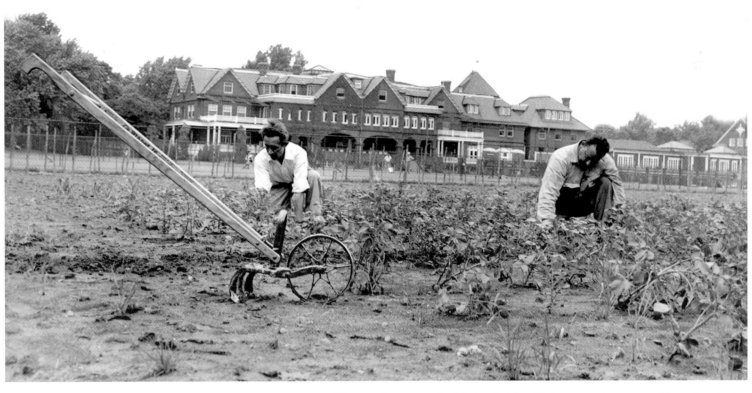

The tennis court at the Merion Cricket Club was used as a vegetable garden during the lean days of World War II. This photo was taken in June 1943.

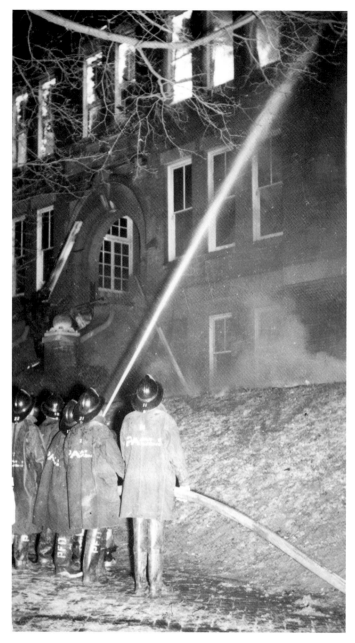

The Paoli Fire Department assists during a fire that struck the West Chester High School in 1947.

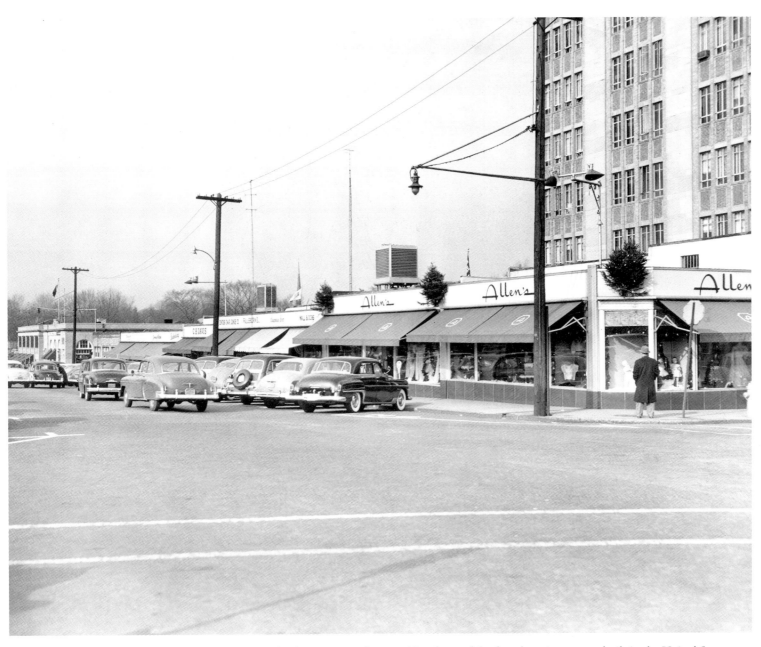

Suburban Square, often considered one of the first shopping centers built in the United States, was completed in 1928. It featured a range of retail and service shops all designed as a cohesive shopping experience. This view shows the area in the late 1940s. The large building to the right is the Times-Medical Building, which housed medical offices and those of the *Main Line Times* newspaper.

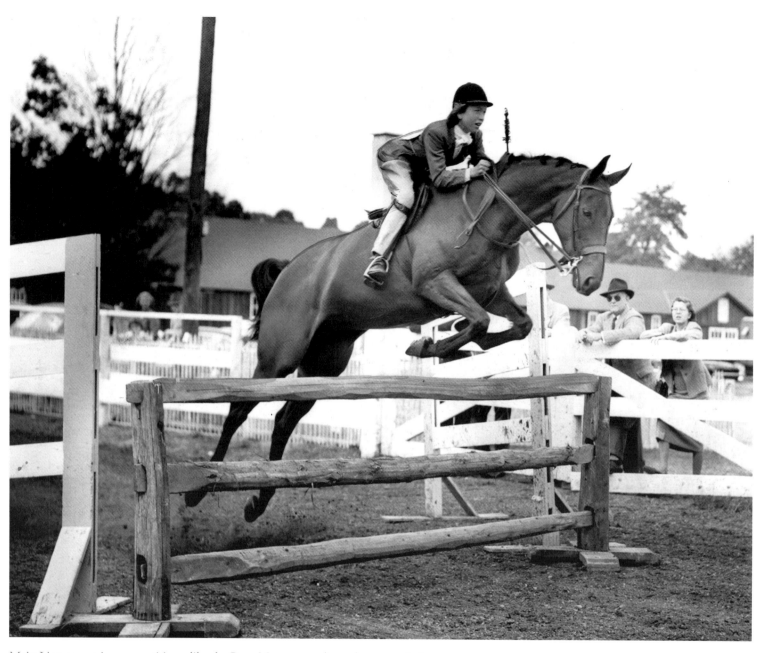

Main Line equestrian competitions, like the Bryn Mawr event shown here, remain important elements of the Main Line lifestyle in part because they represent both the agrarian history of the communities along the railroad and the affluent "country-life" aspirations of the first wave of suburban estate builders and developers.

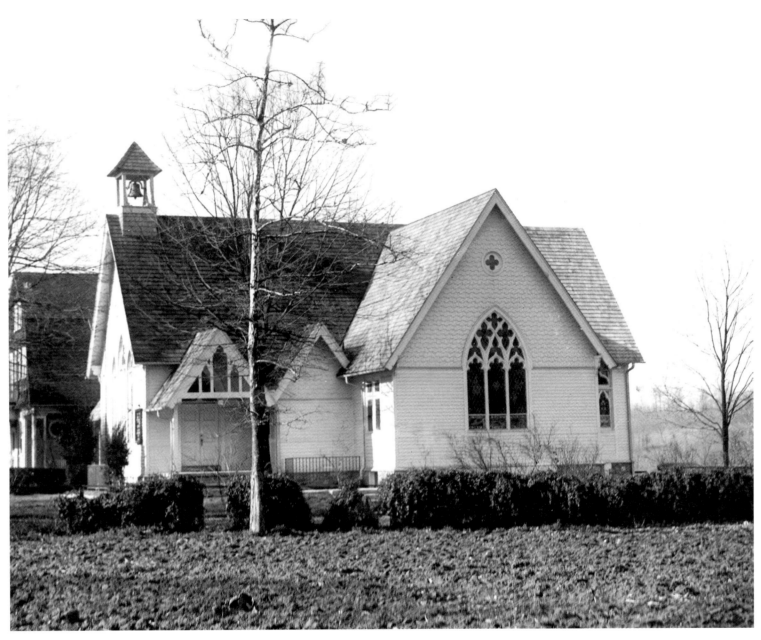

St. John's Presbyterian Church in Devon.

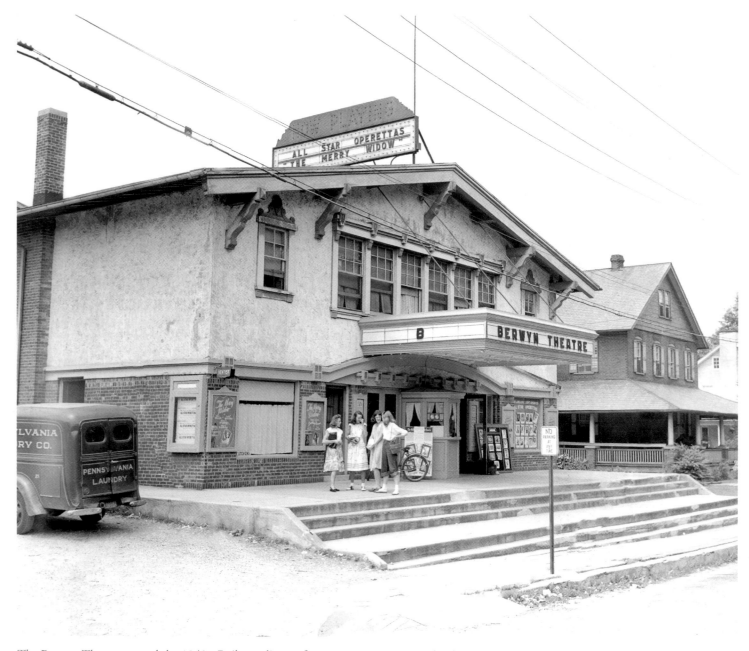

The Berwyn Theatre around the 1940s. Built as a live performance venue in 1913, the theater went on to become a movie theater in the 1940s and a roller rink in 1951, occasionally featuring for record hops future *American Bandstand* host Dick Clark. Today it has been converted to an office building and is known as Cassatt's Crossing.

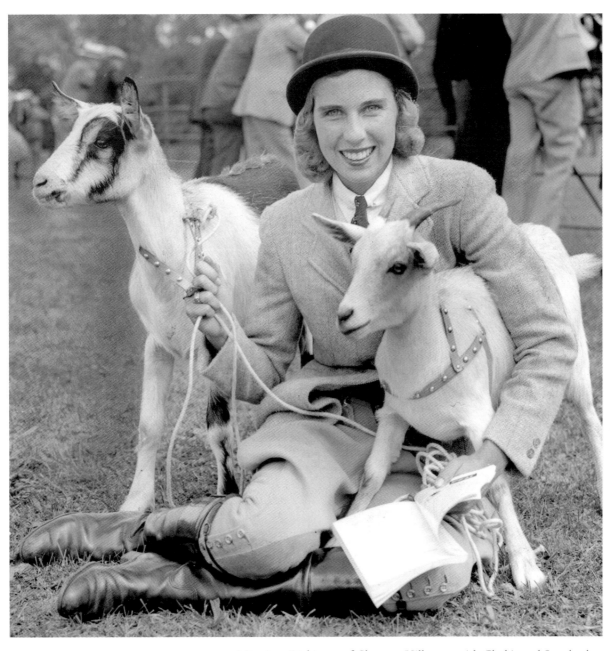

Miss Ann Dickinson of Chestnut Hill poses with Clarkie and Snooky, her
horse stable mascots, at the Bryn Mawr Horse Show.

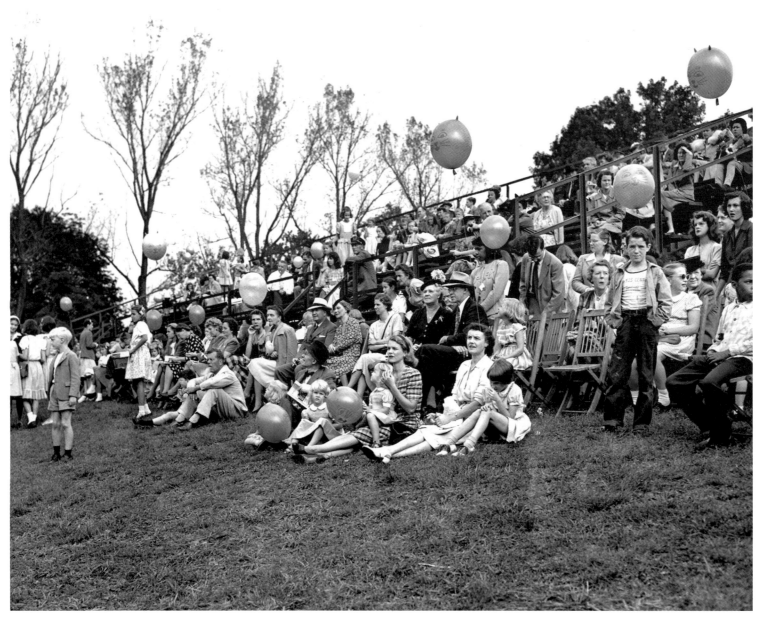

A mix of adults and children turned out for the children's pony class competitions at
the Bryn Mawr Horse Show in 1946.

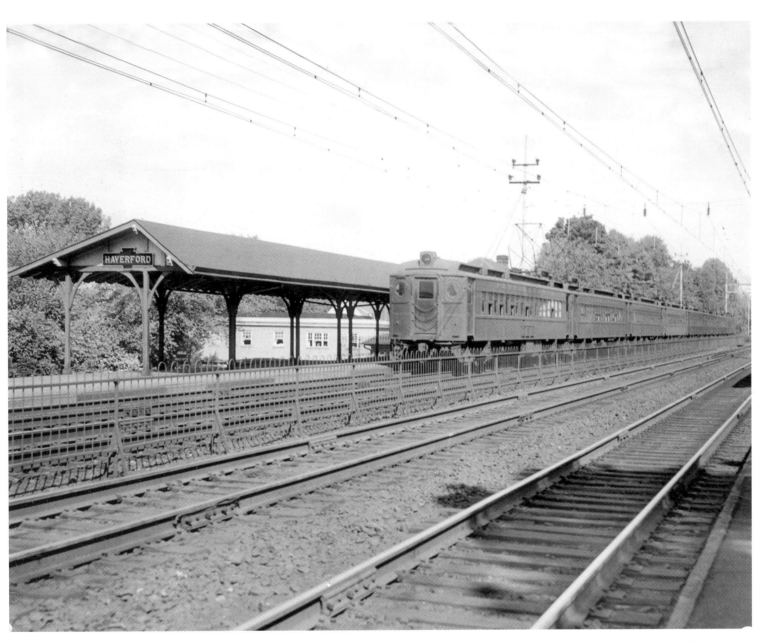

The electrified Pennsylvania Railroad at Havertown around 1945. The line from Philadelphia to Paoli was one of the first to be electrified by the Pennsylvania Railroad in 1915. It was also the first to use high-voltage overhead lines.

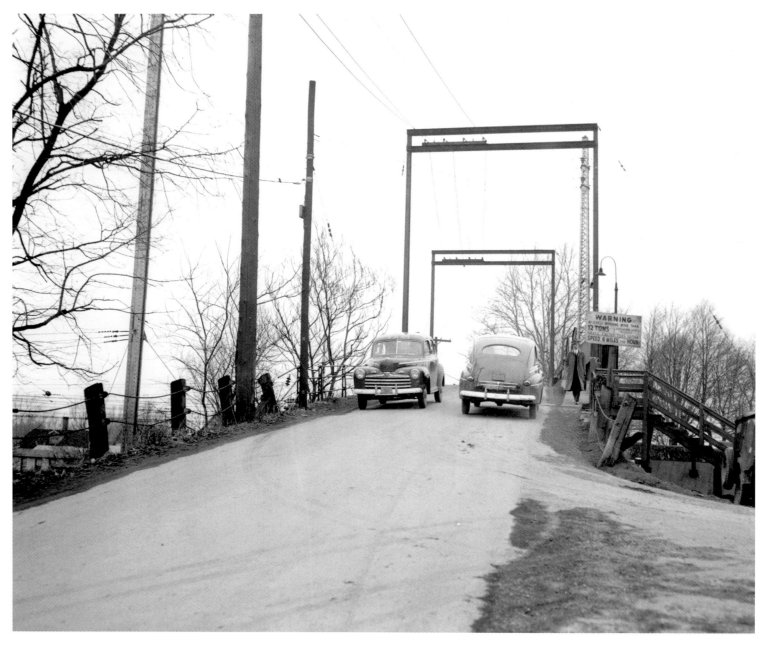

An 1880s bridge across the Pennsylvania Railroad tracks at Paoli as seen in September 1948. Many bridges such as this one were identified in the postwar years for expansion or complete replacement.

Philadelphia mayor Bernard Samuel cuts the ribbon to open the Devon Horse Show and Country Fair at an event in the Bellevue-Stratford Hotel on Walnut Street in April 1947. Today Mayor Samuel remains the most recent Republican to hold that office.

Like many urban and suburban communities, the Main Line experienced a dramatic increase in the demand for middle-class housing following the end of World War II. The Haverford and Wynnewood homes pictured here in 1948 are typical brick styles popular throughout much of the Main Line.

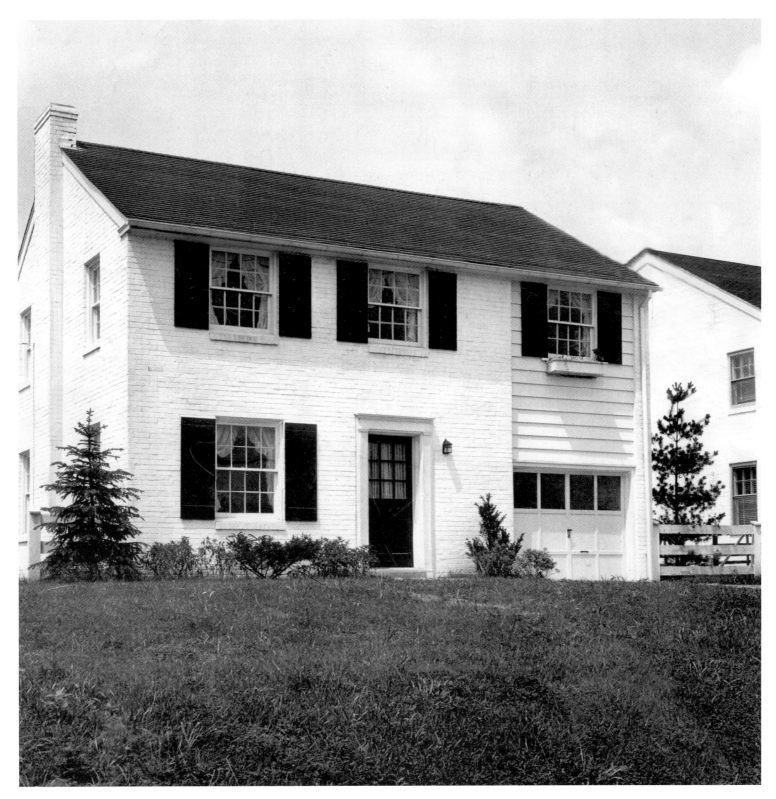

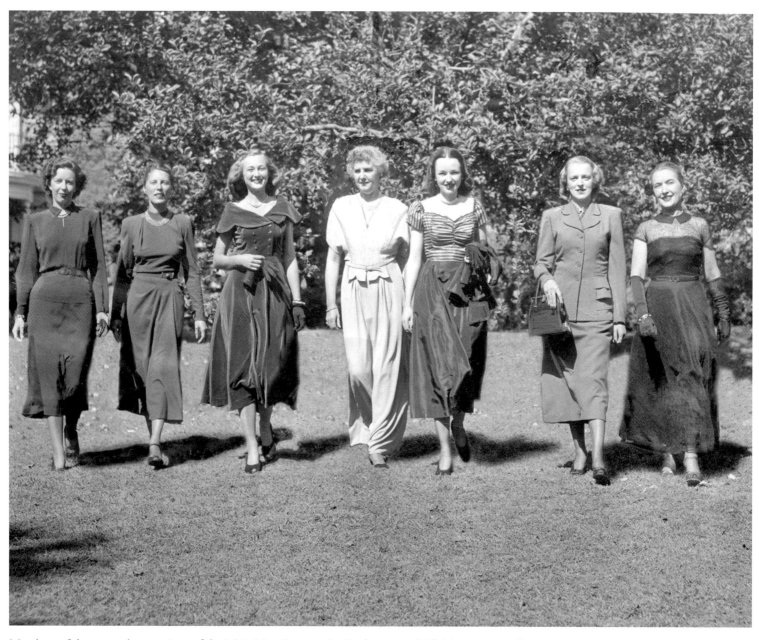

Members of the women's committee of the Main Line Community Orchestra model fashions as part of a fundraising effort in 1948.

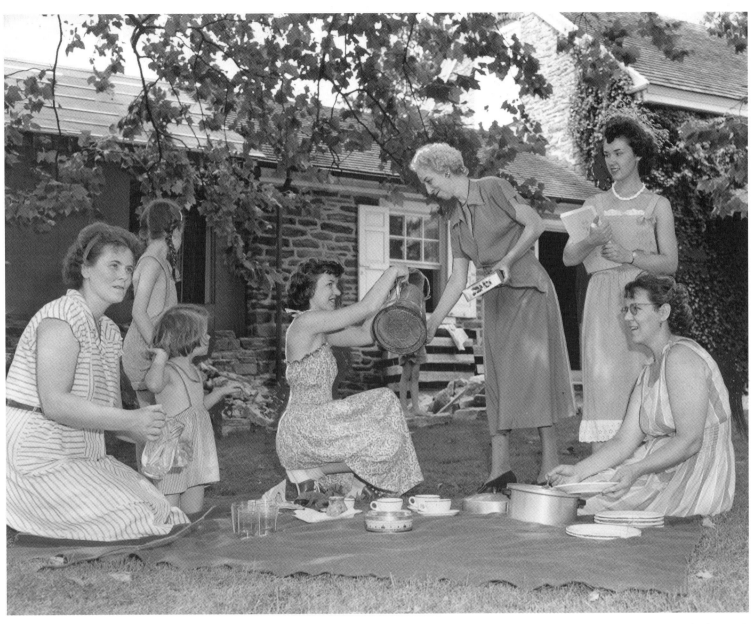

In 1949, a picnic was held to feed the workers building a new day school for the Haverford Friends Meeting. Mrs. Carl Huber, wife of the designer of the addition, is shown pouring iced tea.

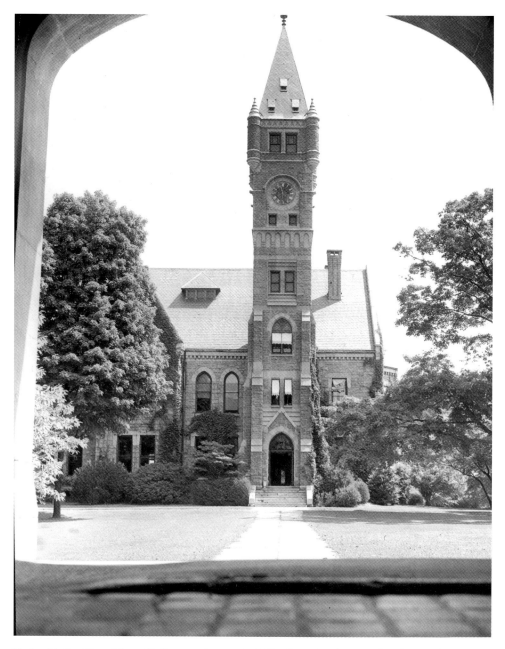

Taylor Hall at Bryn Mawr College on August 1, 1950. Completed in 1884 and named after a primary benefactor, it was the first structure built for the new college.

THE FUTURE IS NOW

(1950–1970s)

The advent of the Second World War saw communities along the Main Line join together to serve the nation. Hundreds of residents enlisted, while local companies like the Autocar Company and Supplee Dairies met the needs of the armed services abroad as well as on the home front. The end of the war brought about yet another housing boom, and more empty land was consumed by residential developments. Expansion of community services soon followed, most notably in the form of hospitals, schools, and businesses.

As the midpoint of the twentieth century approached, much of life along the Main Line remained the same if not busier and with greater mobility. The Schuylkill Expressway, a high-speed highway that followed the Schuylkill River and connected downtown Philadelphia with much of the Main Line, was completed in the mid-1950s. Residents continued to look to the large urban center in Philadelphia as the core of commercial trade and money-making.

Inevitably the turmoil of the 1960s and 1970s brought about changes throughout the Main Line. The entire region struggled with the loss of industry and suffered a dramatic decline in population. A national drop in the numbers of young families with children resulted in the closing of several public schools, and other districts merged to save money. Many of the large private estates were sold or their lands were subdivided. Some remain in use today as retirement homes or business headquarters.

By the 1980s, the area was an important participant in a regional rejuvenation and renewal. As Philadelphia found ways to attract new industry and residents, the Main Line benefited from its long history and reputation. New businesses moved in and offered a variety of service and retail opportunities. The Main Line was, as it had always been, one of the preeminent regions in the country.

Throughout its history, the Main Line addressed the forces of change by evolving without losing its connection to the past. The line of communities that grew up from the seeds of early Pennsylvania managed to retain their special flavor, even as the character of the world around them shifted. The strength of the Main Line identity lies in the strength of its institutions and in the community's commitment to ensure the successful future of this unique area.

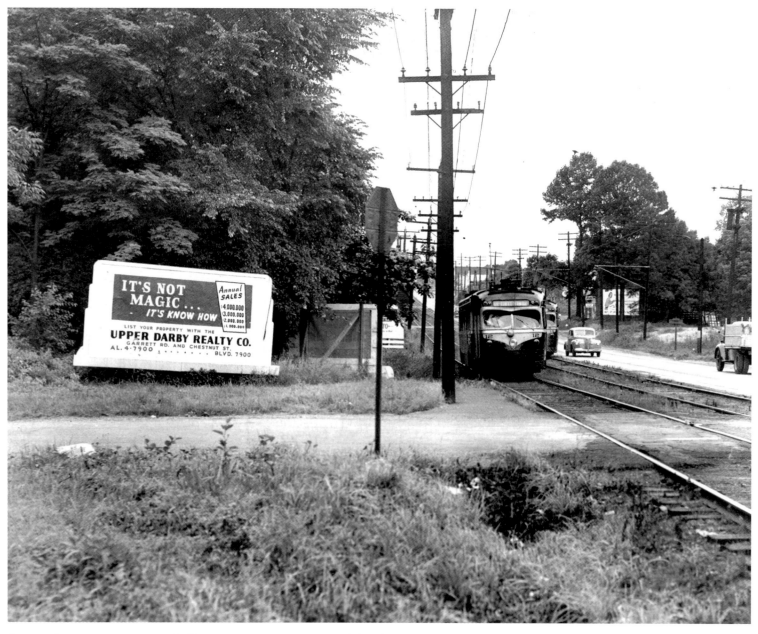

As part of a community-requested effort in 1950 to improve automobile safety along West Chester Pike in Haverford, large billboards such as the one seen here were to be removed. The trolley shown was run by the Red Arrow Line.

An outdoor display of art featuring busts of ancient philosophers is visited by students of Bryn Mawr College in October 1951. The display was placed in front of Radnor Hall, a dormitory.

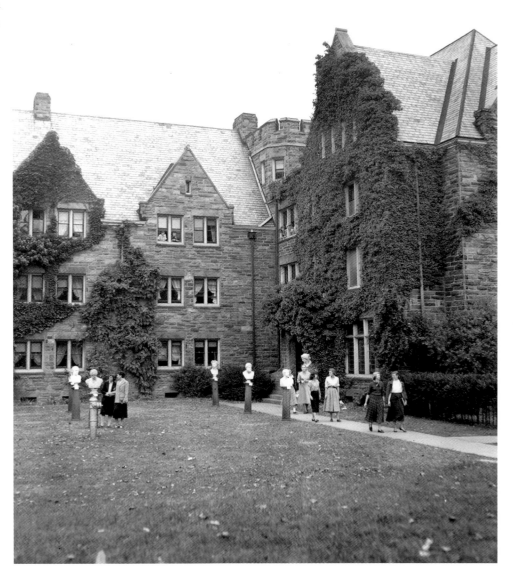

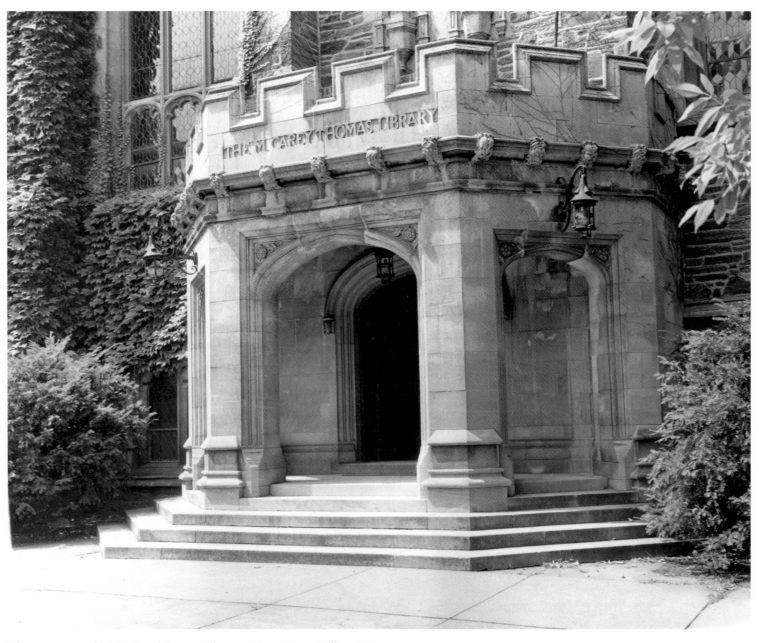

The entrance to the M. Carey Thomas Library at Bryn Mawr College. Miss Thomas was the first dean and second president of the college. The hall is no longer used as a library and instead serves as a performance and public use venue.

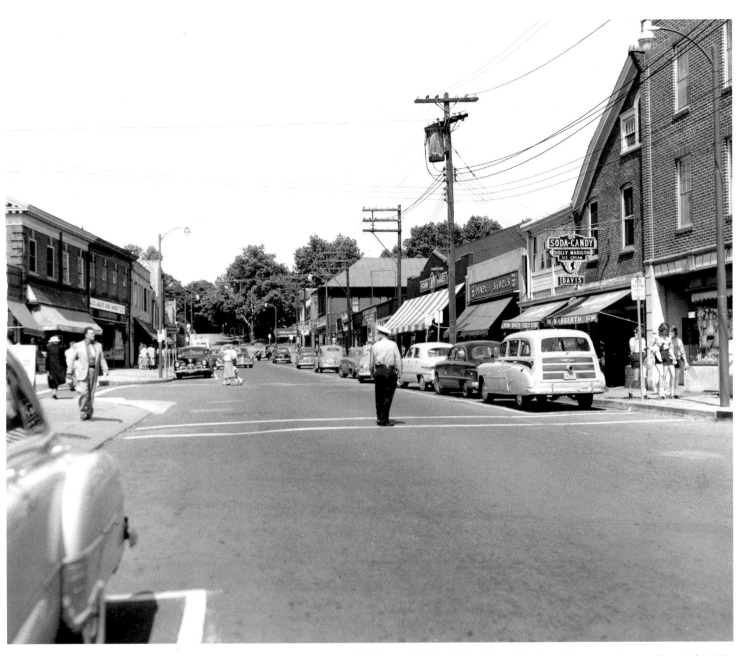

The heart of Narberth's business district on Lancaster Avenue, June 24, 1951.

The library at Haverford College in 1951. The library is known today for its excellent Quaker Collection.

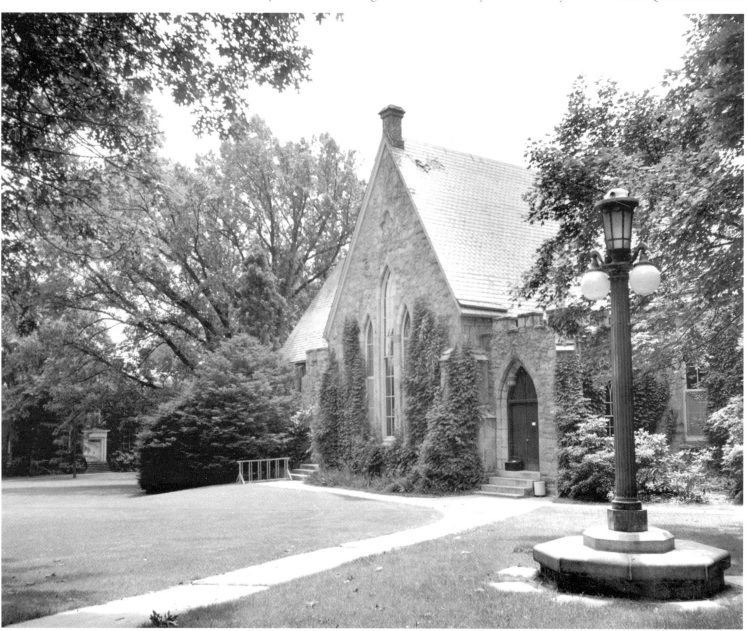

Roberts Hall at Haverford College, 1951.

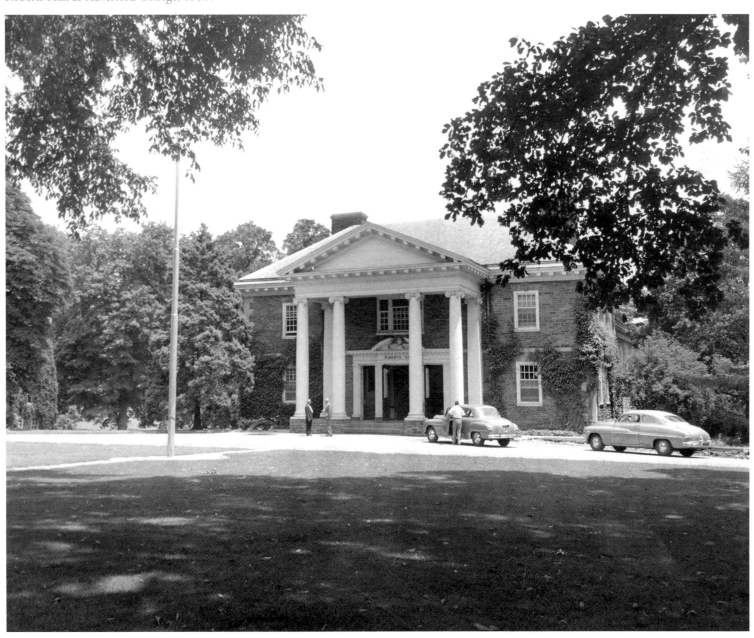

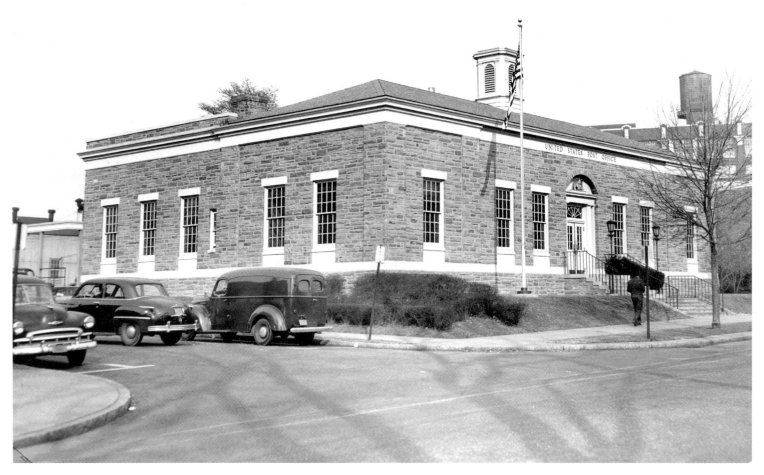

The Ardmore Post Office in 1951.

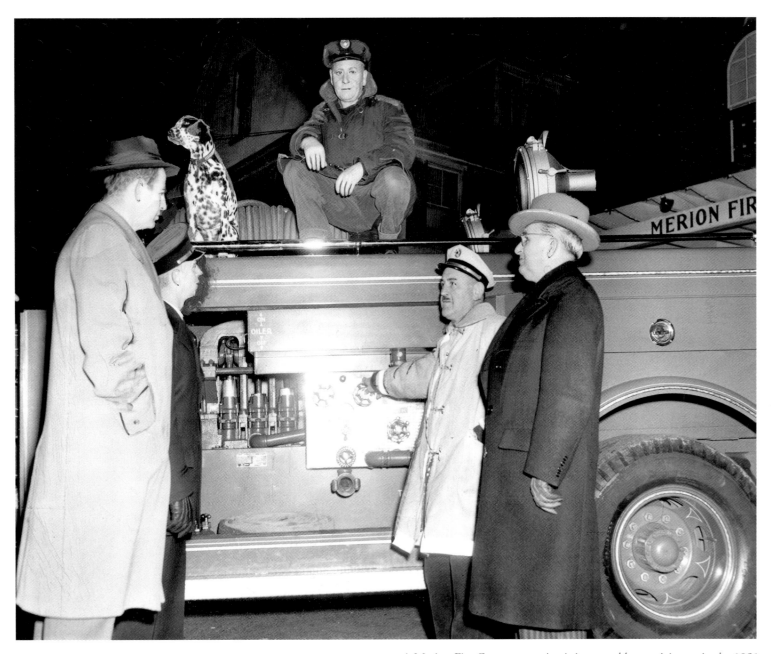

A Merion Fire Company engine is inspected by participants in the 1951 Ardmore-Wynnewood Parade, held in mid-December.

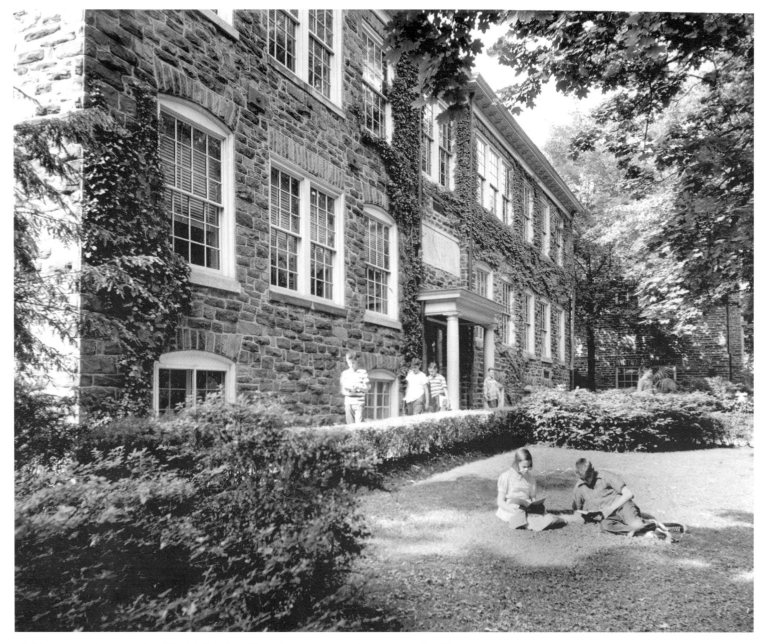

Children enjoy the grounds of the Narberth public school in 1951. The two-story building was completed in 1892 and demolished in 1961. A second school building on the same site was used until 1978 when declining enrollment forced the school district to close the school.

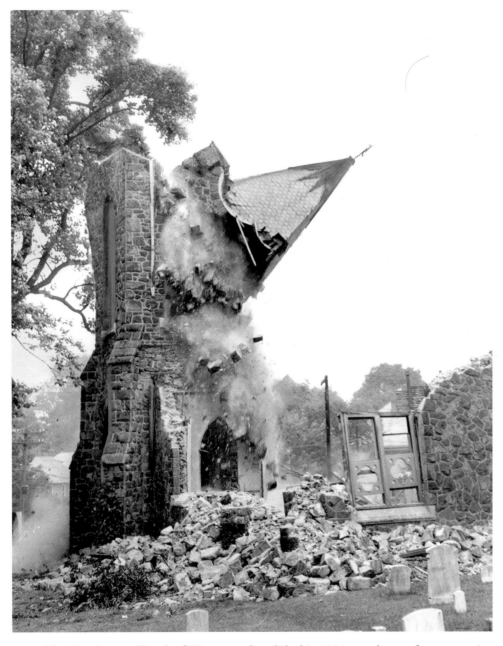

The First Baptist Church of Wayne was demolished in 1951 to make way for construction of a commercial building. The loss of landmarks like this one led to a revival of interest in local preservation, an effort that continues today.

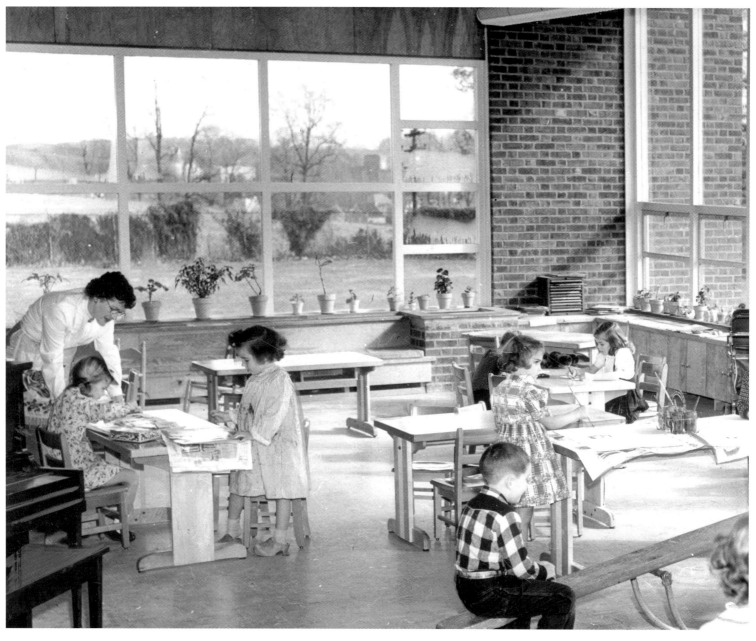

Kindergarteners explore the world of art and teeter-totters at a
Rosemont school in November 1952.

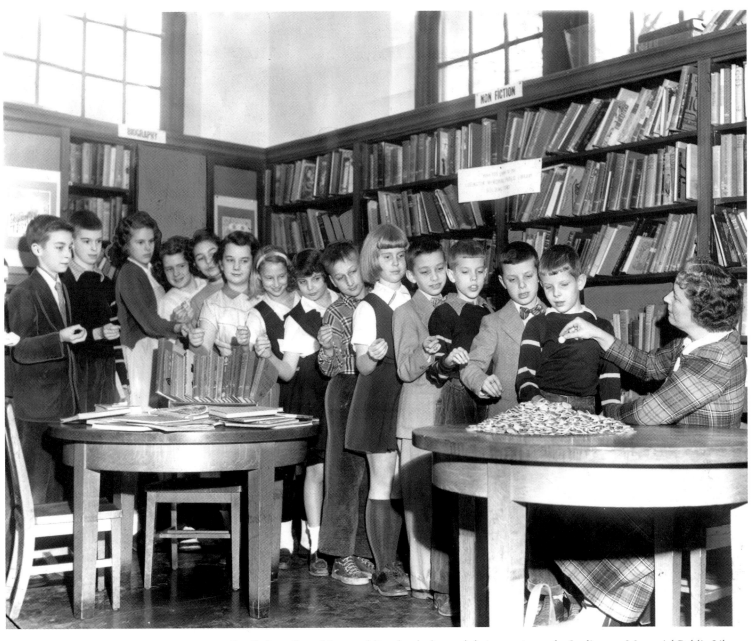

Pupils from Bryn Mawr public schools donated their pennies to the Ludington Memorial Public Library Building Fund in 1953. The library was eventually built and continues to serve Bryn Mawr residents.

The scene on Morris Avenue at the Bryn Mawr Station in 1953. The large maple
tree to the left was scheduled for removal to expand a parking lot.

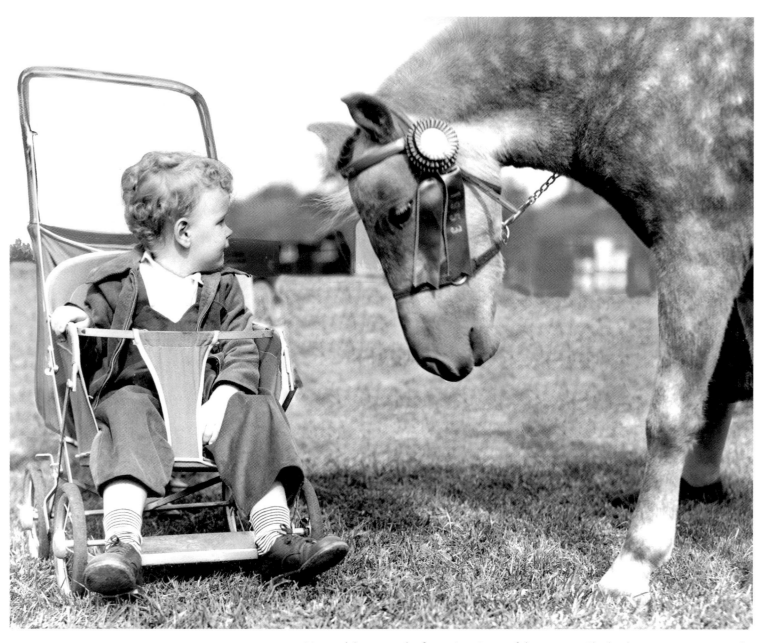

Linwood Supreme, the first-prize winner of the two-year Shetland pony competition at the 1953 Bryn Mawr–Chester County Horse Show, greets two-year-old Gregory Howard Cole.

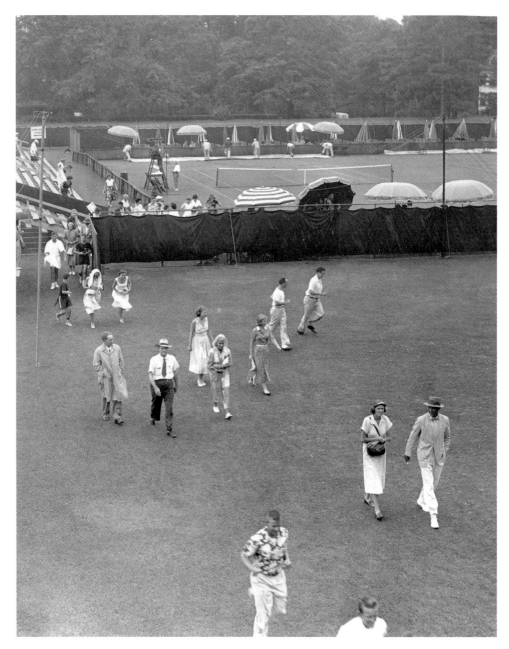

Spectators exit a rained-out tennis tournament at the Merion
Cricket Club in Haverford in 1953.

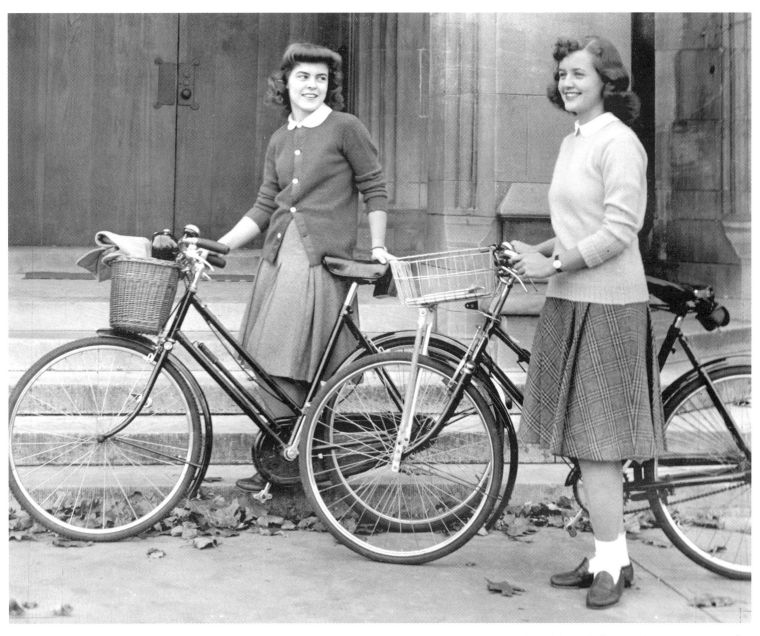

Bryn Mawr College students, in penny loafers
and bobby socks, around 1955.

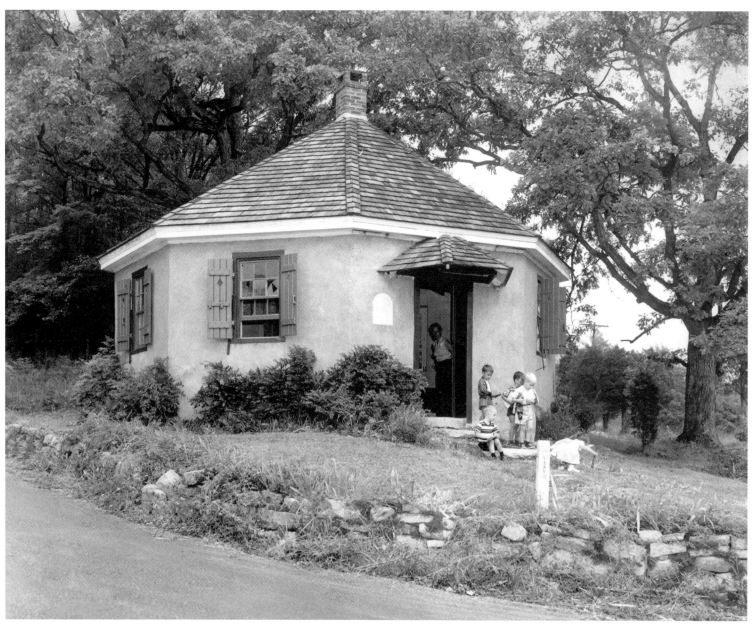

Located near Paoli, the Diamond Rock Octagonal School was built in 1818 by Mennonites as a one-room schoolhouse. The eight sides accommodated all six grade levels, a teacher's wall, and the door. The teacher stood in the center of the room to address each "class." The school was restored in 1908 and is seen here in 1955. It remains a popular summertime historic attraction.

Students at Rosemont College enter the chapel around 1955.

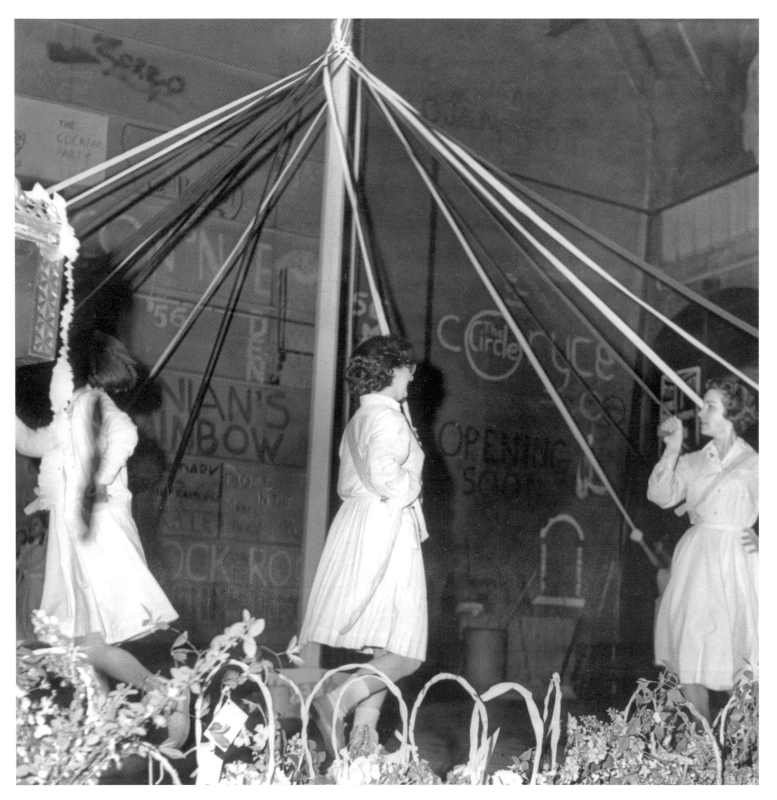

Driven indoors by inclement weather, Bryn Mawr students and their audience enjoy the traditional maypole dance as part of the college's May Day celebration around 1955.

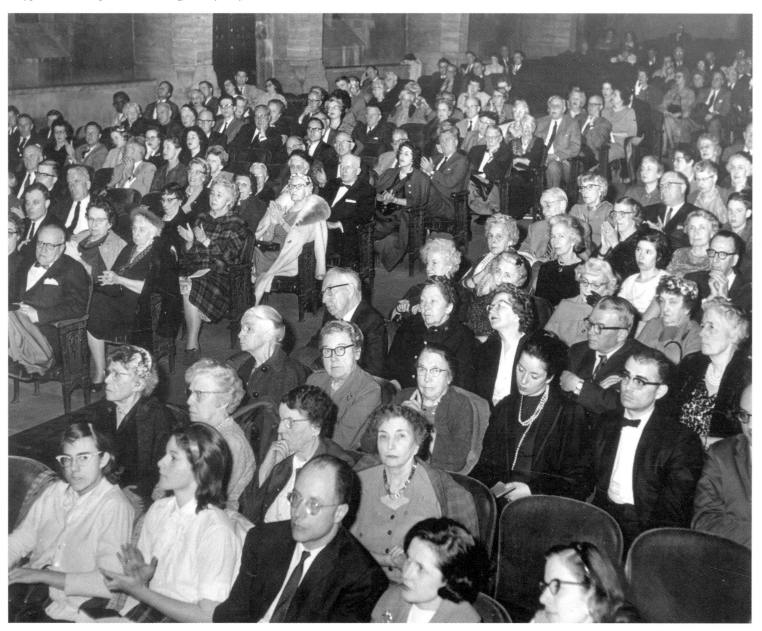

The Gertrude Kistler Library on the campus of Rosemont College, January 18, 1955. The new wing at right was completed and ready for dedication.

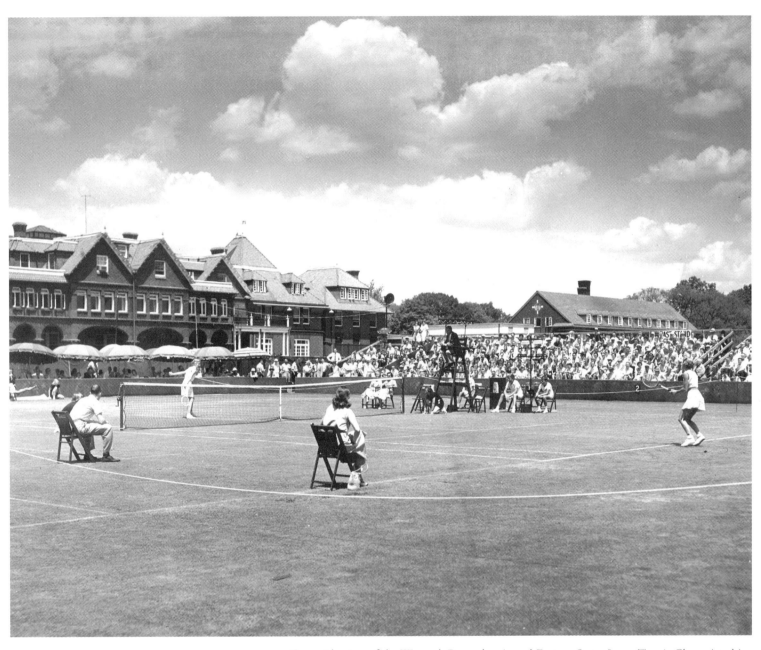

Courtside view of the Women's Pennsylvania and Eastern States Lawn Tennis Championships final in 1954. The tournament was held at the Merion Cricket Club in Haverford.

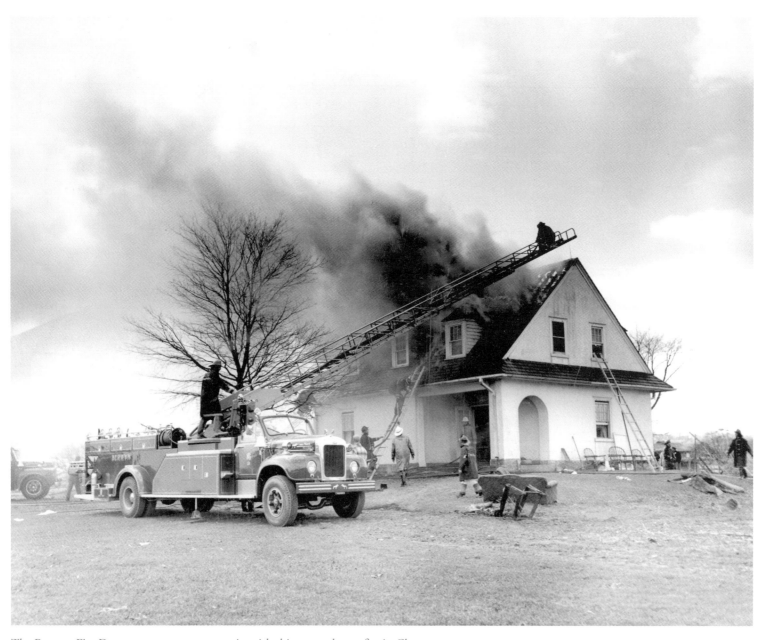

The Berwyn Fire Department attempts to extinguish this tenant house fire in Chester
County on February 23, 1956.

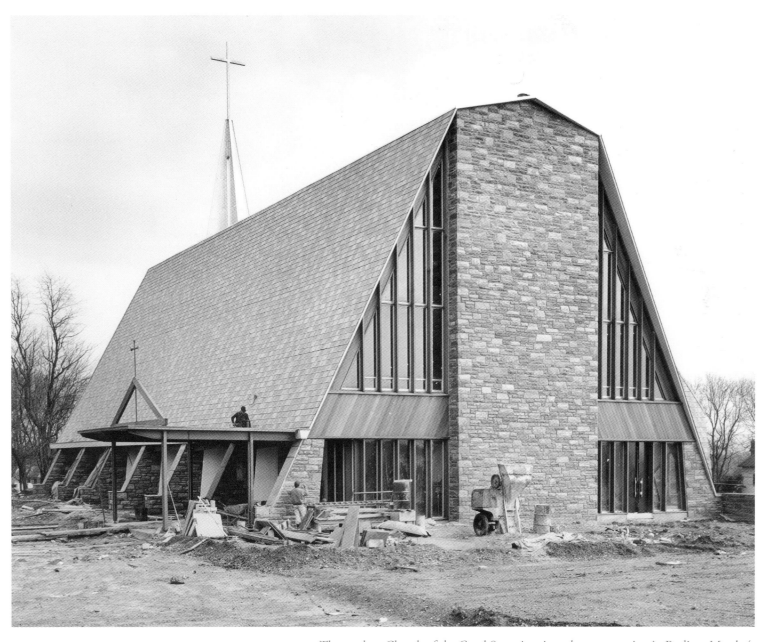

The modern Church of the Good Samaritan is under construction in Paoli on March 4, 1958. It is one of the largest Episcopal congregations in the region.

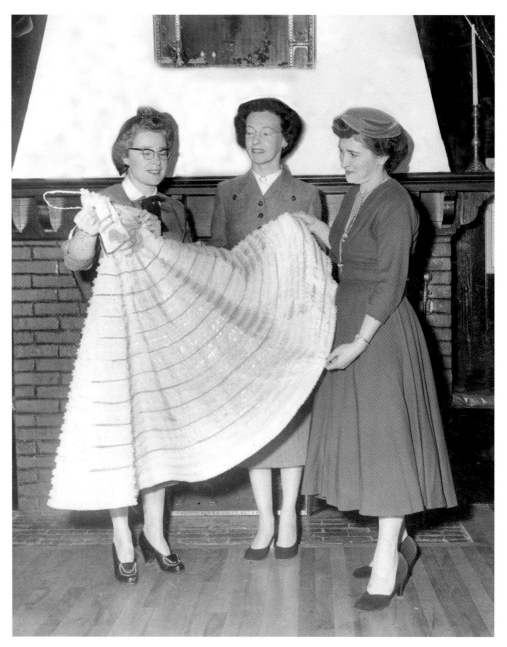

Members of the Saturday Club of Wayne admire one of the gowns to be worn at the club's fashion show in 1955. Founded in 1886, the club is still an active social and philanthropic organization.

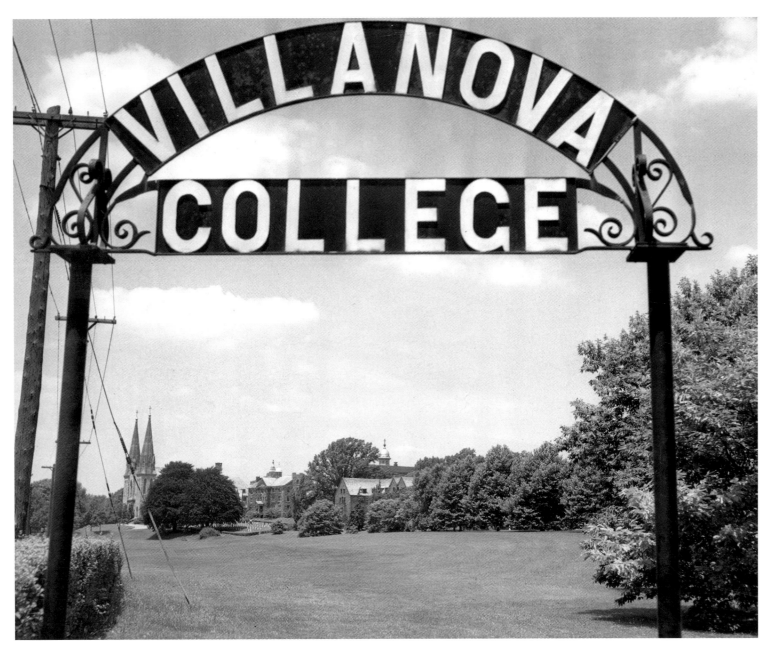

Founded in 1842 by the Augustinian Order, Villanova University was built on the Randolph estate in Radnor Township, known as "Belle Air" in the late 1840s. The first class of 24 students graduated in 1847. The college went on to become Villanova University in 1953, around the time this photograph was taken. The sign was located at the Lancaster Avenue entrance to the campus.

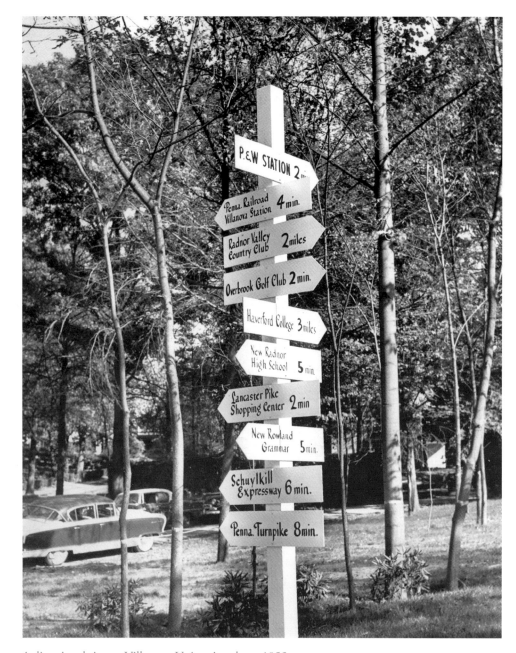

A directional sign at Villanova University, about 1955.

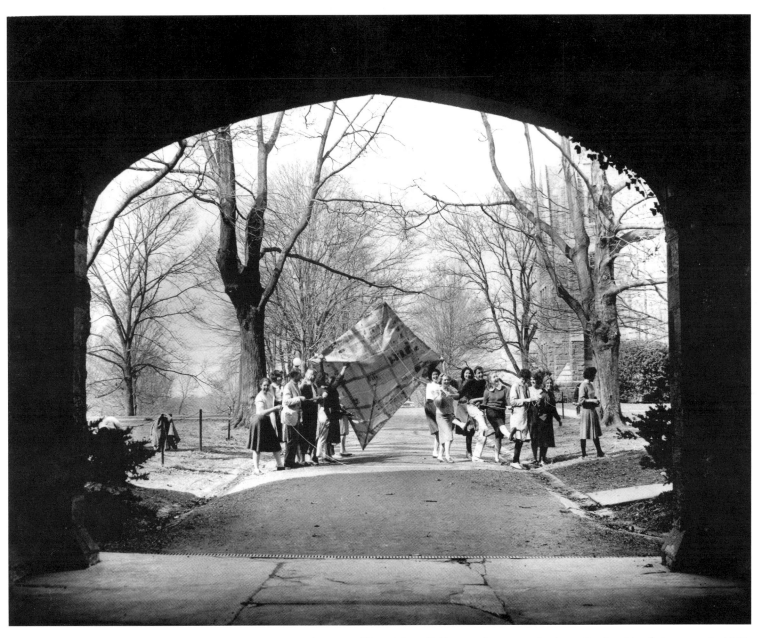

A group of Bryn Mawr College students organized a springtime kite-flying event in 1961.
The men pictured are students from nearby schools, probably Haverford College.

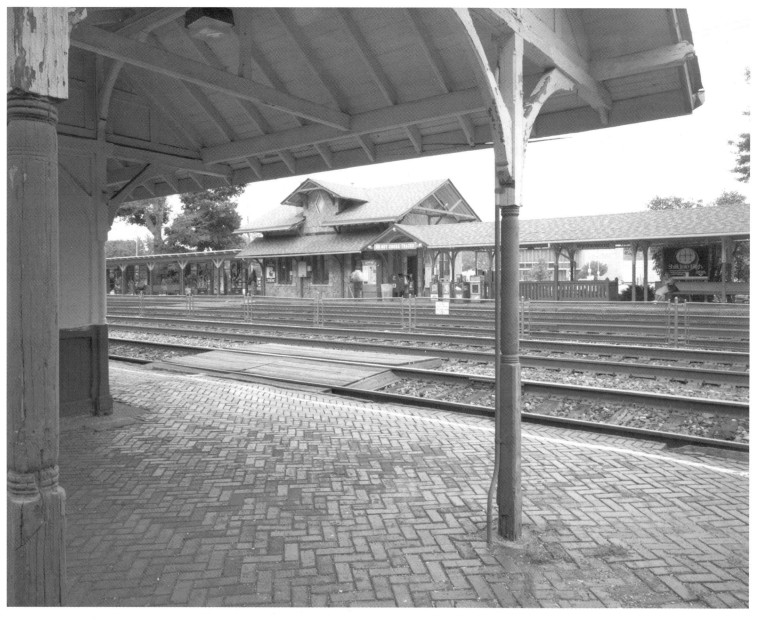

The Wynnewood Railroad Station was built in 1870 by Philadelphia architects Wilson Brothers & Company, who were known primarily for commercial work. Most notable among their projects was the massive Broad Street Station and the first Bryn Mawr Hotel, both commissioned by the Pennsylvania Railroad.

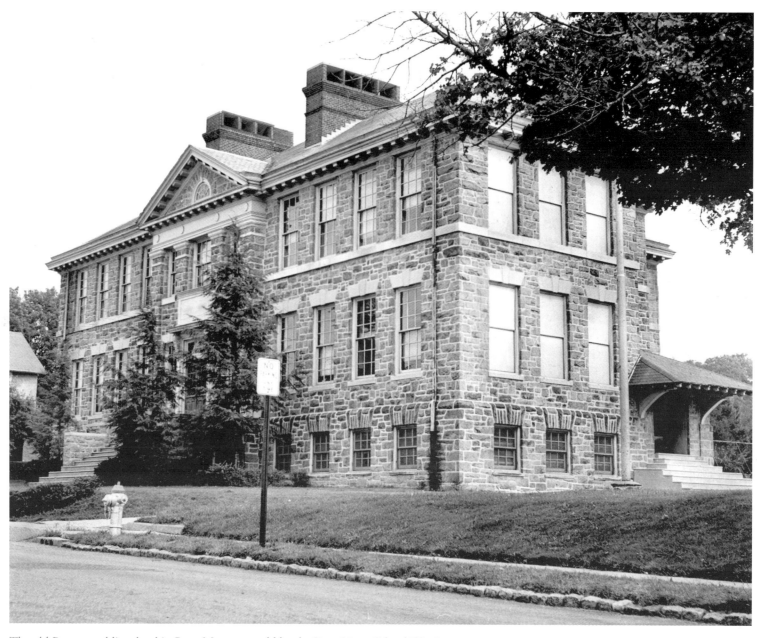

The old Preston public school in Bryn Mawr was sold by the Bryn Mawr School District in 1963. It was used for storage in the five years following the construction of the new Coopertown Elementary School in 1958.

Ashwood, located in Villanova, was once home to Peter Penn-Gaskell, representative of the Penn family in America beginning in 1785. The original home was built in 1723, with many nineteenth-century additions.

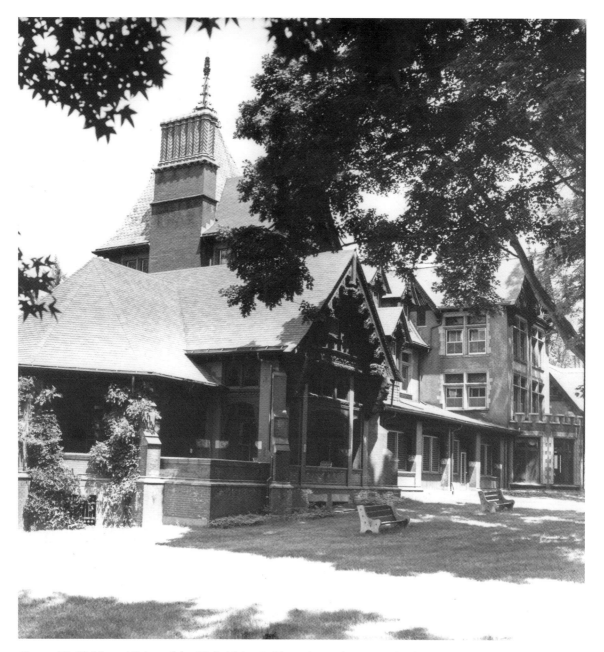

George W. Childs, publisher of the *Philadelphia Public Ledger* and primary developer of Wayne and other areas along the Main Line, lived here at "Wooten" in Bryn Mawr. The large estate was eventually purchased by George W. Childs Drexel, Childs' namesake and partner's son, in 1894.

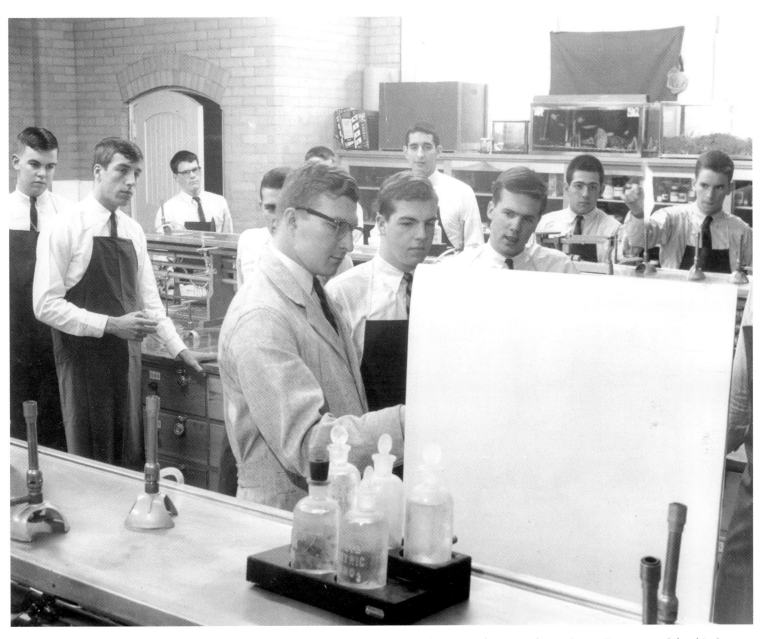

Chemistry instructor Robert B. Norwicki lectures his senior chemistry class at Devon Preparatory School in January 1964. Devon Prep was established in 1957 and continues today as one of the country's best boys' schools.

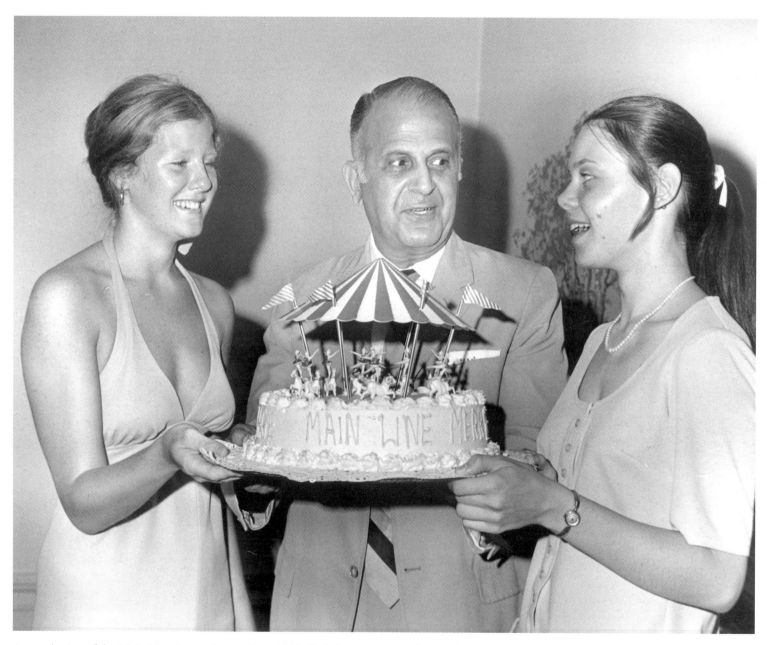

At a gathering of the Main Line Dance Group about 1965, Beth Bryant and Carolyn Mathieu share a moment with John M. Kapp, executive director of USO Philadelphia, Incorporated.

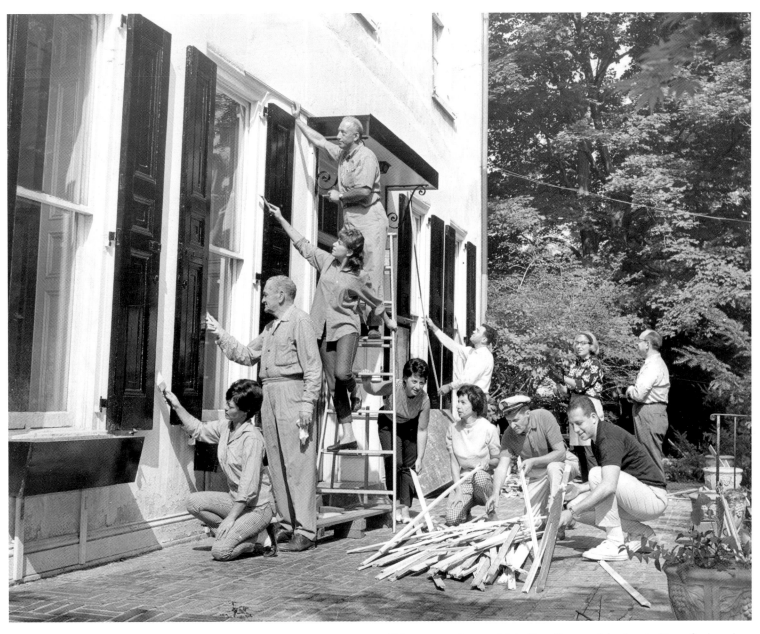

Volunteers at the new Main Line Center of the Arts in Haverford work to prepare for the first open house in 1963.

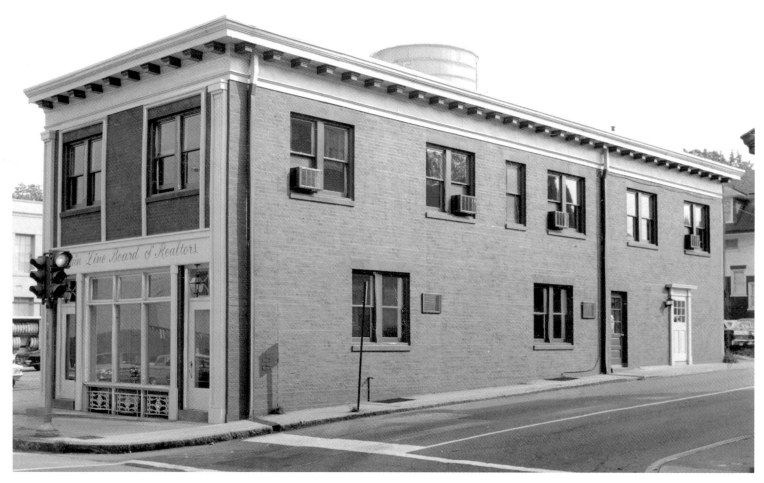

The new home of the Main Line Board of Realtors in
Bryn Mawr, in 1963.

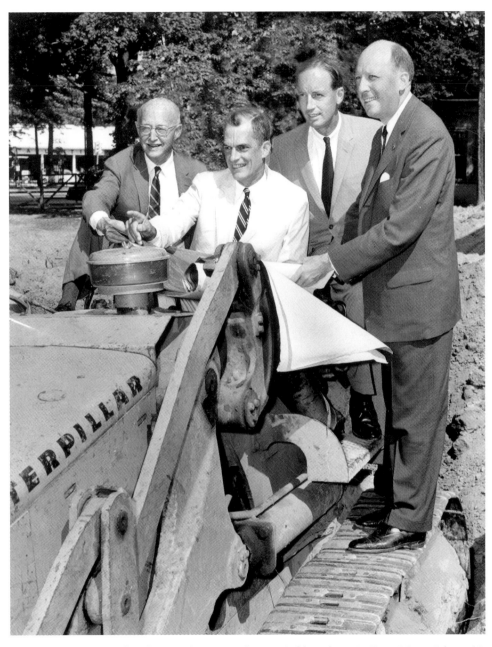

Groundbreaking at the new Ludington Public Library in Bryn Mawr, July 1965.

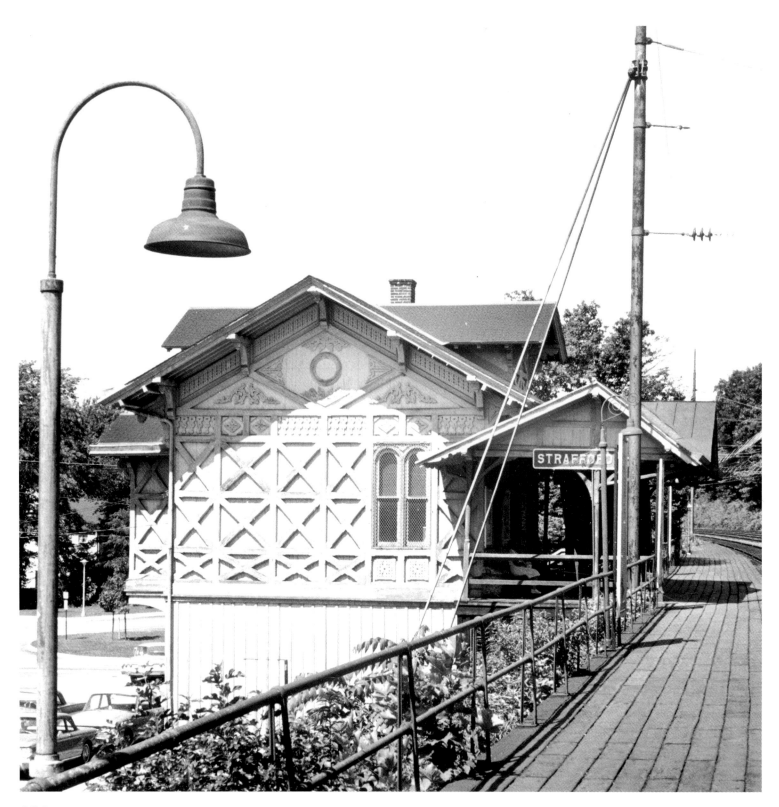

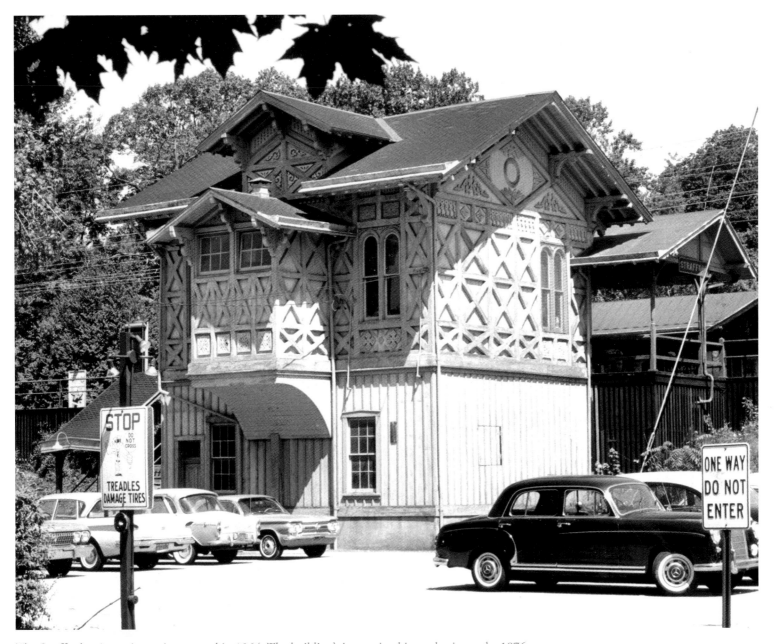

The Strafford train station as it appeared in 1964. The building's interesting history begins at the 1876 Centennial Exposition held in Fairmount Park, where it was likely used as a catalog sales shed. It was purchased by the Pennsylvania Railroad and moved to the Wayne station. In the late 1880s, it was moved for the last time to Strafford, where it remains today.

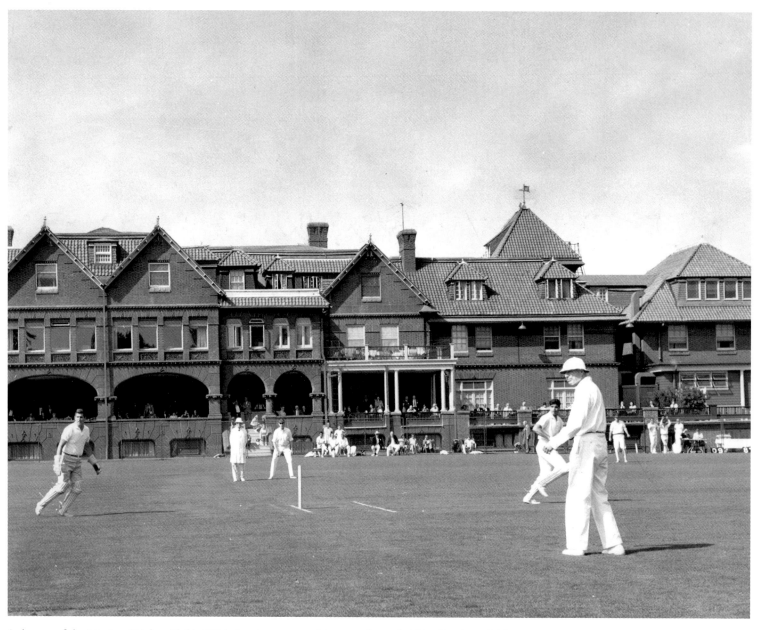

In honor of the Merion Cricket Club's 100th Anniversary, a cricket match was held in October 1965.

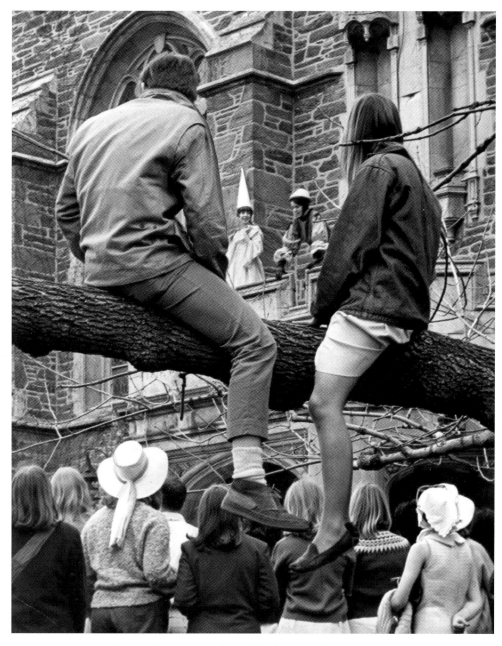

During the annual May Day play in the cloisters of the Bryn Mawr College Library in 1966, two audience members find a first-class seat.

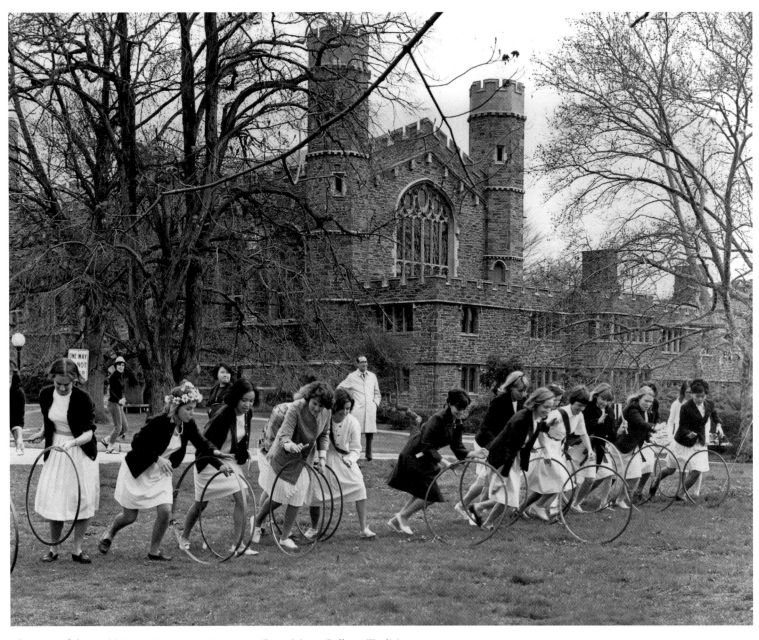

The start of the 1966 Hoop Race on senior row at Bryn Mawr College. Tradition
decreed that the winner would be the first to marry after graduation.

The Bryn Mawr Band entertains audience members at the Berwyn Elementary School on September 18, 1969. The community band was led by clarinetist and schoolteacher Herman Giersch from 1912 to 1974.

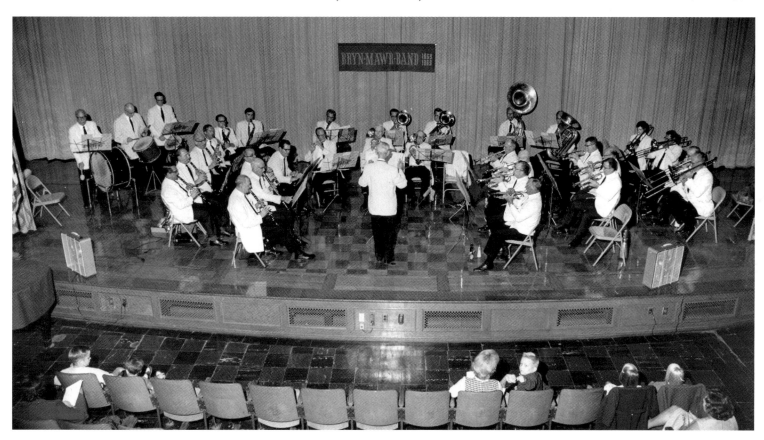

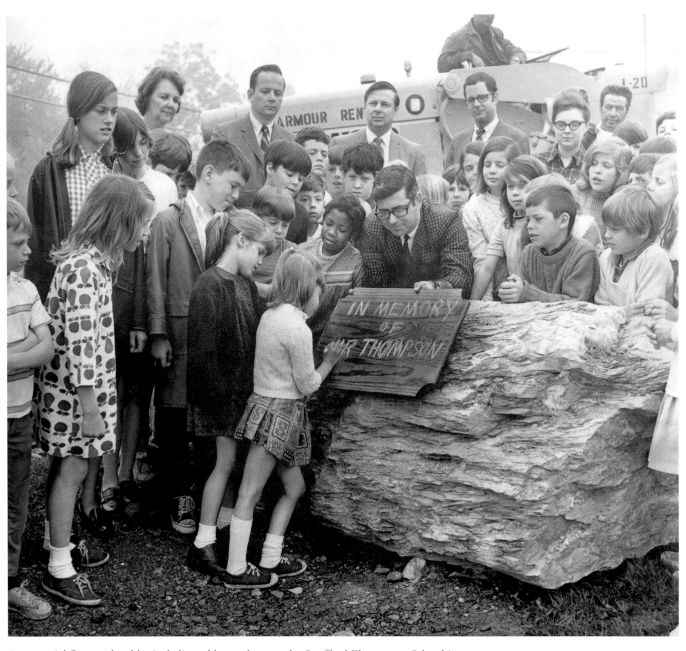

A memorial five-ton boulder is dedicated by students at the Strafford Elementary School in 1970 to honor their deceased principal Robert H. Thompson.

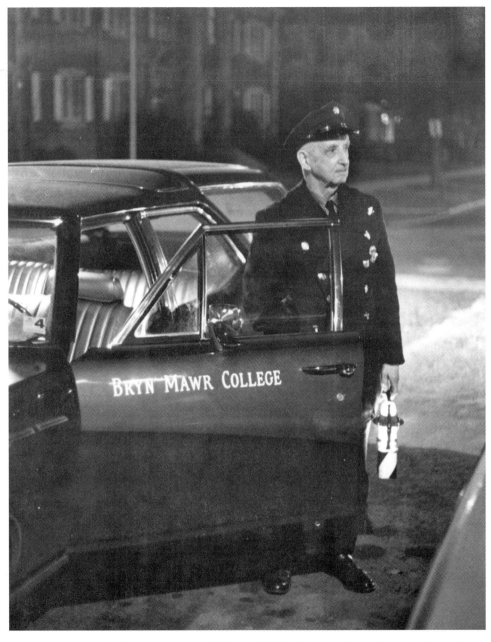

Bryn Mawr College security guard Edward O'Keefe waits at the train station for students who need a ride to campus on the evening of April 4, 1970.

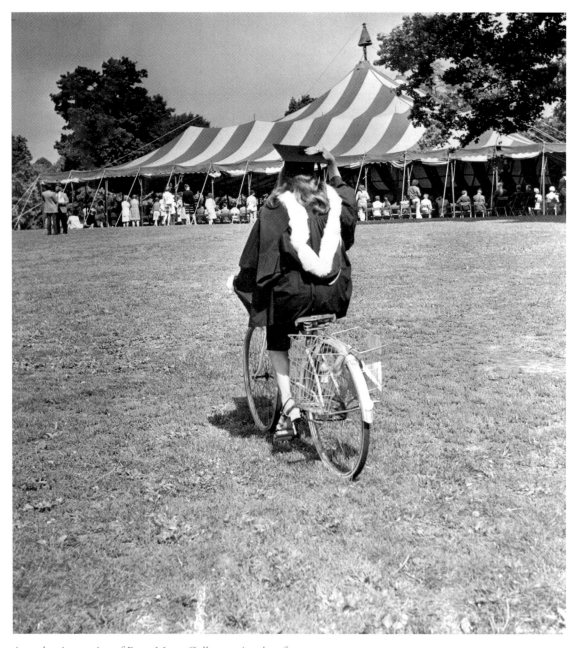

A graduating senior of Bryn Mawr College arrives late for commencement
exercises on May 24, 1971.

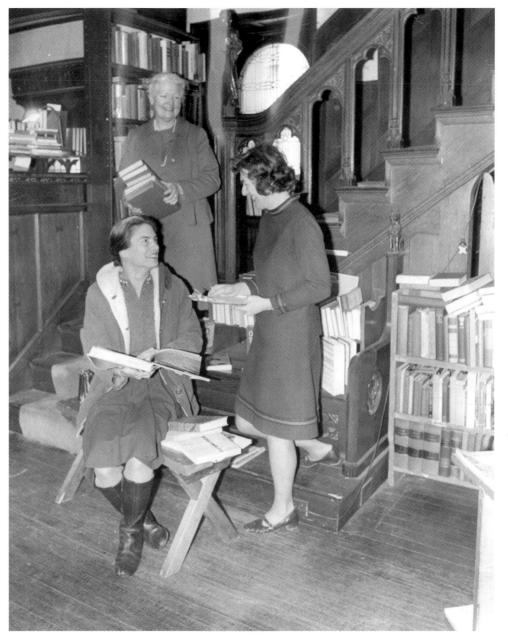

A shopper visits the Owl Bookshop at Bryn Mawr College in 1972. The Owl, named after the three owls featured on the college's official seal, was closed in 1999 owing to consolidation of administrative offices in the building located at Morris Avenue and Yarrow Street.

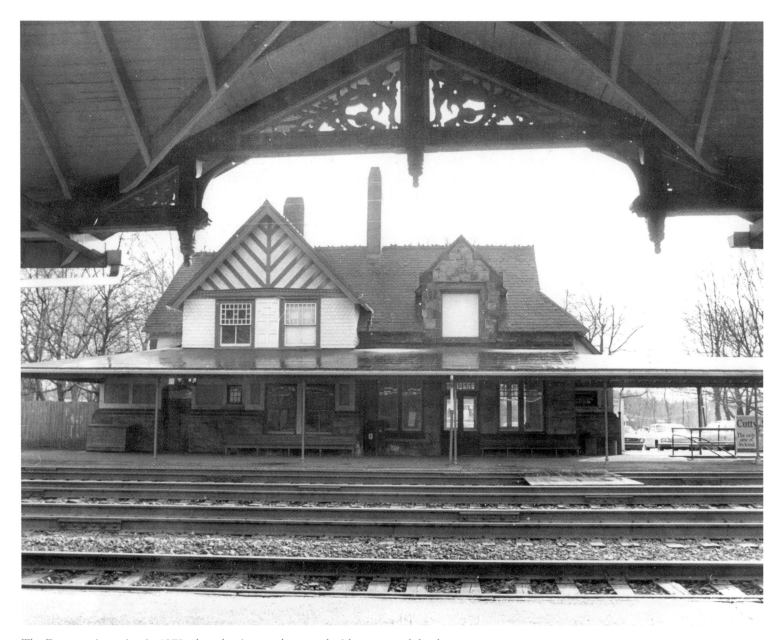

The Devon train station in 1972 when the site was threatened with a proposed development of apartments. The station survived and is currently undergoing renovations.

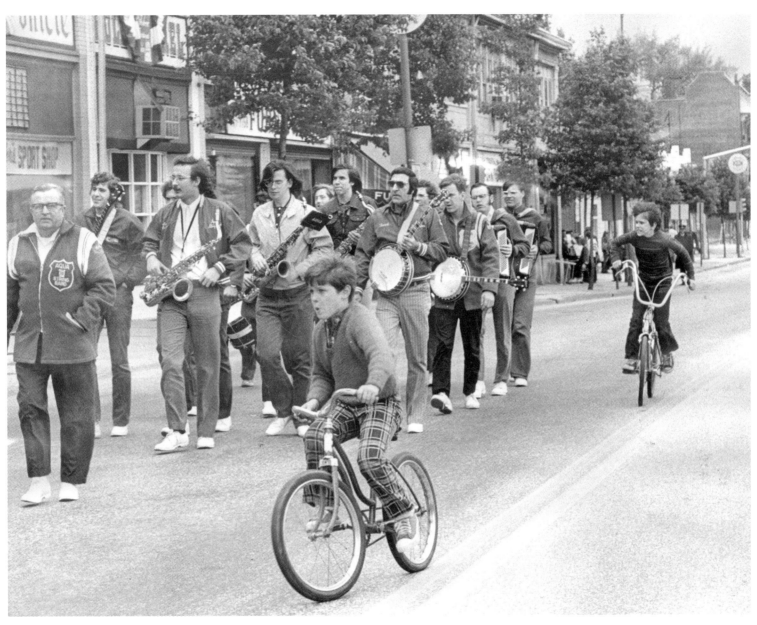

Ardmore's centennial celebration was marked on May 7, 1973, with a parade down Lancaster Avenue. A mummers group, the Aqua String Band from northeast Philadelphia, led the parade in street clothes because of cold and rainy weather.

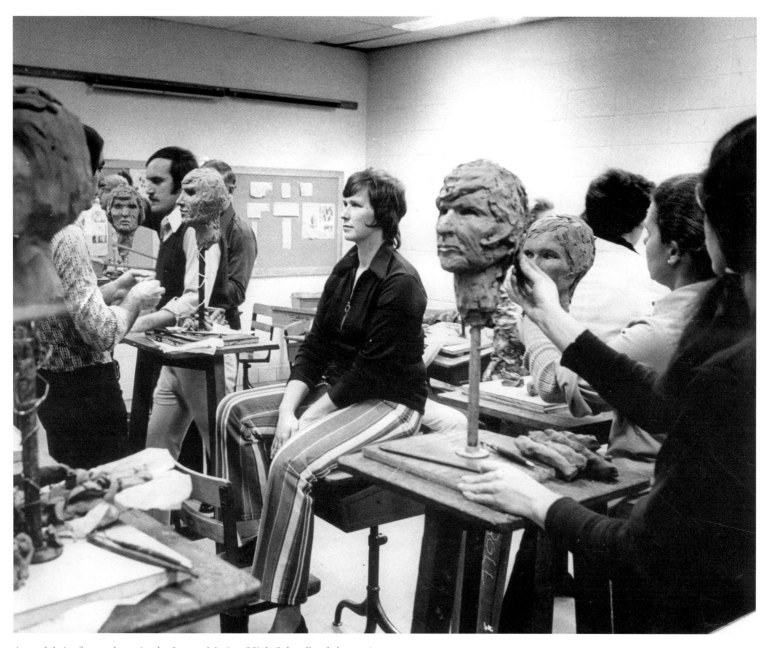

A model sits for students in the Lower Merion High School's adult evening art class on March 6, 1973.

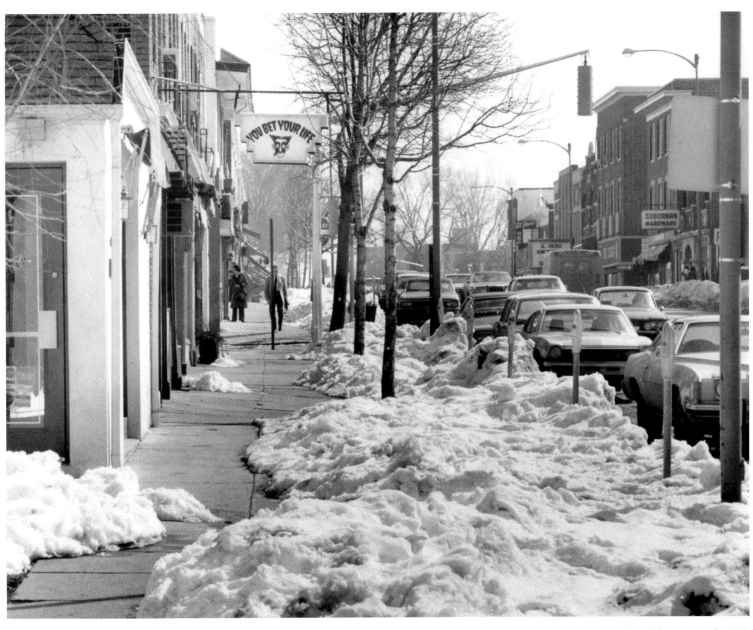

Lancaster Avenue in Bryn Mawr around 1975.

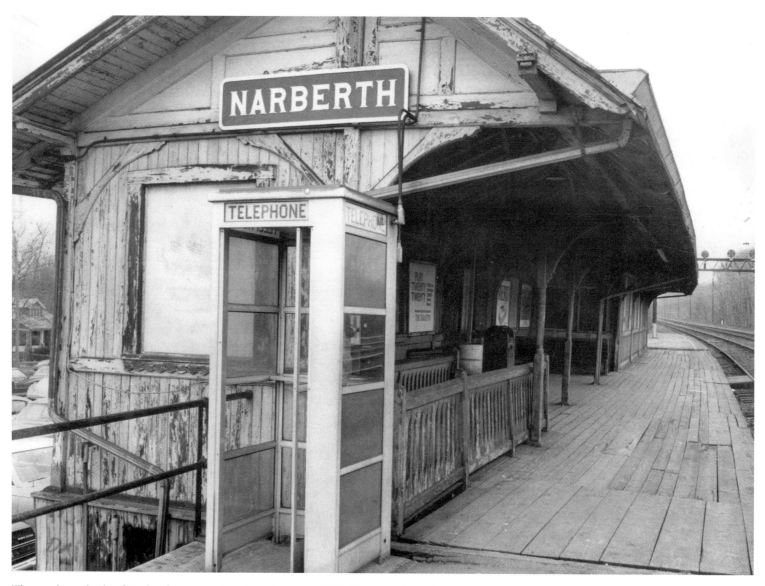

The westbound side of Narberth train station shows its age in 1978. Two years later the building was replaced with a modern, minimalist-design station.

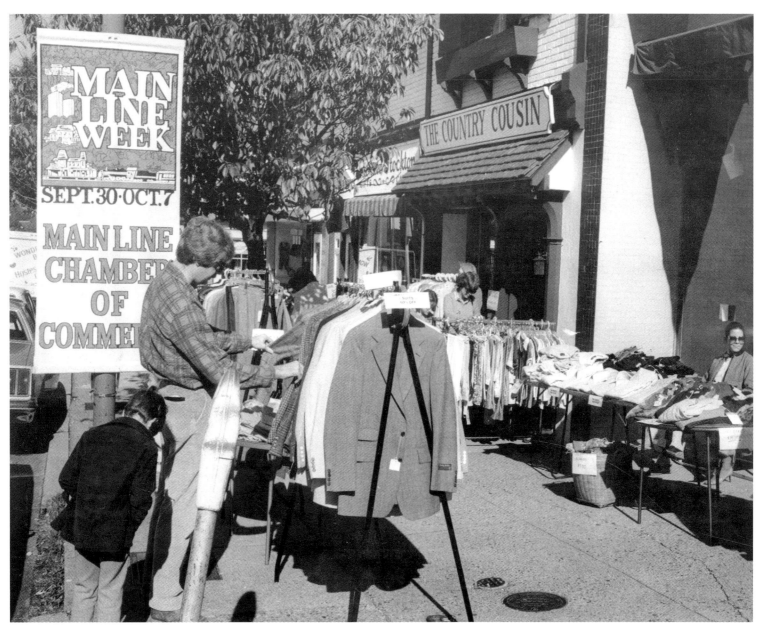

A sidewalk sale was held to commemorate Main Line Week in 1979.

Notes on the Photographs

These notes, listed by page number, attempt to include all aspects known of the photographs. Each of the photographs is identified by the page number, photograph's title or description, photographer and collection, archive, and call or box number when applicable. Although every attempt was made to collect all available data, in some cases complete data was unavailable due to the age and condition of some of the photographs and records.

146 LARGE BILLBOARD
Temple University Libraries
Urban Archives
Philadelphia, Pa.
TU-UA Haverford

147 BUST DISPLAY
Temple University Libraries
Urban Archives
Philadelphia, Pa.
TU-UA Bryn Mawr Box 94

148 M. CAREY THOMAS LIBRARY
Temple University Libraries
Urban Archives
Philadelphia, Pa.
TU-UA Bryn Mawr Box 94

149 NARBERTH'S BUSINESS DISTRICT
Temple University Libraries
Urban Archives
Philadelphia, Pa.
TU-UA Narberth Box 347

150 LIBRARY AT HAVERFORD COLLEGE
Temple University Libraries
Urban Archives
Philadelphia, Pa.
TU-UA Haverford

151 ROBERT'S HALL AT HAVERFORD COLLEGE
Temple University Libraries
Urban Archives
Philadelphia, Pa.
TU-UA Haverford

152 ARDMORE POST OFFICE
Temple University Libraries
Urban Archives
Philadelphia, Pa.
TU-UA Ardmore

153 MERION FIRE COMPANY ENGINE
Temple University Libraries
Urban Archives
Philadelphia, Pa.
TU-UA Merion

154 NARBERTH PUBLIC SCHOOL
Temple University Libraries
Urban Archives
Philadelphia, Pa.
TU-UA Narberth Box 347

155 FIRST BAPTIST CHURCH OF WAYNE
Temple University Libraries
Urban Archives
Philadelphia, Pa.
TU-UA Wayne

156 KINDERGARTENERS
Temple University Libraries
Urban Archives
Philadelphia, Pa.
TU-UA Rosemont

157 DONATING PENNIES
Temple University Libraries
Urban Archives
Philadelphia, Pa.
TU-UA Bryn Mawr Box 93

158 MORRIS AVENUE
Temple University Libraries
Urban Archives
Philadelphia, Pa.
TU-UA Bryn Mawr Box 93

159 LINWOOD SUPREME
Temple University Libraries
Urban Archives
Philadelphia, Pa.
TU-UA Bryn Mawr Box 94

160 RAINED-OUT TENNIS TOURNAMENT
Temple University Libraries
Urban Archives
Philadelphia, Pa.
TU-UA Merion

161 BRYN MAWR COLLEGE STUDENTS
Temple University Libraries
Urban Archives
Philadelphia, Pa.
TU-UA Bryn Mawr Box 94

162 DIAMOND ROCK OCTAGONAL SCHOOL
Temple University Libraries
Urban Archives
Philadelphia, Pa.
TU-UA Paoli

163 MAYPOLE DANCE
Temple University Libraries
Urban Archives
Philadelphia, Pa.
TU-UA Bryn Mawr Box 93

164 MAYPOLE DANCE 2
Temple University Libraries
Urban Archives
Philadelphia, Pa.
TU-UA Bryn Mawr Box 93

165 ROSEMONT COLLEGE STUDENTS
Temple University Libraries
Urban Archives
Philadelphia, Pa.
TU-UA Rosemont

166 GERTRUDE KISTLER LIBRARY
Temple University Libraries
Urban Archives
Philadelphia, Pa.
TU-UA Rosemont

167 TENNIS CHAMPIONSHIP
Temple University Libraries
Urban Archives
Philadelphia, Pa.
TU-UA Merion

168 BERWYN FIRE DEPARTMENT
Temple University Libraries
Urban Archives
Philadelphia, Pa.
TU-UA Devon

169 CHURCH OF THE GOOD SAMARITAN
Temple University Libraries
Urban Archives
Philadelphia, Pa.
TU-UA Paoli Box 372

170 MEMBERS OF THE SATURDAY CLUB
Temple University Libraries
Urban Archives
Philadelphia, Pa.
TU-UA Wayne

171 VILLANOVA COLLEGE
Temple University Libraries
Urban Archives
Philadelphia, Pa.
TU-UA Villanova Box 510

172 DIRECTIONAL SIGNS AT VILLANOVA COLLEGE
Temple University Libraries
Urban Archives
Philadelphia, Pa.
TU-UA Villanova

173 FLYING KITES AT BRYN MAWR COLLEGE
Temple University Libraries
Urban Archives
Philadelphia, Pa.
TU-UA Bryn Mawr Box 94